HAWKSMOOR'S LONDON CHURCHES

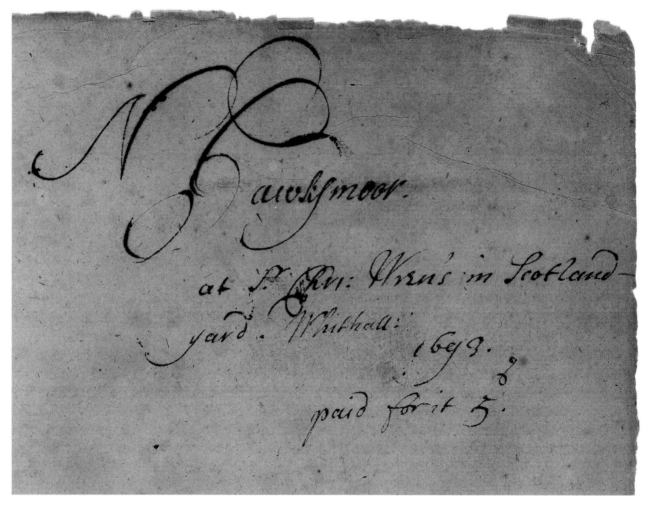

Nicholas Hawksmoor, ownership inscription from his copy of Michael Wright's *An Account of His Excellence Roger Earl of Castlemaine's Embassy, from His Sacred Majesty James II . . . to His Holiness Innocent XI* (London, 1688), flyleaf (Queen's University at Kingston, Ontario).

Hawksmoor's London Churches

Architecture and Theology

Pierre de la Ruffinière du Prey

THE UNIVERSITY OF CHICAGO PRESS

Chicago and London

PIERRE DE LA RUFFINIÈRE DU PREY is professor in the Department of Art
at Queen's University in Kingston, Ontario. He is the author of several books,
most recently *The Villas of Pliny from Antiquity to Posterity*.

The University of Chicago Press, Chicago 60637

The University of Chicago Press, Ltd., London

© 2000 by Pierre de la Ruffinière du Prey

All rights reserved. Published 2000

Printed in the United States of America

09 08 07 06 05 04 03 02 01 00 1 2 3 4 5

ISBN: 0-226-17301-1 (cloth)

Library of Congress Cataloging-in-Publication Data

Du Prey, Pierre de la Ruffinière.

 Hawksmoor's London churches : architecture and theology / Pierre de la Ruffinière
 du Prey.

 p. cm.

 Includes bibliographical references and index.

 ISBN 0-226-17301-1 (cloth : alk. paper)

 1. Church architecture—England—London. 2. Hawksmoor, Nicholas,
1661–1736—Criticism and interpretation. 3. London (England)—Buildings,
structures, etc.

 I. Hawksmoor, Nicholas, 1661–1736. II. Title.

NA5470.A1 D8 2000726.5'092—dc21 99-047674

To Deirdre and Phyllis,

Paul and Rosalind,

and in memory of Edgard and Tweet,

lovers of Hawksmoor and

Wren's city of spires

CONTENTS

ILLUSTRATIONS

ACKNOWLEDGMENTS

Like Leone Allacci's De templis Graecorum, mentioned at the beginning of my first chapter, this book is a short one. But it has taken a long time to reach completion, and scholarly debts have piled up. It is a pleasure to acquit myself of them at last.

My debts begin with my students, my colleagues, and the members of my family who have listened to and read various versions of my research in progress over the years. First I acknowledge my wife, whose support of my work has sustained it during the two decades it has been under way on and off. Among the students who brought their fresh perspectives to the topic I think particularly of Suzanne Birks, Joni Carroll, Tony Lever, and the class of graduate students who created with me in 1995 the exhibition "Architects, Books, and Libraries," along with its accompanying published collection of essays. While she was my research assistant, Jillian Harrold helped me secure photographs, and she has continued to do so even after she moved permanently to London. Most recently, in 1997 I conducted a seminar on imaginary restitutions of the Temple of Jerusalem. Another group of Queen's University graduate students worked closely with me, and they prepared for publication the text of appendix 1, where each is acknowledged for her individual contribution. A much earlier draft of this book received very helpful criticism from my colleagues Paul Christianson and J. Douglas Stewart. They encouraged me to submit it to Tod Marder, then editor of the *Journal of the Society of Architectural Historians.* He helped cut it down to the length of an article, which appeared in March 1989. Robert Buck, managing editor of the journal at the time, expertly saw it through the press. As I was preparing this book, the Reverend David H. Smart, my colleagues Ross Kilpatrick and Charles Pullen, the two anonymous readers selected by the University of Chicago Press, and the Press's senior manuscript editor Alice Bennett have eliminated errors, elucidated my interpretation, and improved my expression. Many others have helped, and in my notes I have tried to single them out. But I would be remiss were I not to gratefully mention here my colleagues on the Arts Research Committee of

Queen's University for the research funds they made possible by a timely and generous grant.

Over the course of time I have been invited to lecture on various aspects of this topic to audiences all the way from my home in Kingston to Montreal, Quebec City, Washington D.C., Sewanee, Guelph, Toronto, Boulder, and my alma mater, Princeton University. I have even had the privilege of speaking about Hawksmoor in his own church of Saint Anne's Limehouse. I thank my hosts and my listeners, including my son and daughter, for their many helpful comments and their enthusiasm. Like me, they must have wondered when, if ever, my ideas would see their way into print.

Various institutions at home and abroad have aided my work, and I acknowledge them for their help, beginning with the Lambeth Palace Library, where the research for this book really all began. My own university, Queen's, started out as a theological college, and it therefore possesses a goodly array of what the Reverend William Whiston once called "primitive books." In addition, Queen's Special Collections has to its credit acquired a number of unique association copies that have directly furthered my research. In Canada I also feel privileged to have near at hand the extraordinary holdings of the Canadian Centre for Architecture in Montreal. At Oxford, that most bookish of cities, I spent a thoroughly enjoyable stay at the Bodleian Library, thanks in part to the kind assistance of Sir Howard Colvin and to the hospitality of my cousins Charles and the late Anne Spain. While there I profited greatly from visits to Worcester College, to Christ Church, where portraits of Hawksmoor's clergymen-clients still hang, and to the architect's own Codrington Library at All Souls. On the same occasion I consulted the Hawksmoor drawings in the King's Maps Division of the British Library and at the Royal Institute of British Architects in London.

While working on my previous book in the wonderfully conducive setting of the Institute for Advanced Study in Princeton, I would occasionally play truant to delve into Hawksmoor-related material at the Firestone, Marquand, and Theological Seminary libraries. More recently, a fellowship at Yale University's British Art Center permitted me to use a marvelous constellation of facilities including the Seeley Mudd Book Depository. I lugged out of it hefty if dusty stacks of rich material and came to appreciate the physical as well as the intellectual weight of seventeenth- and eighteenth-century biblical scholarship. "Its great tomes," the late Reverend Gareth Bennett somewhat ruefully remarked, "lie heavily on the shelves of old libraries." My book, short though it may be, aspires to redeem from obscurity that worthy tradition of scholarship and to shed new light on the architecture it inspired from Nicholas Hawksmoor.

\mathcal{P} ROLOGUE

THE CLASSICAL TRADITION meanders in and out of the history of architecture, sometimes looping back upon itself as if to suggest that time has stood still. One such remarkable oxbow links the eighteenth-century ecclesiastical architecture of Nicholas Hawksmoor with that of Christians in the Near East some thirteen hundred years earlier. The early Christians in this part of the world had built thousands of churches whose remains litter the countryside. For example, the "dead cities" of modern-day northern Syria are full of such sacred ruins—sometimes as many as two or three in a community no larger than a small village. For three hundred years and more, from the early fourth century onward, this church-building frenzy continued unabated. Then, for reasons not entirely clear, the architectural efflorescence suddenly ceased. It is probable that economic decline brought about by poor agrarian policies, political instability abetted by doctrinal differences or sectarian strife, and the steady advance of Islam all contributed to ending so abruptly the brilliantly original church building of these early Christians. What survives are vast monastery complexes, basilicas marking the principal Christian pilgrimage sites, and legions of parish churches, mausoleums, and meeting houses. They owe their survival partly to the indifference or tolerance of Islam, partly to the clement climate, and partly to the excellent materials used: easily cut grayish sedimentary rock, durable dark basalt, and the honey-colored Judean stone from which all Jerusalem is built. They form a remarkably well preserved testimony to building practices and religious zeal at the end of the pagan Roman period.

In addition to the quality and abundance of their stone, the early Christians had the advantage of the strength they drew from the simplicity and primitive purity of their faith. Such an interpretation, whether naive or not, certainly existed in the minds of many Christian theologians contemporary with Hawksmoor. They were eager to escape the divisiveness that had dogged Christianity for centuries and that still plagued them. The problem remained, of course, that each denomination firmly believed it had God on its side. So although it is impossible to really speak at that early date of a post-Reforma-

tion ecumenical movement in the modern sense, a genuine attempt at mutual understanding was under way, at least among the well-educated clergy and architects who will frequently appear in these pages. Part of this ecumenical tendency stemmed from an interest in early church history and liturgy that freely crossed linguistic, national, and denominational boundaries. The scholarly translation and publication of the Bible, the Jewish rabbinical texts, and the writings of the church fathers all reinforced serious study of the origins of Christianity. A fascination quickly developed regarding the way the early Christians had practiced their religion. Scholars increasingly asked themselves questions that had an architectural bearing. Were the earliest churches simple meeting places? Did churches derive from contemporary synagogues, or from the splendid Temple of Jerusalem, or from the equally magnificent basilicas of the ancient Romans, or from a combination of all these sources of inspiration? Responses varied considerably. But among Protestants generally, and particularly among the Anglicans who are the focus of this book, the search for the earliest forms of liturgy had a virtue in its own right. They reasoned that if they could correlate the true forms of early worship with their own, a special sort of legitimacy would ensue. They could bypass entirely the Church of Rome and arrive at their own architecture sanctioned by the earliest practices—those closest in time to the ministry of Christ.

According to these theories, it stood to reason that if a denomination built its architecture in emulation of early Christian churches, then the places of worship themselves would bestow greater holiness on the worshipers gathered within. People attending church would experience the spiritual benefits of a truer, purer religion. In short, they would partake of a more "primitive Christianity," to quote the phrase so frequently employed by Anglican theologians in their sermons, religious pamphlets, and books of theology. The task of providing a contemporary architecture commensurate with these ideals and based on primitive models came quite naturally to Hawksmoor because he had been immersed in the history of architecture from the days of his apprenticeship with Christopher Wren. One of my main aims in the first chapter is to show how the origins of Hawksmoor's love of the history of architecture extended back to his architectural education in Wren's office. Master and pupil focused their attention on the wonders of the ancient world, many of which had stood in the Near East but survived in a ruined state if at all. Based on literary descriptions and the travel accounts of contemporaries, Wren and Hawksmoor indulged a penchant for imaginary reconstructions, or restitutions as I prefer to call them. Both architects tried to convey to paper the supposed appearance of the wonders of antiquity and of great monuments of the Judeo-Christian tradition, such as the Temple of Jerusalem or Hagia Sophia.

Meanwhile, in their own scholarly way, theologians themselves began speculating about the appearance of some of the same buildings, with interesting if not always artistic results. Anglican and Nonconformist clergymen alike followed a course of inquiry much like that of Wren and Hawksmoor, except that it largely focused on the physical form of the church among the primitive Christians. The paths of the divines and the architects eventually converged when in 1711 Parliament established a commission for building fifty new churches in London and its environs to alleviate rampant overcrowding. As my second chapter shows, the moment was ripe for the building campaign. A sudden turn of political events, and the political will to make the most of the situation, helped forge a holy alliance on the issue of the churches. Tory Party members who were in the majority in Parliament united with their high church allies among the Anglican clergy in the belief that some sort of new age had dawned and that the churches would provide tangible evidence of its arrival. Opposition Whig Party members and their low church allies agreed with the ruling faction at least to the extent that they saw the building of the new churches as a blessing. All involved in the legislation pronounced it a worthy cause, long overdue, and the potential cure to many social ills. To some it must have seemed that church and state had reunited behind a single theocratic banner, as in the early days of the Byzantine emperors.

The extremely ambitious mandate for fifty new churches based on primitive Christian precedent posed many stumbling blocks. It stipulated a complex architectural program and an equally complex process of design review. Acquiring sites to meet the requirements proved a problem and funding was sporadic, so the actual construction dragged on for two decades. Hawksmoor persevered against all these odds. Of the several architects involved, he worked the longest for the commission and built half of the twelve churches that eventually materialized. While remaining true to his personal vision of classical architecture, he fulfilled the call for Anglican churches renewed through emulation of early Christian models. He embodied this concept as early as 1711 in his "Basilica after the Primitive Christians," a design for an ideal type of church intended to serve as a model for the entire Anglican community. He subsequently rose to the challenge of creating six buildings that did not look as if they were designed by a committee of parliamentarians and clergymen but bore the stamp of his idiosyncratic genius. At the same time, he profited greatly from contact with the highly educated members of the commission, many of whom apparently shared his interest in historical restitution. Only such a meeting of minds can explain some of the flights of architectural speculation that Hawksmoor translated into stone with the encouragement of the divines.

The third of my trinity of chapters explores Hawksmoor's design process

and the symbolic message he meant to convey. By analyzing in detail his architectural drawings as related to the design of the steeples, I show how he fused aspects of the still-vigorous medieval ecclesiastical tradition with the understanding of the classical tradition he based on his historical training under Wren. Ultimately the concept of a primitive Christian archetype that had somehow become lost provided Hawksmoor with insights that liberated his style from following too closely the precedent of his teacher's churches. Emboldened by what he interpreted as the early Christian disregard for certain norms of classical design, he tried out new solutions and forms with increasing confidence and freedom. What he called his "Manner of Building the Church as it was in yᵉ...purest times of Christianity" led to astonishing results. He simplified his surfaces by removing as much classical detailing as possible. He increased the bulky volume of his masses. He unified his interior spaces with great overarching vaults or with windowed clerestories rising above the rooflines. And his strangely compelling steeples clearly reflected his belief that the early Christians' pragmatic approach to salvaging and combining disparate elements from the pagan past allowed them to create a new architectural expression all their own.

In turning restitution into physical reconstruction, Hawksmoor came remarkably close to approximating the appearance of real early Christian churches in the Near East, without ever having seen them. With only travelers' accounts to base his ideas on, he nevertheless captured the early Christians' powerful sense of mass, their love of overall symmetry, the simplicity of their elevations, and their insistence on strict east-west orientation of their churches. His use of a limestone similar to theirs reinforced the similarities. In the end, however, this ability to project his imagination back to a distant time did not make Hawksmoor an imitator; rather, it encouraged the fascinating originality that has earned him so much esteem as an architectural rebel, particularly within the past fifty years.

As my conclusion points out, Hawksmoor's historical speculations, his drawings, and above all his majestic churches convey the impression that he saw the classical tradition in a clearer light than many of his contemporaries. Like them he recognized it as a series of phases, but he stressed the way the one phase blended into the other to form an unbroken continuum. It had its ups and downs—its meanderings, to reuse my initial analogy of a river—but according to him it kept right on flowing along.

Damascus/Aleppo	"Thrums" near Glendower, Ontario	Jerusalem
Easter	Michaelmas	Advent
	1998	

ABBREVIATIONS

AS All Souls College, Oxford

BL British Library, London

BLO Bodleian Library, University of Oxford

BLY Beinecke Library, Yale University

LPL Lambeth Palace Library, London

RIBA Royal Institute of British Architects Library, London

HAWKSMOOR'S LONDON CHURCHES

WREN, HAWKSMOOR, AND THE
WONDERS OF THE WORLD

A T COLOGNE IN 1645 there appeared a short book with the long title *De templis Graecorum recentioribus, ad Ioannen Morinum; de narthece ecclesiae veteris, ad Gasparem de Simeonibus; necnon de Graecorum hodie quorundam opiniationibus ad Paullum Zacchiam.* According to the erudite taste for Latin favored by that age, the printer styled himself Kalcovium, the place of publication as Coloniae Agrippinae, and the author as Allatius. Better known by the name Leone Allacci (1586–1669), this Greek Catholic from Chios arrived to study in Rome at the tender age of nine, and toward the end of his life he eventually became Vatican librarian. His *De templis Graecorum* studied early Christian churches with special reference to the sophisticated architectural terminology used to describe them, much of it still current in the Greek Orthodox faith.[1] Allacci's subject is also the subject of this book, except that I seek to extend his search for the roots of early Christian architecture to encompass seventeenth- and eighteenth-century English theologians and their architect contemporaries such as Wren, Hooke, and Hawksmoor.

Five years before *De templis Graecorum,* the prolific Allacci had brought out another book titled *De septem orbis spectaculis.* It focused attention for the first time in print on the Seven Wonders of the Ancient World, which have remained common knowledge ever since. The familiar list by Allacci comprises the Great Pyramid of Khufu, the Hanging Gardens of Babylon, the Temple of Artemis at Ephesus, the chryselephantine statue of Zeus at Olympia, the Colossus of Rhodes, the Lighthouse at Alexandria, and the Mausoleum at Halicarnassus. According to philologists' analysis, the person who codified this list was an obscure writer of the fourth or fifth century A.D. who took Philo as his nom de plume. It has not helped matters that the same name had belonged to the celebrated writer on mechanics Philo of Byzantium (fl. 225 B.C.). The identities of these two men often get hopelessly mixed up.

In publishing Philo's fifth-century text, Allacci took full advantage of his privileged position as *scriptor* at the Vatican. Like many another scholar-li-

brarian, he turned material that came into his hands to his own account before it ever reached anyone else's. He knew about the Philo text because he helped transfer the earliest extant copy of it from the Palatine Library at Heidelberg to the Vatican. But unfortunately for Allacci, and for posterity too, the Palatinus 398 manuscript of Philo breaks off just as the scribe reached the climactic seventh section, which the surviving preamble indicates would have described the Mausoleum at Halicarnassus on the coast of Asia Minor. As other accounts make clear, the mausoleum was architecturally the most distinguished of the entire group of seven. In fact, lore about the Seven Wonders of the World resonated through classical literature long before Philo, who simply served as the tradition's sounding board much later on. For example, the celebrated first-century b.c. text of the architectural writer Vitruvius demonstrates that he knew the seven wonders by repute. His *De architectura*, however, discussed only the Mausoleum at Halicarnassus (bk. 2, chap. 8), which he admired and ranked as "one of the seven wonders [*septem spectaculis*] of the world," as if to imply that his readers had heard all about the other six.[2]

There was nothing at all unusual about Allacci's publishing in quick succession books on lost pagan monuments and on the history and form of the early Christian church. Among Allacci's like-minded near contemporaries the architect Sir Christopher Wren (1632–1723), his collaborator the polymath Robert Hooke (1635–1703), and Wren's pupil, Nicholas Hawksmoor (ca. 1661–1736; fig. 21), all shared Allacci's interest in the wonders of the ancient and Judeo-Christian worlds. In their day no boundary existed between church history and what would now be called classical archaeology. They would have found the idea of such distinctions an absurd contradiction to what must have seemed the relatively seamless continuum of time. They recognized, of course, such major divisions as pagan and Christian. But in common with many others in the seventeenth and eighteenth centuries, they sought to bridge eras, demonstrate cross-cultural links, and emphasize age-old traditions. In the case of Wren, at least, the similarity of his interests to Allacci's should come as no surprise given their strong religious backgrounds.

Wren was the son and nephew of high-ranking clergymen within the Church of England. His father, the Reverend Christopher Wren, dean of Saint George's Chapel at Windsor Castle, and his uncle Matthew Wren, the bishop of Ely, saw to it that the youngster had an Anglican religious upbringing. They may have intended him for a career in the church, as was common among dynasties of divines at the period. But Wren also received a good classical education, initially in the form of home schooling because of his supposed delicate health (he lived to the ripe old age of ninety-one). He could read and write Latin, knew some classical Greek, and at an early age became

recognized as a genius in mathematics, anatomy, and astronomy. He left home to study at Westminster School under the redoubtable Dr. Busby, where he preceded the equally brilliant Hooke by a few years. Next, in 1646, Wren went up to attend Wadham College at Oxford, where his path eventually crossed Hooke's and they became friends. As frequently happens with mathematical child prodigies, the sources of Wren's inspired inventiveness started to run dry in his late twenties. Thereafter he increasingly turned his talents from pure science to the applied science of architecture. The field had previously interested his father, who sometime before his death in 1658 owned and annotated a copy of Sir Henry Wotton's *Elements of Architecture* (London, 1624).[3]

The education of Nicholas Hawksmoor is undocumented until he entered his master's service about 1679 or 1680 upon arriving in London from his native Nottinghamshire. Wren must have trained him at an early date in the use of Latin. From then on Hawksmoor affected the scholarly convention of using that language for inscriptions on drawings. He even went to the slightly comic lengths of translating scale bars from English feet into *pedes Britanorum* (cf. fig. 5). How delightfully pedantic! To Wren's influence, in large part, can be attributed what John Summerson so nicely described as Hawksmoor's "slightly childish delight in everything Latin."[4] Further proof of this came to light when a copy of Vitruvius's *De architectura* in the French translation by Claude Perrault unexpectedly turned up with the following inscription on the flyleaf:

Nic: hawkesmoor
At Sᵣ Chr: Wren's in Scotland Yard[5]

Listing Wren's office address as his own underscores the owner's youthfulness (for another example see my frontispiece), but the subject matter of the book was certainly not child's play. Perrault's *Dix livres d'architecture de Vitruve,* first published in Paris in 1673, augmented the density of the original author's Latin text with copious annotations. They were even lengthier by the time of the 1684 edition, the one Hawksmoor purchased, probably at Wren's suggestion. Obviously by his mid-twenties Hawksmoor had begun book collecting in the grand tradition of other bibliophile architects over the ages.

Wren had already sanctioned the study of Vitruvius well before Hawksmoor's arrival on the scene. He purchased a copy for the use of his office staff engaged in rebuilding the City of London churches after the Great Fire of 1666. The chances are that it was Perrault's first edition.[6] Meanwhile, about the same date, two of Wren's friends from the Royal Society, Hooke and John Evelyn (1620–1706), entertained the vain hope that, in the latter's words, "our Master Vitruvius, published by the learned Perrault, shall be taught to speak English."[7] Always practically minded, Evelyn tried to turn words into

deeds. A protégé of his named Christopher Wase started a translation of Vitruvius in 1670. Hooke tried to promote the scheme, but according to his diary entry of 21 September 1676 he found Wase "drunk" and belligerent. After this no more is heard about the Vitruvius translation project.[8]

In the first instance Vitruvius would have appealed to Wren because of the Latin writer's down-to-earth precepts regarding materials, siting, foundations, the orders of architecture, and much more. Quite apart from these practical hints, however, Wren and the young men in his office such as Hawksmoor could have gained information from Perrault's erudite footnotes and would have responded to his beautifully engraved plates, starting with the sumptuous frontispiece, illustrated here from Hawksmoor's copy (fig. 1). Its elaborate allegory paid homage to the enlightened arts policy of France, personified by the figure on the right wearing a gown interwoven with fleurs-de-lis. On another level the allegory advertised Perrault's contributions to creating the golden age of French classicism. The background shows his east facade of the Louvre. On a hill behind it—too faint to make out in this copy—hovers the Paris Observatory, a reminder that, like Wren, its designer linked the professions of scientist and architect. At the top left appears the triumphal arch Perrault temporarily erected on the outskirts of Paris. The capital at the bottom left, propped up for all to admire, is his attempt at a French order of architecture.[9]

The visual stimulation of Perrault's Vitruvius does not stop with the frontispiece. Throughout his edition he included illustrations to aid his readers' understanding of Vitruvius's often obscure prose. Vitruvius himself had set the precedent by illustrating his long-lost original manuscript. Perrault tried to convey the author's theories regarding the origins of architecture by including pictures of various wooden huts; he tried to express graphically the anecdote regarding the invention of the Corinthian order; and he tried to work out the appearance of the law courts that Vitruvius had designed at Fano in Italy. The impressive engraved cross section of that Roman basilica almost certainly inspired the vaulted naves flanked by side aisles of such Wren interiors as Saint Bride's Fleet Street or Hawksmoor's Saint Anne's Limehouse in the next century.[10]

Very occasionally, as with the Fano basilica and the passing reference to the Mausoleum at Halicarnassus mentioned earlier, Vitruvius rose above the mundane to evoke some of the architectural grandeur of the classical world that he had read about, had personally witnessed, or had even contributed to creating. It was especially moments like these that would have captured the imagination of Wren, his contemporaries, and his pupil Hawksmoor. Those tantalizing descriptions of vanished antique monuments inspired readers to

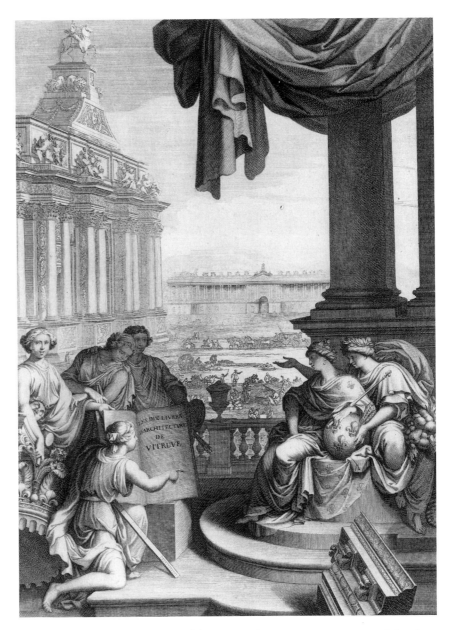

1. Vitruvius, *Les dix livres d'architecture de Vitruve,* trans. Claude Perrault, 2d ed. (Paris, 1684), frontispiece illustration from Hawksmoor's copy (Collection Centre Canadien d'Architecture/Canadian Centre for Architecture, Montréal).

emulation and fueled architects' determination to recapture some of that lost grandeur by architectural restitutions on paper, if not physical reconstructions using bricks and mortar.

A Nicholas Hawksmoor imaginary restitution drawing of the type just discussed shows the Mausoleum at Halicarnassus (fig. 2). It unexpectedly appears among the printed pages of the so-called heirloom copy of *Parentalia, or Memoirs of the Family of the Wrens.* This self congratulatory tome—part geneal-

will appear half the Face, or like the Façade of a Tuscan Temple, to which the Breadth of the Brim of the Petasus, & the Bells, supply the Place of an Entablature:

I have been the longer in this Description because the Fabrick was in the Age of Pythagoras and his School, when the World began to be fond of Geometry, and Arithmetick.

N.B. In all the Editions of Pliny for Tricenûm read Tricentenûm, as the Sense requires.

2. Nicholas Hawksmoor, imaginary restitution drawing of the Mausoleum at Halicarnassus, elevation, from the heirloom copy of Christopher Wren, comp., *Parentalia, or Memoirs of the Family of the Wrens* (London, 1750), plate opposite p. 367 (British Architectural Library, RIBA, London).

ogy, part omnium-gatherum—was compiled by Sir Christopher's son, Christopher Junior. His grandson Stephen, who published it in 1750, grangerized the copy in the Royal Institute of British Architects with prints, a manuscript "Discourse on Architecture," and a restitution of the mausoleum, identifiable as Hawksmoor's by its deft draftsmanship.[11] Moreover, Hawksmoor's characteristically flowing penmanship (see frontispiece) differs from Christopher Junior's awkward hand as seen in the words "Statue of Mausolus" as well as the rest of the text on the top half of the sheet. Actually this page consists of three pieces of paper glued together. A blank sheet forms the support for the second or upper sheet and the third or lower one with the Hawksmoor drawing, stuck down in such a way as to cover part of Christopher Junior's writing. The words hidden beneath are still visible when held up to the light. Then someone, presumably Stephen, scrawled a broad flourish of the pen from the second piece of paper to the third in an attempt to disguise the paste-up job.

Judging from the relatively youthful style of his mausoleum drawing, Hawksmoor certainly knew about the seventh wonder of the ancient world at an early date, probably first alerted to it by Perrault's Vitruvius. Decades later, in a long letter dated 3 October 1732, he discussed it in considerably more detail than had Vitruvius. His recipient, Lord Carlisle, had commissioned him to build a magnificent tomb on the family estate of Castle Howard in Yorkshire. Hawksmoor wrote defending his design against criticisms launched by the architect earl of Burlington. Among the numerous antique sources Hawksmoor cited as precedents, he mentioned at length "the famous Mausoleum Built by Artemisia the Queen. . . . The whole work according to Pliny was 140 foot high. Sr. Christopher Wren, contemplated this Fabrick with great exactness according to the measures given by Pliny."[12] Not only does this passage reveal Pliny the Elder as Hawksmoor's ultimate authority, but the reference to Wren shows why the drawing of the mausoleum had been inserted on the next-to-last page of *Parentalia*. On the page opposite the drawing, the printed text resumes with Wren's own ideas about the mausoleum "so well described by Pliny." And on the last line of the last page an editorial note reads: "The plate of the above is omitted, on account of the drawing being imperfect."[13] Sure enough, a rough plan of the mausoleum does accompany the manuscript of *Parentalia* in Christopher Junior's hand that Stephen presented to the Royal Society in 1751. Because the son and grandson thought the restitution "imperfect," they eliminated it from the printed version. Then Stephen had second thoughts; coming upon a Hawksmoor student drawing among the family papers, he included it in the heirloom copy.[14]

The drawings of the mausoleum, *Parentalia*'s printed text, and

Hawksmoor's manuscript letter all derive their information from the detailed discussion of the seventh wonder of the world contained in the *Naturalis historia* (bk. 36), by one of antiquity's most knowledgeable and observant writers, Pliny the Elder (d. A.D. 79). From the Wren passage quoted above, the architect clearly knew the writings of Pliny, who was a polymath like himself, well versed in the arts as well as the sciences. At the time of their dispersal the Wren and Hawksmoor libraries each contained two editions of Pliny.[15] Quite apart from the mausoleum, Pliny's *Naturalis historia* inspired a number of other remarks at the very end of Wren's *Parentalia.* That is the section to which Christopher Junior allocated his father's theoretical writings, divided into four "tracts." The fourth culminates with the Mausoleum at Halicarnassus, just as Philo's list of the seven wonders had once done. The last two tracts have received the least scholarly attention because of their derivativeness. They embark on a more or less tortuous route through the history of architecture loosely organized around the evolution of a proto-Doric order to which Wren gave the name Tyrian. In contrast, tracts 1 and 2 contain the sort of insights into Wren as thinker, teacher, and scientist-architect that have attracted modern critics.[16]

Wren's well-known theoretical discussion in tract 1 draws a distinction between two concepts of beauty: beauty as something eternal, immutable, and geometrically definable ("natural beauty"), versus beauty as something that varies from place to place, age to age, and that lies in the eyes of the beholder ("customary beauty"). In general terms, Wren's dichotomy reflects the theoretical debate among French academics, who fell into two camps: traditionalists versus modernists. The *querelle des anciens et des modernes,* as it was known, found expression in the *Ordonnance* published by Claude Perrault in 1683 and in his brother Charles's *Parallèle des anciens et des modernes...* (Paris, 1688).[17] The Perraults introduced into the discussion of the immutability of the orders a relativism and a healthy skepticism that Wren obviously found congenial. Wren later put the case quite succinctly in tract 3 when he remarked of a letter by Pliny's nephew, Pliny the Younger, that if the ancients manufactured mass-produced columns, ready made for any occasion, then how could the orders all comply with a single system of mathematical proportions?[18] But the exact meaning of Wren's none-too-clear musings has led to a twentieth-century debate about their sources that is at least as unresolved if not as heated as the *querelle* three hundred years ago. By contrast, Wren's views on history, especially as they influenced Hawksmoor, have largely escaped notice until recently.[19]

Scattered datable references throughout the tracts suggest that Wren started writing them in the decade before Hawksmoor's arrival and probably

continued revising them intermittently well into the next century. This drawn-out process accounts for the tracts' fragmentary and slightly disjointed quality—like lecture notes never quite polished up. Other corroborating evidence from Hooke's diaries, to be discussed shortly, indicates the same time frame. Whatever the exact chronology, tract 4 and to a lesser extent tract 3 took their cue from Pliny's account of the *miracula,* or wonders of the world contained in book 36 of the *Naturalis historia,* principally chapters 4 and 13–24. In this book Pliny made a lengthy digression on the subject of famous buildings. He also turned it into a cautionary tale about prodigious monuments, the powerful men and women who raised them, and the consequent vainglorious expenditure of human effort and materials. Because Pliny included Roman monuments as well as those of the Egyptians, Babylonians, and Greeks, his list far exceeds in number the seven wonders referred to by Philo and alluded to by Vitruvius. Wren's tracts sought to elucidate and illustrate at least part of Pliny's list.

Pliny's description of the Mausoleum at Halicarnassus shows quite well Wren's approach to history through literary sources. Wren tried to work out the plan, and he enlisted Hawksmoor's help regarding the many-columned elevation with its multiple stories supporting a pyramid twenty-four steps high. Beside the stepped pyramid section on the drawing, Hawksmoor inscribed the words "in metae cacumen," quoted directly from the Latin of Pliny (bk. 36, chap. 4). Finally, on top stood what Pliny described as a quadriga sculpted by Pythis reaching the full 140 feet in height. It must have struck Wren and Hawksmoor as an extraordinary, almost unbelievable, affair when they sat discussing and drawing it. Nevertheless, the long-lost monument known only from ancient accounts captivated their imaginations. Hawksmoor mulled over the problematic restitution for decades, as already seen in the letter he wrote about Castle Howard. And thanks to the fertility and tenacity of his mind the mausoleum eventually took form in the church tower of Saint George's Bloomsbury (plate 12), his most unusual and whimsical contribution to the many-steepled skyline of London.

Even more clear-cut than the mausoleum are the three other instances in which Wren tried to teach Pliny to speak English—as Evelyn and Hooke had intended to do for Vitruvius. Pliny's chapter 24, one of his longest, turns his readers' attention to the *miracula* of Rome. Among the numerous buildings mentioned, Wren's tract 4 singled out the Temple of Peace built by Emperor Vespasian and the Temple of Mars Ultor in the Forum of Augustus. Wren had a ground plan of the latter prepared for *Parentalia* and discussed both temples at length on pages 363–66. Similarly, Pliny's chapter 21 deals with the Temple of Artemis at Ephesus, one of Philo's seven wonders. In this instance Pliny provided complete information as to the dimensions, number of columns, and

temporaries claimed he derived the inspiration directly from Baalbec, and this seems very likely.[23] With its composite sources, this church ran the distinct risk of looking pedantic or, at worst, like a concoction awkwardly patched together. It is in fact neither. Through the power of his creative genius Hawksmoor transcended his bookish sources to make Saint George's something artistically compelling.

To return to Pliny's influence on Wren, consider a final instance that had a lasting effect on Hawksmoor. This reference to one of the more obscure *miracula* mentioned by Pliny occurs in the fourteen-page "Discourse on Architecture. By S.ʳ C: W:" written in the hand of Christopher Junior. As I already mentioned, Stephen Wren inserted the manuscript and Hawksmoor's mausoleum drawing directly after the printed tracts at the back of the heirloom copy of *Parentalia.* Pages 10–14 form the longest single discussion in the text and relate to the tomb of the sixth-century b.c. Etruscan king Lars Porsenna. Pliny (bk. 36, chap. 19) quoted a now lost description of it by Marcus Terentius Varro. The monument's reputed size and the stupendous engineering feats it would have involved impressed Pliny, just as they naturally did Wren. The wonders of the world were not called *miracula* or *spectacula* for nothing! People marveled at them then as they marvel still. But the tomb's disappearance without a trace prompted Pliny to comment censoriously on Porsenna's folly and extravagance. Wren took a less moralizing tone in the "Discourse."

4. (*below*) Nicholas Hawksmoor, Temple of Bacchus at Baalbec, engraved south elevation and partial cross section, from Henry Maundrell, *A Journey from Aleppo to Jerusalem at Easter, A.D. 1697,* 5th ed. (Oxford, 1732), plate opposite p. 135.

5. (*below, left*) Nicholas Hawksmoor, Temple of Bacchus at Baalbec, engraved plan and cross section, from Henry Maundrell, *A Journey from Aleppo to Jerusalem at Easter, A.D. 1697,* 5th ed. (Oxford, 1732), plate opposite p. 135.

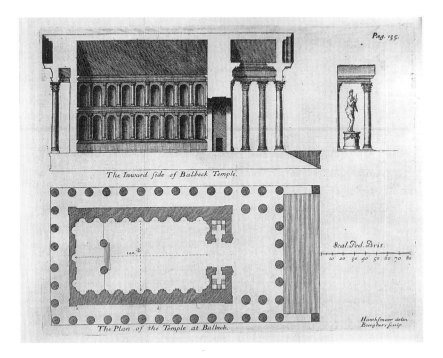

He wrote: "Great Monarchs are ambitious to leave great Monuments behind them, and this occasions great Inventions & Mechanicks Arts."[24]

Wren's positive attitude toward the effects of royal patronage on architectural innovation sounds as if it is based on recollections of commissions he had received, such as the mausoleum intended to commemorate Charles I. Parliament enacted the necessary legislation for the mausoleum on 29 January 1678, but Wren could easily have got wind of the scheme from his Royal Society crony Bishop Thomas Sprat, who read the sermon in the House when the bill came up for approval.[25] This might explain Wren's flurry of speculation the previous autumn on the subject of Porsenna's tomb, as documented in the cryptic but extremely informative diary kept by Robert Hooke, his frequent collaborator before the arrival of Hawksmoor.

Hooke discovered his twin vocations for science and architecture in the reverse order from Wren. After early training with the artist Peter Lely, Hooke increasingly turned to pure science, but he always seemed to find time to help Wren out with architectural projects. On four occasions in October 1677 Hooke met with Wren and "discoursd with him long of Porcena's tomb." On the fourth of that month he saw Wren's imaginary restitution but took exception to it. "Comparing it with the words [by Pliny]," Hooke wrote, "it agreed not." By the eighteenth Hooke had prepared his own "rationall porcena." Unfortunately, no record of the design survives. The day before, however, he had seen Wren and had roughly sketched his colleague's tomb of Porsenna onto a diary page (fig. 6).[26] The amazing contraption Hooke depicted bears little similarity to Wren's Charles I mausoleum, though it does accord quite closely with Pliny's description. Wren's plan, labeled a by Hooke, has a 300-foot-square base honeycombed with tomb chambers. In the elevation, marked B by Hooke, the 50-foot-high base is surmounted by five pyramids 150 feet tall— so far so good. But from this point on the complexity of the tomb eludes Hooke's ability to sketch it on a small scale. According to Pliny, a vast bronze disk above the pyramids would have supported a group of four more tetrahedrons one-third shorter, and on top of them a conical cupola ("orbis aeneus et petasus"). Perhaps that is what Hooke's broken arching lines are meant to indicate. From this level bells hung down, and above stood five more pyramids of great but indeterminate height.[27] No wonder Pliny's puzzling description posed such a challenge to Wren and Hooke. Their restitutions raised as many questions as they answered, adding to the fun of heated intellectual debate.

Whether or not the Porsenna's tomb restitution inspired the Wren mausoleum for Charles I, a connection certainly exists between the tomb and the mausoleum that Hawksmoor designed for Lord Carlisle nearly fifty years later. Hawksmoor possessed such powers of recollection that he could dredge

6. Robert Hooke, imaginary restitution sketches of the tomb of Lars Porsenna after the restitution by Christopher Wren, from Robert Hooke's diary entry for 17 October 1677 (MS 1758, Guildhall Library, Corporation of London).

up memories stretching back to his earliest days in the Wren office, when Porsenna's tomb still remained a lively topic of conversation. Writing to Lord Carlisle in 1726, he broached the question of possible precedents for the proposed family mausoleum at Castle Howard. Paraphrasing Vitruvius, he recommended the Halicarnassus structure, "so famous that it got the title of one of yc Seaven Wonders of yc World." Paraphrasing Pliny he continued: "That which was the most famous in Italy was the Monument of Porsenna yc king of Tuscany, if I may be allowed to call it among the Latins, being in yc Early days of Rome."[28] After the architect's death his widow submitted to Lord Carlisle her husband's outstanding bill. An item on it, still unpaid since 1727, related to "A Mosoleum like the Tomb of King Porsenna." Finally, the Hawksmoor sale in 1740 contained twenty-eight drawings "of the Tombs of Parsenna."[29] All this evidence leaves the distinct impression that for the rest of his life Hawksmoor remembered the tomb and intermittently drew inspiration from it. In the words of his obituary writer: "He was perfectly skilled in the history of architecture, and could give an exact account of all the famous buildings, both ancient and modern, in every part of the world, to which his excellent memory, which never failed him to the very last, greatly contributed."[30]

Wren's "Discourse," like the writings of Pliny and Philo, includes the Egyptian pyramids among those monuments of the ancient world worthy of attention for either their enormous size or their innovative construction. From Wren's point of view the pyramids represented what might be called a gigantic make-work project. He speculated that during periodic famines, when the entire population went on the dole, people were put to work rhythmically laying stones, probably in time to music. Similarly, the "stupendous" walls of Babylon, according to Wren, stretched fifteen miles on a side. In this case Herodotus provided the information, and he did so again with what Wren called a "surprising Relation" of the Tower of Babel. Time and time again throughout the "Discourse," biblical references—so familiar to Wren and his contemporaries from their religious upbringing—vie with classical sources such as Philo, Pliny, and Herodotus. The pyramids, for example, put the architect in mind of Joseph and Pharaoh during the seven years of famine. The name Babylon immediately conjured up memories of the captivity of the Jews. And Wren considered the Tower of Babel "the first Piece of Civil Architecture we meet with in Holy Writ."[31]

In addition to the places just discussed, the "Discourse" mentioned the city to which Cain gave the name of Enoch, the two columns built by the sons of Seth, Noah's ark, the pillar or tomb of Absalom, and finally the Temple of Jerusalem. The last two come up again more briefly in tract 4, as does the pil-

lared hall that the imprisoned Samson brought down around his Philistine captors' ears. These monuments, to Wren's way of thinking, had an architectural interconnection. He claimed they exemplified the Tyrian, that is to say Phoenician, order of architecture. Tract 3, page 358, and the "Discourse" (page 7) loosely define it as "grosser" than the Doric but less stocky than the Tuscan. Besides all these links, Wren saw the group of monuments mentioned as related to the Seven Wonders of the World on account of their innovative technology. The mathematician in him praised Porsenna's tomb because it dated from "when the World began to be fond of Geometry and Arithmetick." So too he believed that Seth's sons had raised columns "to preserve their Mathematical Science to Posterity." To him the tomb of Absalom (2 Sam. 18:16–18) must have seemed almost as technologically "remarkable," to use his own word, as the seven wonders. Wren tried to visualize Noah's ark with a mixture of awe and zoological incredulity. He even went to the lengths of trying to calculate how many columns it would have taken to hold up the roof over Samson's head. The "Discourse" and the tracts considered the marvels of the Bible and the wonders of the ancient world to be equally old and therefore worthy of the same admiration. To all intents and purposes they all belonged to one great canonical list.[32]

Of all the biblical monuments discussed in the "Discourse," the Temple of Jerusalem naturally receives the limelight, and tract 4 also deals with it extensively. As I stated earlier, Wren's initial reason for including the temple was to further illustrate the Tyrian order. He based his evidence on biblical and historical sources. Several verses from the Old Testament recorded that King Hiram of Tyre supplied King Solomon with Phoenician materials and artisans for building the first temple (1 Kings 5:2–6; 2 Chron. 2:3–12). And the New Testament quoted the disciples remarking to Christ as they left the temple, "Master, see what manner of stones and what buildings are here" (Mark 13:1). Wren took this to refer to the Gate of the Gentiles mentioned in the account of the temple in Flavius Josephus's *Jewish Antiquities* (bk. 8, chaps. 3–4). According to Wren, "Herod built the Atrium Gentium . . . to be a Triple Portico [with] thick Pillars of the grosser Proportions . . . being whole stones of an inevitable Bulk."[33] Wren used all this as ammunition to defend his vision of the temple as a simple and monolithic Tyrian affair.

Wren's tactics become clear from his attack against a rival interpretation of the order in the temple as a rich Corinthianesque concoction. In tract 4 Wren wrote:

> Villalpandus hath made a fine romantic piece after the Corinthian Order, which, in that age, was not used by any nation; for the early ages used much

grosser pillars than the Doric: in after times, they began to refine from the Doric, as in the Temple of Diana at Ephesus (the united work of all Asia) and at length improved into a slenderer pillar and leafy capital of various inventions, which was called Corinthian; so that if we run back to the age of Solomon, we may with reason believe they used the Tyrian manner, as gross, at least, if not more than the Doric, and that the Corinthian manner of Villalpandus is mere fancy.[34]

The Villalpandus referred to is, of course, the Spaniard Juan Bautista Villalpando, S.J. (1552–1608), who, together with a fellow Spanish Jesuit architect named Jeronimo de Prado (1547–95), wrote the monumental three-volume work *In Ezechielem explanationes et apparatus urbis ac templi Hierosolymitani commentariis et imaginibus illustratus* (Rome, 1605).[35] As will be clear shortly, Wren may well have known these theologians' massively learned tomes, but that is not specifically the work he had in mind when writing his critique of Villalpando. Wren almost certainly referred to an engraved plate showing the temple's order reproduced in a book he owned, his friend John Evelyn's 1664 translation of Roland Fréart de Chambray's *Parallèle de l'architecture antique et de la moderne* (fig. 7). Evelyn resided in Paris in 1650, when the book first came out, and he started working on a translation in the middle of the decade. A consummate bibliophile, Evelyn made a habit of presenting friends with specially bound copies; Wren learned in April 1665 that his awaited him at the binders.[36]

The architectural amateur Roland Fréart de Chambray (1606–76), like the brothers Perrault, came from a family of minor French nobility working in the service of the Bourbon monarchy. Fréart's *Parallèle* fired the opening shot in what would later become the *querelle des anciens et des modernes*. The ensuing battle put him and these younger confreres more or less on opposite sides. At the time it appeared in French and English, nothing came close to matching its superlative plates, its short and to the point critical commentaries, or the glossary of technical terms that Evelyn appended to his translation. Consider, for example, Fréart's remarks on the order of the Temple of Jerusalem. They alluded to the Bible's assertion that Solomon's design had received divine inspiration; they mentioned Josephus's subsequent description; and they paid tribute to "that great work of Villalpandus." This gave credit where credit was due. The impressive plates of Villalpando had served as the basis for Fréart's temple order. But he went on in an original vein to suggest that the "Order of Orders,"[37] with its combination of feminine delicacy and sacred connotations, would make it ideal for churches dedicated to martyred Christian virgins. His

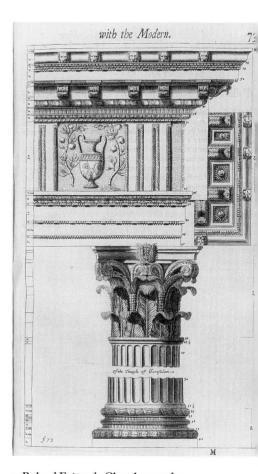

7. Roland Fréart de Chambray, order of architecture of the Temple of Solomon in Jerusalem, from Fréart's *Parallel of the Ancient Architecture with the Modern*, trans. John Evelyn (London, 1664), pl. 73.

dovetailing of classical Corinthian form with biblical associations would not have escaped Wren, Hooke, or Hawksmoor, all of whom owned copies.[38]

That Wren for his part knew more about Villalpando's temple restitution than the single plate in Fréart is strongly hinted in a letter sent to him on 7 October 1674, nine years after he received Evelyn's gift of the *Parallel.* This letter from the Dutch man of letters Constantijn Huygens (1596–1687) introduced Rabbi Jacob Judah Leon (ca. 1603–75) in the following terms:

> This bearer is a Jew by birth and profession, and I am bound to him for some instructions I had from him, long ago, in the Hebrew literature. This makath me grant him the adresses he desireth of me; his intention being to show in England a curious model of the Temple of Salomon, he hath been about to contrive these many years. Where by he doth presume to have demonstrated and corrected an infinite number of errors and paralogisms of our most learned scholars who have meddled with the exposition of that holy fabrick, and most specially of the Jesuit Villalpandus, who, as you know, Sir, hath handled the matter ingenti cum fastu et apparatu, ut solent isti [with enormous display and complexity, as such are wont]. I make no question but many of your divines and other virtuosi will take some pleasure to hear the Israelite discourse upon his Architecture and the conformity of it with the genuine truth of the holy Text: But Sir, before all, I have thought I was to bring him acquainted with your self who are able to judge of the matter upon better and suror grounds than any man living.[39]

If Huygens's letter can be taken at face value, then Wren certainly met Rabbi Leon, one of the foremost authorities on the temple. Furthermore, the wording makes it sound as if Villalpando's erudition was a matter of common knowledge to both Huygens and Wren. They may have realized, however, that despite some architectural training and a passion for finding the divine archetype, neither Villalpando nor de Prado possessed much artistic originality. Because of Villalpando's training under Juan de Herrera, second architect of the Escorial, the Jesuit's temple restitution resembled that palatial monastery complex to a considerable extent.[40]

By the date of Huygens's letter, Jacob Judah Leon had earned the nickname "Templo" because of his model. According to one source the rabbi tried to sell it to Queen Henrietta Maria of England as early as 1643. Several decades, books, and promotional prospectuses later, Leon had still to find a customer; hence his visit to London in 1674. He died there the next year at the time the model was on display.[41] This part of its peregrinations is corroborated by an illuminating entry of 6 September 1675 in Hooke's diary. It reads: "With

Sr Chr. Wren. Long Discourse with him about the module of the Temple of Jerusalem." Once again Hooke comes to the rescue by indicating the date when the lively discussions of the temple must have taken place that culminated in the passages in Wren's "Discourse."[42] Whatever the shortcomings of "Templo" or Villalpando, Wren and Hooke probably agreed on the temple's central importance to the whole Judeo-Christian theological and architectural tradition (see appendix 1).

Apart from what Fréart, Villalpando, and Leon provided, the remaining information on the temple contained in Wren's "Discourse" came almost exclusively from the Old Testament. In the fairly short space of two pages Wren assembled an intricate mosaic of biblical references relating to the size and construction of the temple. Principally he drew on the first book of Kings and the second book of Chronicles, with a few remarks culled from other sources, such as the Roman Jewish historian Flavius Josephus's account of the building. As with Noah's ark, the organizational and engineering aspects gripped Wren's interest most. He tried to calculate exactly how and why King Solomon had deployed so many beasts of burden and so much manpower raising the stones—"costly" stones as the Bible and Wren called them. Page 9 of the "Discourse" reckoned that Solomon had used music to provide a rhythm for activating winches or capstans. But this fixation with validating Holy Writ scientifically, and with problem solving in general, did not detract from the depth of Wren's religious beliefs. Reaching right back to his childhood, they reflect the rich but now largely forgotten tradition of temple studies among Anglican clergymen before, during, and after his lifetime.

As if to alert readers unaware of the long-standing tradition just referred to, Stephen Wren extra-illustrated the heirloom copy of *Parentalia* with an engraved ground plan of the temple. He drew a ruled border around it, labeled it "Solomon's Temple" in ink on the upper margin, and glued it down onto a support as he had Hawksmoor's Halicarnassus drawing. Although the evidence of Stephen's scissors and paste was in plain sight all along, nobody fully realized it until his original source turned up recently in the form of a much larger engraving (fig. 8). Stephen clipped the plan out of the engraving's top right hand corner and trimmed off the instructions to the binder above, but at the very bottom left he inadvertently retained a tiny telltale finial from the top of the side elevation of the temple just to the left of the letter N (fig. 8, bottom right). In the process, he retained the informative alphabetical key including the name "Dr. Prideaux" set in bold type, which initially seemed a likely clue to the engraving's origin. The Reverend Humphrey Prideaux (1648–1724), who outlived Sir Christopher Wren by a year, had also attended Westminster School and Oxford. He had risen to the position of dean of Nor-

8. *Opposite:* Arthur Bedford, imaginary restitution of the Temple of Solomon in Jerusalem, engraved plan and elevations, from Bedford's *The Scripture Chronology Demonstrated by Astronomical Calculations . . .* (London, 1730).

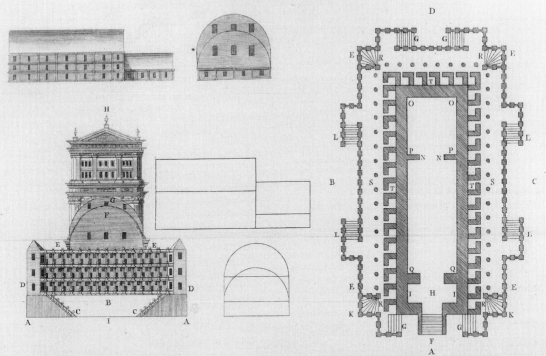

A. *The North side of ye Temple.* E. *Stairs to go up from ye Court of ye Priests to ye level of ye floor of ye Temple.* F. *The level of ye floor.* G. *The winding stairs where two of ye sides appear one shewing ye windows & ye other ye doors landing upon ye galleries.* H. *The Chambers of ye Priests in three rows with windows & ye door on ye right side with pillars opposite to each wall to support ye galleries leading to ye doors.* X *ye narrow lights in ye Holy of Holies.* K. *The narrow lights in the Body of ye Temple in three rows like Solomon's Palace.* L. *The Covering of ye Holy of Holies being in ye form of a semicircle.* M. *The Covering of ye Body of ye Temple being of ye same form.* N. *The Porch before ye Temple being 60 Cubits from ye bottom at O & 3.6.3 but an 120 from ye foundation of ye whole or ye terrace walk 2 Chron 3.4.*

The West end of ye Temple. A *The length 60 feet.* B *the ascent from ye Court of ye Priests to ye Temple 6 Cubits high.* C *Stairs on each side.* D *Winding stairs at each corner to go up to ye Chambers of ye Priests 1 Kings 6.8 In ye front there are three windows & in ye side toward the Temple three doors.* E *The Chambers of ye Priests with pillars before them opposite ye walls to support ye battlements leading to each of ye three rows ye doors being all on ye right hand of each chamber.* F *The back part of ye Holy of Holies.* G *The back part of ye Temple.* H *The porch or Tower 60 Cubits high from* I.

The Ground Plot of the Temple strictly so call'd, as it is describ'd in the Book of Kings & Chronicles, being the parts, which were built upon the level of the Floor of the House. 6 Cubits higher than ye Court of the Priests A *the East Side* B *ye South Side* C *the North Side* D *the West Side* E *ye Battlements round a Cubit thick* F *Stairs to go to ye Temple from ye Court 6 Cubits high. & Steps 14 Cubits long, Exclusive of ye Battlements 12 in all Extending towards ye East 8 Cubits* G *Stairs to ascend from ye Court of ye Priests, to ye level of ye Temple on the outside* H *ye Entrance into ye Temple 12 Cubits* I *ye Breadth of ye Temple ye Porch 8 ye Holy of Holies 20 Cubits 1 Kings 6.2,3,2 Chron 3.3,4 KK ye Breadth of ye whole Building 60 Cubits E 3ra 6.2. LL ye whole length including ye Stairs on each side being 70 Cubits. & is what is meant by Dr Prideaux Anno 534 NN ye Division of ye Temple from ye Holy of Holies. 20 Cubits, equal with ye Breadth 1 Kings, 6.20 2 Chron. 3.8 PQ ye length of ye Body of ye Temple. 40 Cubits. including ye Wall, which parted ye Holy of Holies from it. 1 Kings 6.17 OQ the whole length. or 60 Cubits 1 Kings 6.2 1 Chron 3.3 R ye winding stairs. by which they went up to ye upper Chambers. 1 Kings 6.8 S Pillars to Support ye galleries, belonging to ye second. & third Stories of Chambers 1 Kings 6.5 to ye 11 T ye Chambers of ye Priests five cubits broad. & all ye Doors on ye Right Hand 1 Kings 6.6,8*

The Ichnography of the Temple of Jerusalem with a Description of the same.

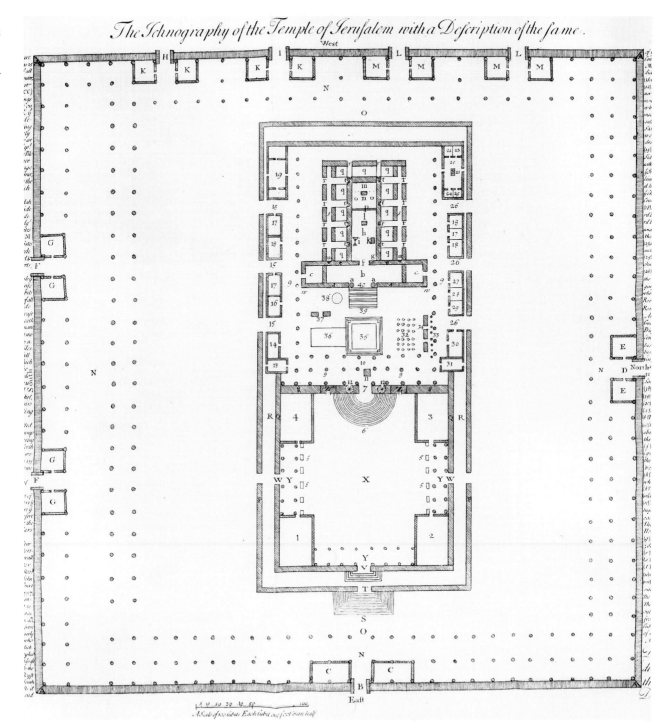

West

East

A Scale of 100 Cubits. Each Cubit one foot & an half.

wich cathedral by the time he published his two-volume book *The Old and New Testament Connected in the History of the Jews and Neighboring Nations, from the Declension of the Kingdoms of Israel and Judah to the Time of Christ* (London, 1716–18). But perusal of Prideaux's "Connection," as the frequently reprinted work became known for short, reveals no image like the one in the heirloom *Parentalia*, though several do indeed depict the temple (fig. 9).

The search for the temple plan's source continued among the largely overlooked writings of Wren's contemporary theologians until it finally led to a country parson, the Reverend Arthur Bedford (1668–1745). By virtue of being almost the last of the seventeenth- and eighteenth-century scholar-divines to devote attention to the imaginary restitution of the temple, he had the advantage of retrospect. With a delightful mixture of humility and hubris that seems to reflect his personality as a whole, Bedford mentioned a good many of these authorities on the subject either in his preface or in his wordy title—an exceedingly long one even by the standards of an age famous for them. His *Scripture Chronology Demonstrated by Astronomical Calculations. . . . Together with the History of the World, from the Creation, to the Time When Dr. Prideaux Began His Connection*, appeared in London in 1730. It contains six engravings of the temple—an exceptional number—tucked in at the back of the volume. Wren never lived to see it in print, but his son and grandson must have known it even before its publication. The engraving from which they snipped the plan was a pre-1730 proof copy that omits some last-minute additions to the plate. Contrasting the Bedford and Prideaux ground plans, the former seems less wooden and cluttered than the latter even though the illustration of Prideaux's plan here (fig. 9) crops off most of his displays of erudition in the long marginalia to either side. Bedford's admiration for Prideaux notwithstanding, it is noteworthy that two plans starting with the same biblical data differ as much as they do. In those differences of opinion, and in that constantly fluctuating relation between prescribed function and built form, lies the temple's inexhaustible fascination for theologians and architects alike.

If it is possible to sing the praises of marginalia, then such praise rightly belongs to the heavily annotated plates and texts of Prideaux, Bedford, and their theologian predecessors. Bedford's preface, for example, reads like an index to English temple restitutions. He started off by rejecting the most recent of them, written by Sir Isaac Newton (1643–1727), Wren and Hawksmoor's most celebrated contemporary. The great scientist's last printed work, the posthumously published *Chronology of Ancient Kingdoms Amended . . .* appeared the year after his death.[43] But Bedford felt no compunction about speaking ill of the recently departed. He found Newton's historical writings "contrary to all mankind and utterly destructive of the Scripture history."[44]

9. *Opposite:* Humphrey Prideaux, imaginary restitution of the Temple of Solomon in Jerusalem, engraved plan from Prideaux's *The Old and New Testament Connected . . .* , 2 vols., 5th ed. (London, 1718), plate opposite 1:112.

His first rebuttal of Newton's *Chronology* came out in 1728. Then he redoubled his efforts for the full-scale assault two years later in his *Scripture Chronology*. It casts aspersions on Newton's use of astronomy to vindicate Old Testament chronology and goes on to praise the earlier efforts at chronology of theologians such as James Ussher (1581–1656), the bishop of Armagh. The names Beveridge, Lightfoot, and Mead also crop up. These three divines, whose studies of the temple and the early Christian church laid the foundations for Wren and Hawksmoor's thinking about ecclesiastical architecture, merit discussion in their own right.[45]

The Reverend Joseph Mead (1586–1638) spent a quiet academic life at Cambridge, where he held a fellowship at Christ's College and a lectureship in Greek. He approached the temple from an entirely different biblical direction than did Bedford, Prideaux, Wren, and Newton. They had relied almost exclusively on the historical books of the Old Testament, whereas he relied largely on the New Testament Book of Revelation. In that sense he shared the most with Villalpando, because both drew upon visionary material: for Villalpando the prophecies of Ezekiel, for Mead the apocalyptic writings of Saint John. Indeed, Mead's most influential book was titled *Clavis apocalyptica . . .* (Cambridge, 1627), later translated as *The Key to Revelation, Searched and Demonstrated out of the Natural and Proper Character of the Visions* (London, 1643). When Mead came to interpret the metaphorical imagery of the first two verses of the eleventh chapter, he chose to do so in a concrete, architectural way. In the passage an angel calls on the writer of Revelation to take up a measuring rod to calculate the size of the "temple of God," its altar, and the people within it. This image Mead clearly interpreted as referring to "the primitive state of the Christian church." The outer of the two courts of this celestial temple he equated with the two courts of the terrestrial temple in Jerusalem (as clearly depicted by Prideaux, fig. 9).[46] Mead also produced a "plot," or plan, based largely on the information in the Old Testament and Josephus (fig. 10). The rather small and crude woodcut simply proves that a theologian totally unversed in architecture or drafting techniques could come up with a credible end product, the first of its kind ever to appear in an English publication. Mead would no doubt have been astonished to see the progress his sketchy little plan would make over the next hundred years or so in terms of complexity and sophistication of representation.

It is important to note that Mead regarded the temple as a model for the religious practices of his own day. In a sermon he delivered at Cambridge three years before his death, he enjoined his listeners to emulate in their own devotions the demeanor of Solomon, "who God chose to build that sacred and glorious Temple to His name." He then went on to describe in glowing terms the

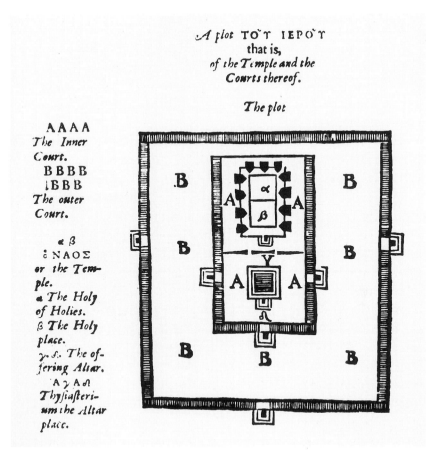

A plot ΤΟ`Υ ΙΕΡΟ`Υ
that is,
of the Temple and the
Courts thereof.

The plot

A A A A
The Inner
Court.
B B B B
ʟB B B
The outer
Court.

α β
ς ΝΑΟΣ
or the Tem-
ple.
α *The Holy*
of Holies.
β *The Holy*
place.
γ. ς. *The of-*
fering Altar.
᾽Α γ Α ᵭ
Thyfiafteri-
um the Altar
place.

10. Joseph Mead, imaginary
restitution of the Temple of Solomon in
Jerusalem, woodcut plan, from Mead's
The Key to the Revelation . . ., trans.
Richard More (London, 1643), 6.

golden interior decoration of the temple with its multitude of carvings. Contrary to the rather flat and certainly colorless impression conveyed by his plan, or by those of Prideaux and Bedford for that matter, his sermon evoked the sensuous side of the temple. What was so difficult for a theologian to express in an architectural plan came much more naturally when spoken from the pulpit with words "sweet as honey," to use Saint John's own expression in Rev. 10:9.[47]

The writings of Joseph Mead seem to have created quite a ripple within the Anglican community and the London printing world. Two titles inspired by him received approval for publication just months before Mead's death in 1638, and both compare the Temple of Jerusalem with contemporary Anglican church liturgy and architecture. The shorter of the two books, *God's Holy House . . .*, specifically starts out by citing Mead.[48] The author, the Reverend Foulke Roberts, saw the magnificence of Solomon's Temple as justification for the "blessed reformation" currently taking place to remedy the deplorable state of Anglican churches, which he described as "so battered without . . . so dusty,

sullied, and forlorn within."[49] The unpaginated preface, moreover, made it clear that credit for the "blessed reformation" belonged to the Right Reverend William Laud (1573–1645), the soon to be executed archbishop of Canterbury. He briefly spearheaded the fledgling Laudian liturgical reform movement that bears his name and that, though cut short by his fall, returned stronger than ever after the Restoration.

Similarly Laudian and Meadian in tone, the second book nevertheless provides a much more sophisticated architectural analysis. The as yet unidentified author of *De Templis, a Treatise of Temples* simply signed the dedication page with the initials R. T. Whoever this was had almost as good a grasp of architectural as of scriptural history. Describing the Temple of Jerusalem as "the most excellent . . . in the world," it does not stop at that. It compares the temple's three internal subdivisions to a porch, nave, and chancel, thereby reassuring Anglicans who "fear . . . to build a Christian church so like Solomon's Temple" lest it resemble a synagogue. The argument concludes with this rhetorical question: "Would Christians be so desperately irreligious [as] to entertain Him [Christ], as the Jewish host did at his first coming, within bare walls and on bare boards . . . [rather than] in the most noble manner we could devise?"[50] Even more prophetic of Hawksmoor's interests, page 170 paints a picture of early church building when "the Apostles and primitive Christians were contented with dining rooms, in private houses, instead of temples." R. T. suggested in plain language, akin to the Koine Greek of the Gospels, how pale the paleo-Christians' shabby meeting places must have seemed when contrasted with the glorious surroundings of the Temple of Jerusalem.

Compared with the ripple of activity produced by Joseph Mead and others (see appendix 1), the writings of the Reverend John Lightfoot (1602–75) ushered in the veritable wave of temple studies that crested with Arthur Bedford a century later. Lightfoot began his studies of Hebrew after leaving Cambridge. Eventually he rose to be one of the most highly regarded Hebraists in Europe. As an authority on temple ritual he contributed very vocally to the debates of the Assembly of Westminster Divines—Oliver Cromwell's puritan response to the Anglican liturgical reform movement of Laud. Lightfoot published two books on different aspects of the Temple of Jerusalem, and contrary to what his name might suggest, they not light reading. They appeared at the time he became master of Saint Catharine's College, Cambridge, a position he held until his death. His portrait still hangs in the hall, and an engraving based on it serves as the frontispiece to a two-volume London 1684 edition of his collected works (fig. 27). These folios contain the two works just alluded to: *The Temple Service as It Stood in the Days of Our Savior* (London, 1649) and *The Temple Especially as It Stood in the Days of Our Savior* (London, 1650). Without

doubt the second of these publications provided the most detailed consideration of the temple in English up to that date. It cumulatively took Lightfoot 221 densely documented pages to delve into the temple's location and dimensions, right down to those of its smallest sacred spaces.

The title of Lightfoot's *Temple Especially as It Stood in the Days of Our Savior* puts its two main goals in a nutshell. On the one hand it tried to envision the temple, as the writings of Mead and others had done. On the other hand, and more important to its purpose, it tried to establish the appearance of the temple in the lifetime of Christ rather than at an earlier point in its history. Lightfoot imagined the way the *second* Temple of Jerusalem would have looked; the sixth-century one reconstructed by Zerubbabel after the Jews had returned from exile in Babylon. Although the dimensions of Solomon's Temple were exceeded by those of Zerubbabel's, Lightfoot asserted that it lacked the "sumptuousness and bravery" of Solomon's structure. In his words, "To those who had seen both, it was as nothing," and they wept out loud.[51] Not unlike Ezra 3:11–13, which he cites, a tone of lamentation pervades Lightfoot's two prefaces. The preface to *Temple Service,* dated 30 May 1649, speaks of a drawing he made of the temple that he hoped to have engraved. The preface to the second book, dated 3 April 1650, reads rather resignedly: "I could with as little pains and travail have journeyed to Jerusalem to have taken a view of the temple, had it now stood, as this has cost me to survey it by the eyes of others. . . . I also drew up a large map of the temple structures . . . which would have made the things here described a great deal more easy and pleasant to be understood, could it have been published."[52] Between the two dates, as noted in Lightfoot's second preface, the Reverend Thomas Fuller (1608–61) had brought out *A Pisgah-Sight of Palestine* (London, 1650). It provided Lightfoot with some consolation because it contained two plans and three exterior views of the temple. Fuller, who appropriately named his book after Mount Pisgah, from which Moses had seen the Promised Land, had real entrepreneurial flair. He found separate sponsors for each of his plans and maps (appendix 1). Meanwhile Lightfoot waited in vain for response to his plaintive appeals.

By the time Lightfoot's collected works came out posthumously in 1684, the "map" of the temple he referred to had been engraved, if rather clumsily (fig. 11). His marginalia, liberally peppered with Hebrew quotations and references, acknowledge that for the dimensions of the temple he relied on the Dutch scholar Constantijn L'Empereur's Latin translation of the Mishnah Middoth tractate of the Babylonian Talmud. L'Empereur's *Talmudis Babylonici Codex Middoth, sive De mensuris templi* (Leiden, 1630) included a plan of the temple that Lightfoot studied attentively. It differed radically from Mead's bilaterally symmetrical arrangement of the sacred precinct by placing the inner

sanctuary off center within the main courtyard; the same feature distinguishes Lightfoot's solution. The plan and wall elevations strengthen the favorable impression of Lightfoot's scholarship if not his artistry. Unlike Prideaux (cf. fig. 9), Lightfoot did not have the good sense to avoid elevations he lacked the skill to portray. His medieval-looking entrance towers not surprisingly recall the gates to colleges like his own Saint Catherine's, so physically near yet so stylistically remote from Wren's contemporary chapel at Pembroke College almost directly across the street.[53]

How far Lightfoot's conception owed its outward form to his Cambridge environment emerges even more clearly from some comments he made re-

11. John Lightfoot, imaginary restitution of the Temple of Solomon in Jerusalem, engraved plan and elevations, from Lightfoot's *The Works of the Reverend and Learned John Lightfoot . . .*, ed. George Bright, 2 vols. (London, 1684), plate opposite 1:1049.

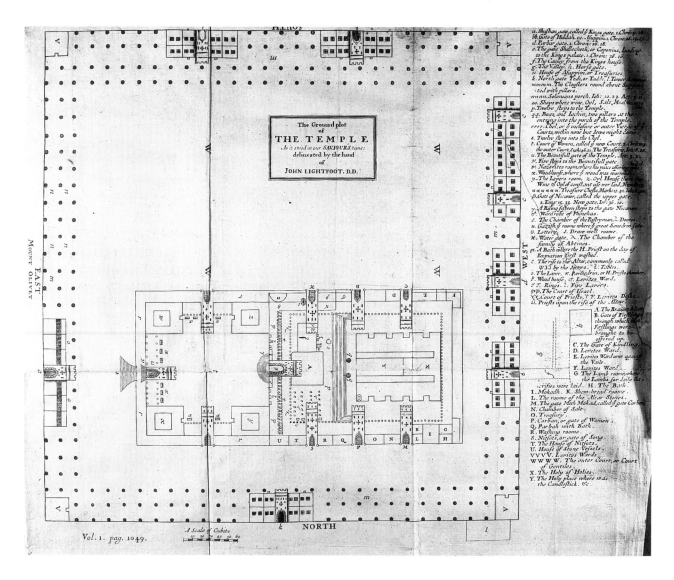

garding the layout of the temple as a whole. He noted that Solomon's Temple "did very truly resemble one of our churches," except that the tower, "like one of our high steeples," stood at the east rather than at the west end.[54] Thus the orientation of the temple, its external appearance, and even the dimensions of the structure built under Solomon reminded Lightfoot of the medieval Christian churches he knew so well. Mead had arrived at a somewhat similar conclusion, based on the apocalyptic vision of the Book of Revelation. Both divines in their separate ways believed the temple was relevant to their turbulent times, when Anglican and Puritan thinkers searched for a new form of worship closer to the early Christian archetype. Quite apart from the temple's ritualistic importance to Lightfoot or its millennial significance to Mead, they held it up to their contemporaries as a template for the future. All this temple lore had a bearing on Hawksmoor's approach to churches, especially to his conception for the altar of Saint Mary's Woolnoth with its twisted Solomonic columns (fig. 60). In addition, it seems to me very likely that Hawksmoor knew the artistically accomplished temple restitutions by Wenceslaus Hollar, which had appeared in two illustrated Bibles of the period.

Like his father, John Lightfoot Junior also took holy orders—the third generation of the family to do so—and in due course became chaplain to the Reverend Bryan Walton (ca. 1600–1661), for a brief while the bishop of Chester. Walton's fame rests on his editorship of the *Biblia Sacra Polyglotta...* (London, 1653–57), the greatest achievement of English biblical scholarship during the Interregnum. The elder Lightfoot's acknowledged mastery of various biblical tongues made him very helpful to Walton. According to George Bright, Lightfoot's biographer and editor, he assisted Walton with the Samaritan Pentateuch, read proofs as they came off the press, and contributed an "animadversion" on the geography of the Holy Land.[55] This brief though learned appendix to the first volume was accompanied by maps, two of the finest of them by the Anglo-Bohemian master etcher Wenceslaus Hollar (1607–77). Earlier in the same volume Walton had inserted a gloss on Villalpando's writings by the French theologian Louis Cappel (1585–1658), in which the talmudic descriptions of the temple, and that by Josephus, augmented the information in the Old Testament. Accompanying the text is an etching attributable to Hollar.[56] It reproduces ten plans of the Temple of Jerusalem—Lightfoot's not among them—all squeezed onto a single page in much the way Walton sandwiched together parallel columns of Latin, Greek, Arabic, Syriac, and Chaldean for easy textual comparison.

Not content with this, Walton proceeded to commission from Hollar a compilation of temple information copied from Villalpando and rearranged by Hollar in the form of three foldout plates. They are scattered somewhat at

random through the early sections of the Old Testament volumes of the *Biblia Sacra Polyglotta,* and they proliferated the image of the temple widely. Walton's ingenious scheme to sell his Bible by subscription exceeded his best hopes for success. Not only did it sell well, but many of the copies in existence lack some or all of the Hollar plates. Heavily used Bibles must certainly have undergone considerable wear. That alone, however, would not account for the systematic removal of so many etchings.[57] It seems that the plates became sought after as collector's items or devotional images. Many must have ended up on the walls of college libraries, in country parsonages, or in architects' print portfolios such as Hawksmoor's.

Hollar's compilation of material taken from Villalpando lacks artistic originality. The same, however, cannot be said of a pair of sensational Hollar images of the temple that appeared slightly later in a different Bible. One is a spectacular oblique view of the temple proper taken from within the main courtyard, signed and dated by Hollar in 1660. The other, signed and dated by him in 1659, is an equally magnificent aerial perspective of the entire temple complex (fig. 12). Against the rather Bohemian-looking rooftops of his imaginary Jerusalem, the temple rears itself up on Mount Moriah to reveal all eight of its courtyards. Crowds of people and sacrificial animals flock around the terrace on the top of Villalpando's temple podium, so high it is mostly cut off from view at the bottom of the plate. Although these etchings remain fairly faithful to Villalpando's elevations, they depart from his restitution's strict or-

12. Wenceslaus Hollar, imaginary restitution of the Temple of Solomon in Jerusalem, etched aerial perspective, probably from the Restoration Bible (Cambridge, 1660).

thogonal viewpoint and therefore provide less reliable data than the plates in the *Biblia Sacra Polyglotta*. Robert Jan van Pelt has remarked that judging by the scale Hollar used for the architecture, the human figures in his views would stand nine feet tall! But representationally speaking, there can be no question that the images are thrilling to look at.

Hollar's slightly later pair of plates appear to have illustrated a sumptuous edition of the King James Bible, called the Restoration Bible because its 1660 date of publication coincided with the restoration to the monarchy of James's grandson, Charles II. Printed at Cambridge by John Field, its publisher was the author and mapmaker John Ogilby (1600–1676), who played a significant part in promoting heavily illustrated deluxe editions of such classics as Virgil and the Bible. Toward the end of his life Ogilby frequently enlisted Hollar's services with the numerous atlases he brought out. At an early date Ogilby must have realized Hollar's talent for perspective from the aerial maps of the Holy Land and Jerusalem in the *Biblia Sacra Polyglotta*. Whether with permission or not, Ogilby included them in his Bible along with some of the Villalpando material. This seems to have been relatively common practice during the freewheeling time of print culture before strict copyright regulations applied and the tedious procedure of obtaining permission to reproduce came into force. Ogilby then commissioned the two entirely new Hollar etchings that creatively transform the rather wooden-looking Villalpando elevations into truly breathtaking vistas of the temple, seen as if by a sacrificial dove on the wing.[58] In this way the Field-Ogilby Bible, despite its considerable cost, increased awareness of the Temple of Jerusalem in circles outside the clergy. In fact, evidence from the sale catalog of Nicholas Hawksmoor's library strongly suggests that Hollar's prints from the Bible circulated separately. Hawksmoor avidly collected Hollars. He owned no fewer than 118, excluding "90 prints of the Bible" that probably included additional Hollars.[59] It is quite likely, therefore, that the architect knew and may have been inspired by the etcher's visionary concept of the temple as though it were the eighth wonder of the world.

For all its rich religious and historical associations, how could the Temple of Jerusalem help the practical design concerns of church builders such as Wren, Hooke, and Hawksmoor? What use was the temple to them as they went about two massive church-building campaigns as a result of the 1666 Great Fire of London and the 1711 act of Parliament to improve conditions of worship in the suburbs of the metropolis? A clear answer to these questions is provided by a sermon delivered at Wren's church of Saint Peter's Cornhill, on the occasion of its reopening on 27 November 1681. The scholarly divine who delivered it was William Beveridge (1637–1708, fig. 26), rector of Saint Peter's

in the City of London since 1672 and later bishop of Saint Asaph. He opened his sermon with the following words:

> When Judas Maccabeus had new-built the altar and repaired the Temple of Jerusalem after it had been polluted and laid waste for three years together, the church of God at that time and place rejoiced. . . . In like manner, we of this parish have cause to be transported with joy and gladness, and to spend this day in praising . . . God, for that our church, which hath lain waste for above five times three years, is now at last rebuilt and fitted again for His worship and service. For what the altar and Temple were unto the Jews then, the same will our church be unto us now. . . . Was the Temple a house of prayer to them? So is this church to us.[60]

To an Anglican clergyman like Beveridge, the temple provided the exemplary model for all Christian church architecture. Surely the same thought would have crossed the mind of Wren or Hooke had they heard Beveridge speak during the rededication ceremonies. It is remotely possible that they did. Wren's presence seems appropriate because he took nominal credit for the design of Saint Peter's in 1674, although building did not begin until 1677. As for Hooke's possible presence in the congregation, he seems to have played a considerable part in the actual design of Saint Peter's, judging from the number of his diary entries relating to it and the drawings of it apparently in his hand.[61] Moreover, he lived around the corner from Saint Peter's at Gresham College in Bishopsgate. After the completion of the church, he and members of his household occasionally attended services there.[62] Some personal pride in the church's design no doubt mixed with his duties as a parishioner.

Quite apart from William Beveridge's clear assertion of the Jewish temple's importance to Christianity, his lengthy sermon included unexpected parenthetical remarks of a practical nature that reinforced the relevance of ecclesiastical history to contemporary church-building practices. Standing in his new pulpit, he gestured toward a wooden screen separating the chancel area from the nave. During the short time since its installation, this unusual piece of church furniture had already aroused some comment—perhaps even consternation. Beveridge defended it by likening the holy of holies in the temple to the equally sacrosanct area of the chancel in a Christian church. His sermon went on to argue:

> Therefore also it [the chancel] was wont to be separated from the rest of the church by a screen or partition of network, in Latin *cancelli*, and that . . . from thence the place itself is called the "chancel." That this was anciently observed . . . within [a] few centuries after the apostles themselves, even in the days of

Constantine the Great, as well as in all ages since, I could easily demonstrate from the records of those times. But . . . I am loth to trouble you with it now.[63]

What a pity that Beveridge chose to spare his listeners further details on an aspect of liturgical history dear to his heart. Had he not restrained his inclination to biblical scholarship, he would have clarified his instigation of the chancel screen at Saint Peter's and what he intended it to symbolize in terms of early Christian practices.

The passage quoted above has mistakenly been used as proof that Beveridge's chancel screen went back to medieval sources for inspiration. Nothing could be further from the case. Beveridge clearly referred to early Christian practices when his sermon evoked as precedents the "centuries after the apostles," or what he called slightly later in the text "the primitive church."[64] His revivalism differed profoundly from that of Archbishop Laud and his followers. It had a much more archaeological bent to it, which would be congenial to classical architects such as Wren, Hooke, and Hawksmoor. Beveridge epitomized the new type of scholar-divine who took an active interest in directing the built form of the Anglican church back to such antecedents as the Temple of Jerusalem and the early Christian or Byzantine church. Like Laud, however, he carried this interest from the theoretical plane into the practical realm. Taking his cue from the titular name of his church, Beveridge seems to have wished to give Saint Peter's the appearance it might have had in the days of the apostle himself.

Beveridge's concept of Petrine primitive Christianity may have been somewhat prone to exaggeration, but he nevertheless founded it appropriately enough on a solid rock—the rock of New Testament scholarship. In 1672 Beveridge brought out in two volumes his magisterial commentary devoted to the synods of the early church. His Συνδικόν, *sive Pandectae canonum SS. Apostulorum, et conciliorum . . .* was printed at Oxford and quickly earned him a place of international honor in an age that had no shortage of biblical scholars. By the time Beveridge graduated from Saint John's College, Cambridge, he had mastered the necessary languages for biblical exegesis. He became for New Testament scholarship what Lightfoot had been for Hebrew studies. Beveridge's notes interpreting the eleventh canon of the first Nicean Council of a.d. 325 run to seven pages of two-column text full of references to early Christian authorities on church building. He ranged from such ancient sources as Tertullian and Bishop Gregory Thaumaturgus to more recent ones such as the fifteenth-century Byzantinist Simeon of Thessalonica and the French monk Jacques Goar (1601–53), whose Ευχολογιον had appeared in his native Paris in 1647.[65]

In Beveridge's annotations to his second volume he described the typical layout of an early Christian church and accompanied those remarks with a ground plan of his own devising opposite page 71 (fig. 13). At the bottom it shows the western columnar entrance porch, followed by a narthex containing a circular baptismal font on the right. From here three portals lead into the central nave and two flanking aisles of the body of the church. The aisles adjoin a projecting semicircular *prothesis* and a *diaconicum* to either side of the eastern *bema,* or chancel. As might be expected, the all-important chancel, with its altar table clearly shown, is separated by a screen from the nave, or *naos.* As a consequence of the author's expressed purpose of localizing all the different parts of such a building in early Christian times, the plan has a rather chopped-up, compartmentalized look, though no more so than others of its ilk. The image, in fact, increased Beveridge's international celebrity. It was quickly spotted by Leone Allacci's successor at the Vatican Library, Emanuel Schelstrate (1649–92). In 1681, the year Beveridge gave his sermon at Saint

13. William Beveridge, engraved plan of an ideal early Christian church, from Beveridge, *Συνοδικόν,* 2 vols. (Oxford, 1672), plate opposite 2:71.

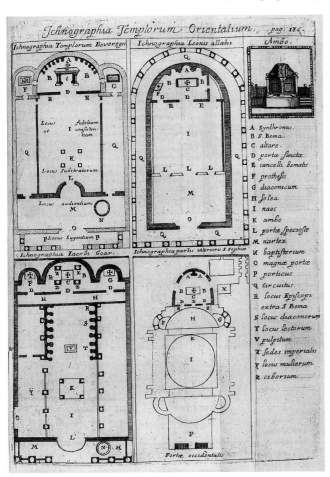

14. Emanuel Schelstrate,
engraved plans of ideal early Christian
churches by various authors, from
Schelstrate's *Sacrum Antiochenum
concilium* . . . (Antwerp, 1681), plate op-
posite p. 186.

Peter's, Schelstrate published a book in his native Antwerp titled *Sacrum Anti-
ochenum concilium*. . . . He illustrated it with an engraved plate of his own (fig.
14) that graphically documents his reliance on previously available scholarship,
including Beveridge's. It is really a composite of four
plans from four different sources, spliced together
much like the plates by Hollar in the *Biblia Sacra Poly-
glotta*. At the lower right is a ground plan of Hagia
Sophia taken from Charles du Fresne du Cange's *Con-
stantinopolis Christiana, seu descriptio urbis Constantinopo-
litaniae* . . . (Paris, 1680). Next to it is the plan based on
the one in the *Εὐχολογιον* . . . by Schelstrate's friend
Goar. The top right plan copies one of the three plates
in Allacci's *De templis Graecorum* . . . , and finally at the
top left appears the plan taken from Beveridge. Thus
Schelstrate's plate bears witness to the close contacts
between an international community of theologians:
two Vatican librarians, a French Dominican, and the
Anglican Beveridge.[66]

Notice how the plans of Goar, Allacci, and Bev-
eridge all include screens separating the chancel from
the body of the church. Beveridge referred to the fea-
ture of the screen on page 74 of his *Συνοδικόν*. In the
plan he labeled them κάγχελλοι, or *cancelli* as he pre-
ferred calling them in his sermon. "I mention it at
present," he told his congregation, "only because some,
perhaps, may wonder why this should be observed in
our church, rather than in the other churches which
have lately been built in this city. Whereas they should
rather wonder why it is not observed in all others, as
well as this." He continued by stressing that the feature, if unfamiliar to his lis-
teners, had a venerable history. Far from being innovative and therefore sus-
pect, it actually helped "avoid novelty and singularity in all things pertaining
to the worship of God."[67] His words from the pulpit prophesied things to
come, as perhaps he already realized.

Three years after Beveridge delivered his sermon another chancel screen,
the second and last among the City churches, was erected in All Hallows-the-
Great on Thames Street (fig. 15). It is surely no coincidence that the minister
of All Hallows, the Reverend William Cave (1637–1713), had attended the
same schools as Beveridge and graduated with him from Saint John's College
in 1656. From then on the two school friends' careers continued to run re-

markably similar courses. Cave's appointment to the prestigious London parish of All Hallows in 1679 followed by seven years that of Beveridge to Saint Peter's. Moreover, the same year that the learned Συνοδικόν appeared, Cave published the first edition of his more popularly oriented book *Primitive Christianity*. Although it makes no reference to Beveridge's exactly contemporary work and limits its sources to a few such as Tertullian, it covers much the same ground when discussing the interrelationship between liturgy and architectural form in the early Christian church. Cave referred to the separation of the *bema* from the rest of the church "by neat rails, called cancelli, whence . . . chancel."[68] Clearly, when Cave arrived at All Hallows he followed Beveridge's example at Saint Peter's and included a similar screen in emulation of the primitive Christians' *cancelli* that both clergymen had simultaneously written about. These two chancel screens show how much clergy might influence church design, at least concerning internal furnishings.[69] This collaboration

15. All Hallows-the-Great, Thames Street, London, engraving of the interior showing the chancel screen, from George Godwin and John Britton, *The Churches of London . . .* , 2 vols. (London, 1839), vol. 2.

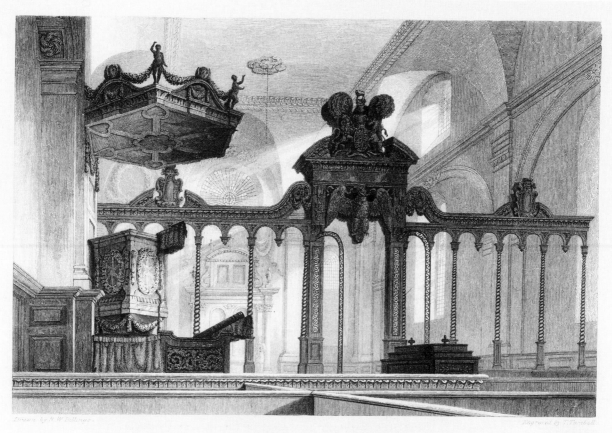

ALLHALLOWS THE GREAT,
Thames Street.

between clergy and architects set a precedent for events three decades later that profoundly affected Nicholas Hawksmoor's church building.

Before turning to Hawksmoor, however, it is important to mention a friendly letter that William Beveridge received from a younger clergyman, the Reverend George Wheler (1650–1723). The letter expresses regret that Wheler could no longer converse with Beveridge as frequently as before on their shared interest in church history. It was sent on 25 March 1701 to Saint Peter's Cornhill, from the cathedral of Durham where Wheler had been a canon for some sixteen years. That these two individuals would have much in common is clear from Wheler's manuscript autobiography, which contains the letter.[70] Unlike Beveridge, Cave, Lightfoot, Wren, or Hooke, Wheler was the son not of a clergyman but of a staunch royalist soldier, hence his birth in exile at Breda in Holland. He eventually attended Lincoln College, Oxford, where he studied under the Reverend George Hickes (1642–1715, fig. 25), of whom much more will be said in the next chapter. Wheler's autobiography described this master-pupil relationship as a "Blessing I am Ever to thank God for."[71] The two began an extensive scholarly grand tour of the Continent in 1673 that lasted three years. It took them at first to France, Switzerland, and Italy. From there Wheler proceeded to visit Greece and cities along the Mediterranean coast of modern-day Turkey. During this leg of his journey Wheler traveled in company with Jacques Spon, a French Protestant physician. Spon published his account of their journey in his *Voyage d'Italie, de Dalmatie, de Grèce, et du Levant* (Lyons, 1678). Wheler's version came out in London in 1682. The fame of these books lies in their early inclusion of firsthand information about ancient Greek architecture. This has tended to shift attention away from Wheler's equally interesting eyewitness account of early Christian churches.[72]

The third chapter of *A Journey into Greece by George Wheler Esq. in Company with Dr. Spon of Lyon* relates the author's trip from Constantinople into western Turkey with the main purpose of visiting as many as possible of the cities mentioned in the Book of Revelation (Revelation 2 and 3). Wheler reported on the ruined state of all the churches he saw, which must have seemed to him in some way a fulfillment of Revelation's apocalyptic predictions. All this sheds light on the future course of his career and the topic of his next book, with which Hickes and Beveridge helped him. His tutor's lessons in ancient Greek had not been wasted on Wheler. Indeed, as Joseph Rykwert has remarked, "the very use of the Greek language, the language of the New Testament, was a direct link to the primitive gospel and to a sacred antiquity which obsessed ecclesiastics as well as church builders in the seventeenth and eighteenth century without respecting distinction of nationality or denomination."[73] Not surprisingly in the light of his itinerary, Wheler took holy orders in 1683.

The next of Wheler's publications—the one most pertinent to this book—came out in London in 1689 under the lengthy title of *An Account of the Churches, or Places of Assembly of the Primitive Christians, from the Churches of Tyre, Jerusalem and Constantinople Described by Eusebius, and Ocular Observation of Several Very Ancient Edifices of Churches Yet Extant in Those Parts; with a Reasonable Application.* It runs to only 130 pages not including a dedicatory letter to George Hickes dated 20 December 1688. The letter thanks Hickes for suggesting to Wheler the idea of imaginary restitutions of the church at Tyre, the Holy Sepulcher at Jerusalem, and the Holy Apostles in Constantinople, based on descriptions in the *Ecclesiastical History* and *Life of Constantine* by Eusebius Pamphilius, the fourth-century bishop of Caesarea. The real reason for Wheler's mission to the Near East, as his book's title makes clear, was to tally Eusebius with "ocular observations" or, as he later put it, "what I have observed."[74] For example, Wheler dealt at some length with the nature of the screens that Eusebius described in Tyre's outer περίβολον, or courtyard, as well as around its altar (*Ecclesiastical History,* bk. 10, chap. 4, 39–44). This was the very feature that had fascinated Cave and Beveridge. Unlike them, however, Wheler did not rely solely on written descriptions. He determined that by screens Eusebius had meant a "lattice work of wood." Wheler based his deduction on his personal observation of Greek Orthodox churches on the island of Corfu and in the area of Turkey around ancient Troy.[75] He put the literary sources under the microscope, so to speak, just as Hooke had done with insects in his pioneering *Micrographia* of 1665. The increasingly accepted norms of scientific experimental methodology initiated by the likes of Wren and Hooke had started to have an effect on the studies of the early Christian architecture by the likes of Wheler.

Having verified his information on the spot, Wheler heeded Beveridge's technique of extrapolating a prototypical early Christian church from written sources. Twice in his *Account* Wheler referred to the notes at the end of the Συνοδικόν "by the learned Dr. Beveridge" and to the engraved plan that accompanied those notes.[76] Not content to leave matters at that, Wheler pressed on to devise his own restitution of a typical early Christian church, based on the one at Tyre that Eusebius dedicated in the year 317 in the presence of Emperor Constantine himself. Wheler accompanied his discussion with an engraved plan and an aerial perspective view both inserted opposite page 62 (figs. 16 and 17). He probably found justification for them in the fact that, as he put it, Eusebius's imprecise description "left scope for fantasy to work."[77] With respect to the element of fantasy, at least, Wheler certainly took Eusebius at his word.

Interestingly enough, Wheler's church plan differs from Beveridge's in several significant respects. First of all, it accords considerable attention to the

outer walled courtyard, or περίβολον, entirely omitted by Beveridge (cf. fig. 13). According to Wheler the court provided early martyrs with a burial place safe from "profanation of man or beast."[78] He went on to say that occasionally, as with the Church of the Holy Apostles in Constantinople mentioned by Eusebius (*Life of Constantine*, bk. 4, chaps. 58–59), the enclosure wall included houses for bishops, ministers, and others "who kept the place."[79] Wheler also differed from Beveridge in the importance he accorded to the external narthex (at C in fig. 16). And he made the quite logical suggestion that Beveridge's triple nave/aisles subdivision might well apply to smaller churches but not by any means to larger ones. Last and most important of all, in contrast to the oblong church plans described by Cave and depicted in the engravings of Beveridge, Allacci, and Goar, Wheler proposed a squarer configuration with the chancel, or *bema,* set inside it (at K). According to him, the whole would be covered over with no fewer than nine domes or half domes. None of the earlier theologians' restitutions had even hinted at domical architecture. His radical interpretation came, once again, from personal observations. He had seen domed churches on Corfu and at Hagia Sophia in Constantinople. But strange though it may seem to modern readers, his *Account* and the earlier *Jour-*

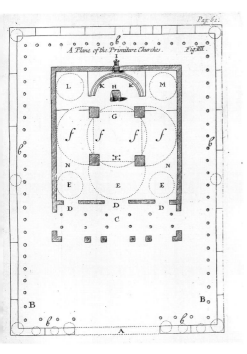

16. George Wheler, engraved plan of an ideal early Christian church, from Wheler's *An Account of the Churches . . .* (London, 1689), pl. 4.

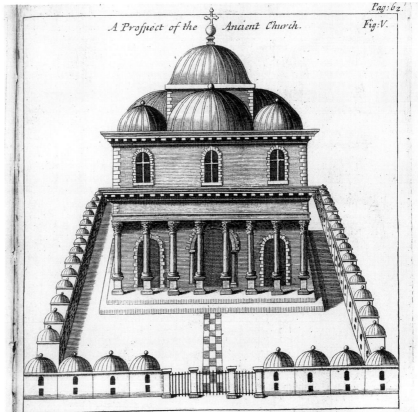

17. George Wheler, engraved aerial perspective of an ideal early Christian church, from Wheler's *An Account of the Churches . . .* (London, 1689), pl. 5.

ney into Greece pass over Hagia Sophia very lightly. It is as if he had hardly paid any attention to the church when he saw it on his travels.[80]

The words "with a reasonable application" at the end of Wheler's book title imply that he responded to the practical implications of Beveridge's chancel screen at Saint Peter's Cornhill. Wheler devoted the entire last chapter to ways his imaginary "primitive" church might apply to contemporary Anglicans. He praised the "beauteous symmetry" of the ancient churches—their "grave . . . yet magnificent . . . simplicity,"[81] which he believed could lend itself to the churches of his own denomination as well as win over Dissenters. He went so far as to equate Quakers with the "catechumeni, or learners," who according to him, Beveridge, and Cave waited outside in the narthex with the penitents until such time as they could be admitted into the body of the church by the sacrament of baptism. In one regard, however, Wheler differed from most of his contemporaries, except his teacher Hickes (see chapter 2), by affirming the ancient practice of separating male worshipers in the *naos* from females, accommodated in side aisles or up in galleries. In a tone of moral indignation Wheler concluded: "The general mixture of all ages and sexes as in most of the London and Westminster churches is very indecent; not to say . . . scandalous."[82]

Did Wheler practice what he preached at the chapel-of-ease, or tabernacle, he opened in suburban Spitalfields on Christmas Day 1693? Surviving correspondence reveals that originally he hoped to consult Wren about the design. But in the end he opted for an inexpensive, semiprefabricated structure of wood. He nevertheless took considerable pains specifying the interior arrangement, though whether he went to the early Christian length of segregating men from women is not known. In any event the tabernacle he paid for out of his own pocket provides an insight into Wheler's slightly self-righteous character. As the diarist John Evelyn said of him: "[He was] a very worthy, learned, ingenious person, a little formal, and particular, but exceedingly devout."[83]

Despite Wheler's emphasis on "ocular observation," he never actually saw the Holy Sepulcher in Jerusalem. He had to rely on the published account and engraving of it by an earlier English traveler, George Sandys (1578–1644), son of the archbishop of York and an early colonizer of Virginia.[84] As for the church at Tyre and that of the Holy Apostles in Constantinople, they had disappeared long before. But as already mentioned, Wheler did know Hagia Sophia firsthand, although to bolster his memories of it he relied on the writings of Guillaume-Joseph Grelot, to be discussed shortly. Hagia Sophia seems to have partly inspired his grandiose, multidomed "prospect of the ancient church" (fig. 17). Notwithstanding this debt, the visionary Wheler building

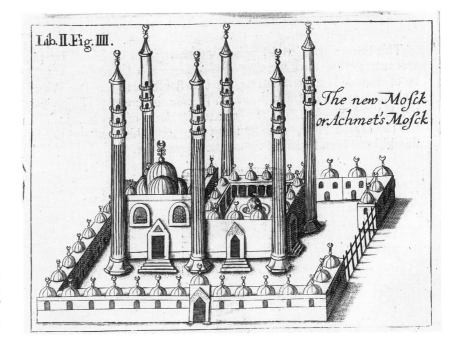

Lib. II. Fig. IIII.

The new Mosck or Achmet's Mosck

18. George Wheler, engraved
aerial perspective of Achmet's Mosque
in Istanbul, from Wheler's *A Journey
into Greece* . . . (London, 1682),
plate opposite p. 187.

owes at least as much to the mosques, caravanserais, and Koranic schools, or
madrasas, that Wheler also admired on his travels. In fact the enclosure wall in
his aerial perspective view of the church resembles the similar one around
"Achmet's Mosck," included among the plates in his *Journey into Greece* (fig. 18).
Eliminate the crescent moon finials from the little domed cubicles around the
perimeter and you have the Christian version in all its bizarre glory. Whether
consciously or not, Wheler's two engravings stressed the continuation of the
classical and Judeo-Christian architectural tradition into the world of Islam.

To return to Grelot, Wheler's near contemporary in Constantinople, he
published a book of his studies in that city carried out in the 1670s under the
auspices of Jean Chardin, a Huguenot merchant adventurer who installed
himself in England in 1680. Grelot's *Relation nouvelle d'un voyage de Constan-
tinople enrichie de plans levés par l'auteur sur les lieux* . . . came out in Paris in 1680.
An English edition, shrunken in size from quarto to octavo but using re-
worked versions of the same engraved plates, appeared in London three years
later as *A Late Voyage to Constantinople.* Perhaps for the benefit of an English au-
dience of clergymen, this edition contains an entirely new section about the
past and present state of the Greek Orthodox Church. Grelot's fourteen en-
graved plates, based on drawings done on the spot, were the first of their kind
to reach western European eyes. They proved influential, especially those
recording the interior and exterior of Hagia Sophia. Grelot secured permis-
sion to take the measurements of the converted church. But recording the in-

formation nearly cost him his life. He got a severe beating when the guards of the mosque caught him sacrilegiously consuming wine and salami in one of the ancient women's galleries, or *gynaikeia* as he called them.[85]

Grelot's efforts to measure Hagia Sophia paid off, especially in terms of book sales in England. Wheler probably owned a copy because he quoted from it; the Wren family library contained both French and English versions of Grelot. What is more, Christopher Wren's second tract specifically cites Grelot on the domes of Hagia Sophia, adding that Wren himself "followed this way in the [domical] vaulting of the church of Saint Paul's."[86] Having extended the wonders of the world to include the Temple of Jerusalem, Wren extended it yet again for the sake of Hagia Sophia. After all, when Emperor Justinian opened the church in 537 he supposedly exclaimed, "Solomon, I have surpassed thee."[87]

Further proof of Wren's interest in Hagia Sophia exists in the form of three drawings of it that have previously escaped notice in the Wren literature. The reason for their obscurity is not hard to find. They came to light in a most unlikely place, pasted down with blobs of sealing wax at the back of a copy of a slim little volume rich in associations. It was written by the French architect-historian Julien-David Leroy (1724–1803) and published in Paris in 1764. The title reads: *Histoire de la disposition et des formes différentes que les chrétiens ont données à leurs temples, depuis le règne de Constantin le Grand, jusqu'à nous.* The copy in question, now in the collection of Queen's University at Kingston, has on its title page a inscription in the hand of Robert Mylne (1733–1811), surveyor of Saint Paul's Cathedral from 1766 until his death. The inscription reads:

> With 3 Drawings of S.ʳ Sophia at Constantinople found
> among Mʳ Flitcrofts papers when sold in 1773.
> And then among some Drawings of Sʳ C.ʳ Wren which
> were evidently *Studios* for St. Pauls, London
> — R. M.—[88]

Because Leroy made mention of Hagia Sophia, his book must have struck Mylne as the logical place to file away the Wren drawings. His inscription states that he had acquired the sketches at the sale of the architect Henry Flitcroft, a predecessor of his as surveyor of Saint Paul's. Unless Flitcroft bought them at the Wren sale or acquired them while assisting the Wrens with *Parentalia* (cf. fig. 3), he presumably came upon them in the cathedral in some parcel containing preliminary studies, or "*Studios*" as Mylne so delightfully called them. Thus the unique Queen's University copy of Leroy has associations with three Saint Paul's surveyors in succession: Wren, Flitcroft, and Mylne. Apart from that, it backs up Wren's previously quoted statement in the

second tract that Hagia Sophia had served him as a model when designing Saint Paul's.

The Wren drawings include two plans (fig. 19 left and right) in pen and sepia ink over pencil on squared or scored paper. They represent the ritual southeast corner of Hagia Sophia at two slightly different levels.[89] (To see the similarities and differences, rotate the right hand plan ninety degrees to the right so that both semicircular apses face upward.) Wren focused on the wall mass with the twin staircases embedded within it. Both plans agree fairly closely with modern ones. Neither, however, reproduces exactly the plan opposite page 90 in Grelot's *Late Voyage to Constantinople*. This immediately raises the question of where the information came from if not from Grelot. An interesting possibility arises from the presence in London of Grelot's patron, Jean Chardin (1643–1712). On arriving in England from the Orient in 1680, Chardin entranced a welcoming party from the Royal Society with stories of his travels. Wren and Evelyn were among those present. Chardin promised to show them the drawings he had had made on the journey. With a little help

19. Attributed to Christopher Wren, two drawings of the plan of the southeast corner of Hagia Sophia in Istanbul, from the extra-illustrated copy of Julien-David Leroy's *Histoire de la disposition et des formes différentes que les chrétiens ont données à leurs temples* . . . (Paris, 1764) (Queen's University at Kingston, Ontario).

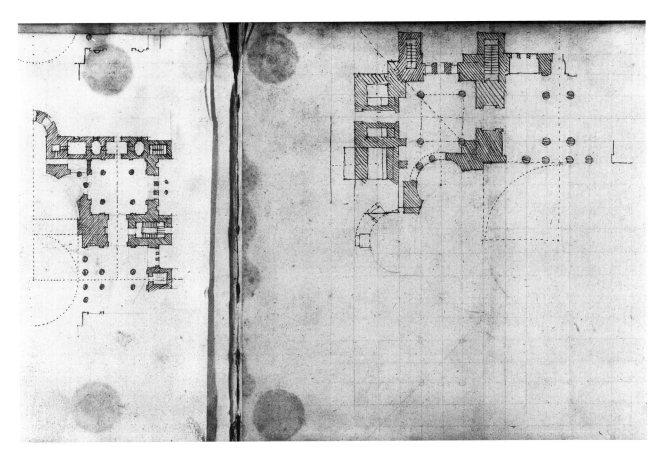

of their faith. They lived in an age fraught with religious and political turmoil, great fires, plagues, civil war, regicide, and genocide. Amid these understandable millennial signs of the end of the world, they turned to the hope for salvation offered them by the Temple of Jerusalem and the church of the primitive Christians.

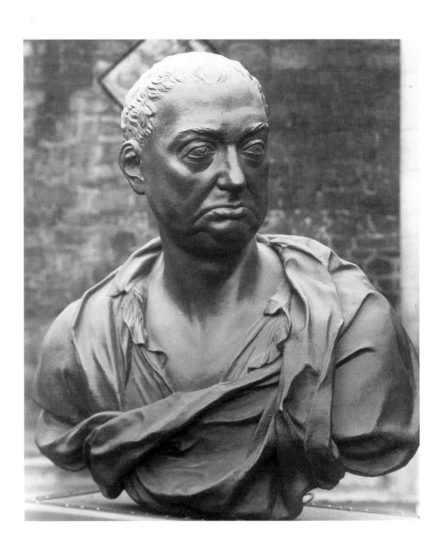

HAWKSMOOR AND THE DIVINES

21. *Opposite:* Attributed to
Henry Cheere, plaster portrait
bust of Nicholas Hawksmoor
(Warden and Fellows of All
Souls College, Oxford).

*J*OHN EVELYN HAS ALREADY APPEARED in these pages as a diarist and an architecture enthusiast. But he was also an avid churchgoer; references to sermons crowd the pages of the diary he kept so meticulously. On Good Friday 1685, for example, he attended the service at Christopher Wren's new church of Saint James's Piccadilly. The preacher was its very recently installed first minister, the Reverend Thomas Tenison (1636–1715), famous for his charitable good works and a decade later to become the archbishop of Canterbury. As such he would play a key figurehead role in the church-building career of Nicholas Hawksmoor (fig. 21), seen here in his only known likeness, a dour-looking portrait bust.

Long before Tenison (fig. 22) rose to archiepiscopal rank, Evelyn often heard him deliver sermons at Saint James's or at Saint Martin's-in-the-Fields, his two London parishes. On 19 July 1691 Evelyn recorded virtually an entire Tenison sermon verbatim, as if somehow the diarist had the gift of total recollection.[1] The occasion was the inauguration of a wooden chapel-of-ease, or temporary tabernacle, not unlike the one George Wheler established two years later in Spitalfields as part of a tabernacle movement that swept London's fringes at the time. Evelyn's diary explains that the structure he saw had been used for Roman Catholic worship in James II's reign before Tenison had it disassembled and reerected on the north side of Piccadilly near Dover Street. In this somewhat makeshift setting Evelyn heard the morning sermon on the text "Lord, I have loved the habitation of thy house, and the place where

22. *Right:* Pieter Vanderbanck,
engraved portrait of
Thomas Tenison, 1695, after
the portrait by Mary Beale
(© The British Museum).

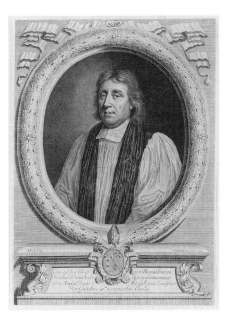

47

thine honor dwelleth" (Ps. 26:8). With remarkable foresight, Tenison preached about church-building events that he helped set in motion two decades later. Therefore his is the first of a gallery of ecclesiastical portraits illustrated in the following pages.

According to Evelyn, Tenison's July 1691 sermon began by briefly tracing the Old Testament accounts of places of worship from the tabernacle in the wilderness to the Temple of Solomon and the New Testament's references to synagogues where Christ had preached. Only during the persecutions of the last pagan emperors had Christians been "banished into desolate places, and into caverns & private recesses." "But so soon as those storms cleared up," Tenison continued, "they never left of[f] building of settled publique places." Then came his concluding argument:

> unreasonable & foolish is the pretence of those who pretend [that] the primitive times . . . [justify] the meanest accommodation, by which they separate themselves from the publique Congregation. . . . [On the contrary] churches were the places where the people were to Worship . . . & by frequenting which, in publique, & before all the world, they shewed that Religion they professed, what God & how they worshiped, which private Conventicles . . . could not do, being broken into many sects & schismes.

The preacher saved his fulminating rhetoric for the end, when he exhorted his listeners "to Resort with all Constancy to the publique places set a part as this Church was . . . that . . . [he predicted] should be made a parish Church, so soone as the Parliament sate. . . . now . . . that Arianisme, socianisme & Atheisme . . . spread among us."[2] Tenison's convoluted prose notwithstanding, he obviously preferred public to private worship. He opposed conventicles—secret meeting places—because they lead to schism. And he warned that undue emphasis on the humble circumstances of the early Christians could tempt his contemporaries into personal devotions as opposed to going to church. He therefore proposed to turn the Dover Street tabernacle into a church as soon as possible and to dedicate it to the Trinity as a means of counteracting heresies such as anti-Trinitarian Socinianism.

Thomas Tenison stood for an Anglicanism that took a militant position in the face of the various Dissenters or Nonconformists who had chosen to depart from the established church. For him new church building held the key to the problem of those who would pray in hidden meeting places. In this regard he agreed with the high church faction of Anglicans, although he was not one of their number. They set out aggressively to correct the very same ills he had pointed to in his sermon at the Dover Street tabernacle, so to them he must have seemed a prophetic figure. More energetically than he, they pursued

a grand architectural vision for new places of worship. Probably he had something simpler in mind, along the lines of his own parish church of Saint James's: plain brick on the exterior, its elegant galleried interior richly fitted up with the carvings by Grinling Gibbons that Evelyn so much admired when he first visited late in 1684. Tenison would therefore have agreed with William Cave's assessment that "the Christians of those [primitive] times spared no convenient cost in founding and adorning public places for the worship of God, yet they were careful to keep a decent mean between a sordid slovenliness and a too curious and over-nice superstition . . . so far as consisted with the ability and simplicity of those days."[3] Tenison may well have read Cave's *Primitive Christianity*. In any event, the sermon just quoted proves he was aware of the considerable literature already existing on the subject of the primitive church and its building practices. In matters architectural as well as political, however, he tried to steer a middle course between high church exponents opposed to any compromise with the Dissenters and the more accepting position of the low church persuasion.

The answer to Tenison's prayers for a renewal of church architecture came about as a result of a natural disaster, analogous to the 1666 Great Fire of London. This time, instead of a holocaust, the roof of the parish church of Saint Alphege's Greenwich collapsed on 28 November 1710, probably in the aftermath of the "Great infamous Wind" that had wreaked havoc all over Britain earlier that month.[4] Parliament had levied a tax on coal to pay for rebuilding the churches burned in 1666. In 1710, as work drew to a close on the last and greatest of them, Saint Paul's Cathedral, government funds could be released for other purposes.[5] A number of parishes with old churches in need of repair must have had their sights set on the possible reallocation of this coal tax money, foremost among them Saint Alphege's. But its plight raised the much broader problem posed by London's increasing suburban population and the inability to keep pace with it of existing parish churches such as the one at Greenwich. In 1711, for instance, the neighboring parish of Deptford was quick to press its own claim in Parliament. The vicar of Deptford, the Reverend George Stanhope (1660–1728), made a plea before the legislators on behalf of his "12,000 souls who cannot possibly be accommodated in the said church . . . for want of which . . . many have wholly neglected their duty on the sabbath day . . . and many others go to meeting houses . . . of Quakers . . . Presbyterians, and . . . Anabaptists."[6] The words sound like an echo of Tenison's Dover Street sermon of twenty years before.

Emotional appeals against Dissenters from the Church of England worked the desired effect on the elected parliamentary officials. In 1711, during the ninth year of Queen Anne's reign, Parliament passed an act to prolong

the coal tax and allow money from it to be diverted to "building fifty new churches in the cities of London and Westminster and the suburbs thereof." The act specified a new church for Greenwich; the other locations remained to be determined by a body of commissioners appointed by royal letters patent dated 21 September 1711.[7] In effect, this first piece of legislation created a fact-finding body under the nominal leadership of Tenison. In response to petitions from eligible parishes, it had to submit a full report by Christmas Day that same year. To have passed such a piece of legislation at all reflected the strength of political will existing at this particular historical juncture.

In the late summer of 1710 the right-wing Tory Party swept to power in the parliamentary elections. In contrast to most of the more liberal-minded Whig Party members, the Tories stood for a renewal of the traditional alliance between the state and the Church of England. They felt that alliance had been undermined during the previous reign of William and Mary, especially as a result of the Act of Toleration, which tried to reconcile all Protestants by granting greater freedom of worship, thus decreasing the hold of the established church. Adherents of the Church of England, first and foremost the clergy themselves, regarded these developments with varying degrees of alarm. Liberal-minded clerics, sometimes accused of Latitudinarianism, took the so-called low church position. Those who opposed any accommodation with the Dissenters were called high churchmen. As one of them defined the term: "If an high churchman be one who is for keeping up the present ecclesiastical constitution . . . without making any illegal abatements . . . such an high churchman is certainly a good Christian and a good Englishman."[8] These words were pronounced by the Reverend Francis Atterbury (1662–1732), the grandson, son, and brother of clergymen (fig. 23). Celebrated for his oratory, he occupied the pulpit of Wren's Saint Bride's Fleet Street at the same time in the early 1690s as Tenison's tenure of Saint James's Piccadilly. Atterbury was one of the leading high church proponents and, not surprisingly, a Tory sympathizer. In fact Atterbury's involvement with politics would eventually lead to his banishment from England as a Jacobite intriguer. But his downfall did not occur until 1722. A dozen years earlier his prospects looked bright, with a Tory victory at the polls and a devout Anglican queen on the

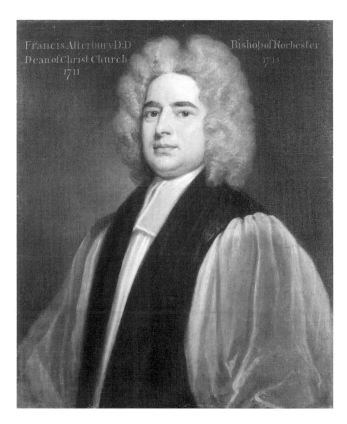

23. Godfrey Kneller, portrait of Francis Atterbury, 1711 (The Governing Body, Christ Church, Oxford, LP139).

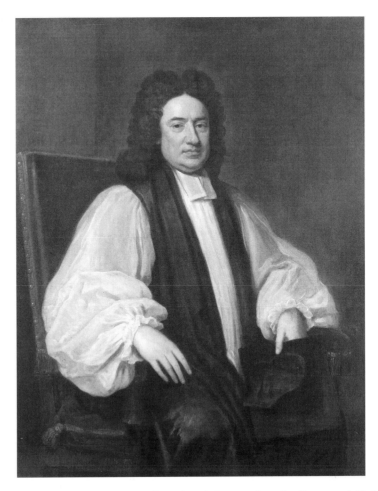

24. Godfrey Kneller, portrait of George Smalridge, 1717 (The Governing Body, Christ Church, Oxford, LP118).

throne. In the words of Atterbury's biographer the Reverend G. V. Bennett, "the Tory millennium" must have truly seemed at hand.[9]

Further evidence of Tory ascendancy came shortly after the landslide at the polls. On 25 November 1710 Atterbury, by this time dean of Carlisle cathedral, was elected the leader, or prolocutor, of the Lower House of Convocation, the ecclesiastical equivalent of the House of Commons. Atterbury had to be presented to Convocation in a speech. He chose to have it delivered on 6 December by his old friend the Reverend George Smalridge (1663–1719; fig. 24), a classmate from Westminster School.[10] Both Atterbury and Smalridge had proceeded to Christ Church, Oxford, a Tory hotbed where they came under the influence of the Reverend Henry Aldrich (1648–1710), the archconservative dean. Both men succeeded him in the deanery: Atterbury from 1711 to 1713, Smalridge from 1713 until his death. And both became commissioners appointed under the act of Parliament to look into the construction of the fifty

new churches. In their meteoric rise the two clergymen mirror one another to a remarkable degree.

In principle the commission established by Parliament had bipartisan representation and reflected high church as well as low church factions. In practice, however, Tories dominated the original commission and imposed their high church values on it. After all, it stands to reason that high churchmen would advocate building churches and would pay special attention to the strict observance of the reformed sort of ritual associated with them. This remains the sense in which the term "high church" within the Anglican faith still denotes a devotion to ritual, ceremony, and *ars sacra*. The writings of Atterbury and Smalridge reflect such thinking. Smalridge liked to illustrate his sermons with architectural and artistic analogies.[11] Atterbury used similar turns of phrase and on one occasion exhorted clergymen under him to pay special attention to the repair of their churches. His library contained a Vitruvius and Leoni's 1715 edition of Palladio, not to mention works by numerous theologians who had speculated on the appearance of the early church and the Temple of Jerusalem.[12] More to the point, the prolocutor is credited with having personally written the original memorandum from the Lower House of Convocation that sparked the legislation for the new churches. He delivered it on 28 February 1711 to the speaker of the Commons, William Bromley (1664–1732), a leading Tory, a firm supporter of Atterbury's high church faction, and another contemporary undergraduate at Christ Church.[13] Atterbury visited Bromley again on 9 March 1711 with a provisional list of the new churches needed. From then on events moved quickly in the parliamentary committee considering the bill. By the end of that month Queen Anne had given her assent to the legislation for the new churches, enacted on 6 April 1711. By September, Atterbury, Bromley, and Smalridge had received their appointments to the commission. All three attended the first meeting on 3 October 1711.

Atterbury's frenetic activities as high church ringleader prevented his active participation in the early, policy-making meetings of the commissioners. So, working behind the scenes, he packed the body with cronies and former classmates such as Smalridge, the Reverend Francis Gastrell (1662–1725), and the Reverend Henry Compton, bishop of London (1632–1713). Gastrell was a graduate and also a canon of Christ Church, as was Compton at one time. The older Compton, a father figure to the younger "high flyers," enjoyed a close relationship with the queen, having been her girlhood religious adviser. He had supported Atterbury from the start, securing Saint Bride's for him. Finally, he had successfully collaborated with Smalridge on recent church tracts.[14] Commissioners' meetings must at times have resembled Christ Church alumni reunions!

The fifty-two original commissioners fall into three fairly distinct groups: clergymen, some of them just mentioned; politicians, who form the largest number; and prominent citizens including architects. Chief among the parliamentarians were the Tory speaker William Bromley, member of Parliament for Oxford University, and his henchman Francis Annesley (1663–1750), a leader of the ultra-Tory October Club.[15] Annesley shepherded the legislation for the Saint Alphege's act through the House in 1711, and he continued to serve as a spokesman for subsequent bills concerning the commissioners and their churches. After the first commissioners' mandate ran out, much the same cast of characters reappeared a year later in a second, enlarged commission. But when the third commission came into force on 2 December 1715, Atterbury, Bromley, Gastrell, and Annesley's names had disappeared from the list. In the interim Compton and Queen Anne had died, the Tories had lost power to the Whigs, and the pro-Whig Hanoverian king George I sat on the throne. Atterbury's web unraveled as quickly as he had spun it.

The third group of commissioners included high-ranking civil servants who were architects. The architect members of the commission formed their own old boy network. They consisted of the surveyor of the royal works, Christopher Wren; the chief clerk, Wren's son Christopher Junior; the works comptroller, John Vanbrugh (1664–1726); and Thomas Archer (ca. 1668–1743), groom porter in the royal household. An amateur architect of genuine distinction, Archer was moreover tied to Bromley by old family friendship.[16] The architects took their mandate seriously. Hardly a commissioners' meeting went by that at least one of them did not attend. Indeed, a letter of 11 October 1712 from Christopher Wren Junior explicitly states that for some time the architects kept a sort of watching brief on the commission's proceedings. Attending in rotation, they were on hand to represent their interests and those of their pupil, friend, and collaborator Nicholas Hawksmoor.[17]

At their second meeting on 10 October 1711, the commissioners appointed Hawksmoor one of the two salaried surveyors along with another Wren pupil, William Dickinson (ca. 1671–1725). At this meeting the commissioners ratified creation of a subcommittee to expedite laying the groundwork.[18] Its membership is particularly relevant to the events that took place. It included most notably the Wrens, Vanbrugh, Archer, and the parliamentarian Annesley. The Reverend George Smalridge chaired all its weekly sessions throughout the autumn of 1711. When meetings resumed in June 1712 after a hiatus, he maintained the same intensity of pace. In 1713 the frequency of the meetings began to slacken, as did Smalridge's own attendance. Careful scrutiny of the minutes of these key subcommittee meetings reveals that the members formulated policy on every aspect of the new churches. In these matters Smalridge, the spokesman of the group, took a leading role, just as he had in the early discus-

sions preceding the act. Of all the commissioners, he must have worked most directly with Hawksmoor. These two men of different backgrounds but with a shared love of architecture would likely have known one another well. Neither mentions the other in personal documents, unless Hawksmoor is the "gent." whom Smalridge consulted in January 1718 on the fine points of architectural terminology.[19]

It remains to consider one more important member of Smalridge's subcommittee, the Reverend George Stanhope, dean of Canterbury cathedral and vicar of Deptford, who had petitioned Parliament on behalf of his dilapidated parish church. Stanhope came close to Atterbury for eloquence as a preacher and was second only to Smalridge for diligence on commission business. One of the original commissioners, he lasted the longest because of his moderate position in church politics. He served each commission in succession right up until his death in 1728. His survival record suggests that he put aside the prevalent but constantly shifting high or low church rhetoric to give top priority to church building. He demonstrates that ultimately every commissioner, regardless of faction, must have regarded building fifty new churches as a positive step—especially because taxpayers at large put up the money rather than the individual parishes. Perhaps too much has been surmised about the divisive effects on the commission of party politics and doctrinal disputes.[20] Instead of divisiveness, Stanhope's lengthy service suggests an underlying unity of purpose. That only twelve of the fifty churches ever materialized need not reflect a stalemate, a change of policy, or a retrenchment. Rather, it is amazing to think that the commissioners ever really hoped and believed they could undertake so gigantic a project. Rarely in the annals of architecture does there exist an ecclesiastical endeavor so large in scope, so concerted in effort, or so conscientiously chronicled.

When the commissioners met for the first time, they had less than two months to carry out their initial feasibility study. At a breathless pace they processed the many submissions from eligible parishes.[21] The subcommittee helped speed matters along. Its meetings and those of the full body of commissioners usually did not fall on the same day. The minutes of the larger body frequently echo decisions the smaller one had agreed on twenty-four hours or so earlier. Both bodies concluded their deliberations temporarily in late December 1711, at which point Hawksmoor and Dickinson received partial salaries.[22] A hiatus in the commission's meetings now took place, lasting until June 1712. The first commissioners' fact-finding mandate had elapsed, and not until 27 September 1712 did Parliament receive royal assent for the new commission with more commissioners and increased powers. Meanwhile, a bill for extending and prolonging the mandate on the original commission received

royal assent on 22 May 1712, so it could resume its activities and begin purchasing sites.[23] After five months' enforced idleness, words could at last be translated into deeds.

Early in the proceedings of the first commission, Christopher Wren wrote a letter to a fellow commissioner (appendix 2) listing eight separate recommendations for the fifty new churches based on his long experience with the fifty or so he had built in London.[24] (Fifty must have seemed a magic number to Atterbury and other admirers of Wren when they drafted the legislation.) Wren wrote about the desirability of open situations for churches, so that they might have "porticoes, both for beauty and convenience," and spires to ornament the skyline. He dwelled at considerable length on provisions for burial, which preoccupied him. He recommended against burial within or immediately around churches as an unwholesome and structurally destabilizing practice, and he recommended large communal cemeteries on the outskirts of town. These true *campi santi* would be planted with yew trees, filled with mausoleums, and walled to protect them. The inner surface of the walls could display mortuary tablets and the like. On 14 November 1711, probably in response to Wren's recommendation, the commissioners accepted the principle of separate cemeteries wherever practicable.[25] And the 1712 bill authorizing the second commission contained a specific clause forbidding burials inside churches.[26]

Always the scientist, Wren calculated the number of parishioners requiring accommodation. He came to the conclusion that the churches would need to seat large numbers, though no more than two thousand, because of the limited carrying power of a typical English preacher's voice. Having sat though many a mumbled sermon, Wren stressed churches as "auditories." As an example of ideal size in relation to acoustics, he recommended one of his parish churches as particularly "beautiful and convenient, and as such, the cheapest of any form I could invent." Surely it was a politic move on his part to single out Saint James's Piccadilly, the former parish church of the head commissioner, Archbishop Tenison! Perhaps Wren's letter was addressed to him. Alternatively, Atterbury might have been the recipient, because Wren wrote him a friendly letter in 1713 regarding the restoration of Westminster Abbey.[27]

Slightly later than Wren's recommendations, John Vanbrugh prepared a similar list of proposals, which not coincidentally also number eight. Whereas Wren envisioned relatively plain churches like his own Saint James's Piccadilly, "Mr. Van-Brugg's Proposals About Building ye New Churches" recommended something much more sumptuous.[28] With his dramatist's flair, Vanbrugh resorted to such expressions as "Magnificence," "Dignity," and "Strength," and at one point he stressed the need for "the most Solemn and

Awfull Appearance both within and without." Vanbrugh expanded on the notion that churches should be visible across broad civic spaces and be freestanding, or "insulate" as he put it. He paraphrased Wren's idea that a portico and steeple would make the churches "Ornaments to the Towne, and a Credit to the Nation." He stressed that without being "luxurious" they should nevertheless be "Monuments to Posterity." He wholeheartedly adopted Wren's idea of suburban communal cemeteries, but he turned them into vast, mausoleum-filled necropolises. To show what he meant, he sketched the walled enclosure with a pyramid at each corner and domes, funerary columns, and spires sprouting up behind. His evocative little sketch, based on an account of the English cemetery at Surat in India, decorates the copy of the recommendations among the papers belonging to Bishop John Robinson (1650–1723), an ally of Atterbury's on the commission.[29] Vanbrugh furthermore claimed that "since Christianity began, there is but [this] one instance, where the Inhabitants of a City have had so Glorious an Occasion as this, to Adorn both their Religion and their Towne at once." And subsequent history has proved Vanbrugh right, because nothing within Anglican architecture quite equals the commissioners' churches.

Obviously some middle ground needed to be found between Vanbrugh's bombast and Wren's more staid, old-fashioned conception of the churches. Although both agreed on most of the practical points, neither could see the liturgical or theological implications of the new churches the way a clergyman would. Such a clergyman was the Reverend George Hickes, already encountered as the tutor and traveling companion of George Wheler. Specialists know Hickes as a respected biblical and Anglo-Saxon scholar and as a nonjuror, one of those divines who deemed it illegal to swear allegiance to William and Mary.[30] Less generally known is that Hickes (fig. 25) wrote a manuscript, "Observations on Mr. Vanbrugg's proposals about Buildinge the new Churches," as a rebuttal to Vanbrugh (appendix 3).[31] A crossed-out version of the title, "Observations upon a paper sent to one in commission for building the new churches," obviously singles out the recipient as a commissioner such as Bishop John Robinson. His papers in the Bodleian Library contain Vanbrugh's original recommendations, suggesting that Robinson may have been the one who sent Hickes a copy for his comments. And indeed just such a copy also ex-

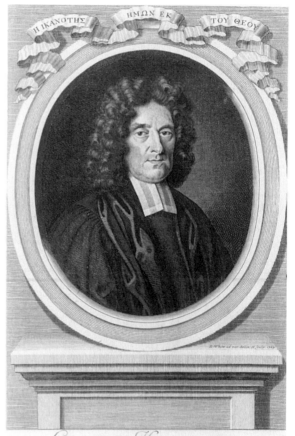

25. Robert White, engraved portrait of George Hickes, 1703, from Hickes's *Languarum veterum septentrionalum thesaurus . . .*, 2 vols. (Oxford, 1703–5), frontispiece to vol. 2.

ists in the Bodleian Library.[32] Hickes returned his correspondent's favor by sending back his observations for general discussion among the commissioners. The text implies wider circulation, warning that "the gentlemen in Commission for building the churches will take care, that the new models of Architecture, do not exclude the old manner of building churches . . . [and that] they will guard ag.* the Theatrical form, to w.ch many of our new churches, and chappels too nearly approach." He expanded on this conservative credo earlier in the observations by going straight to the point. Citing Eusebius directly, but thinking back also to Wheler's book, Hickes wrote: "It will appear that the old way of building churches is capable of most if not all the state, and graces of Architecture, and as that way of building was the most ancient: so it is most fit to be imitated." In such sweeping statements as these, Hickes went to the heart of the matter in a way the architects' recommendations never did. His document is a fascinating one. Its general thesis about emulating primitive

26. *Below:* Michiel Vandergucht, engraved portrait of William Beveridge, 1708, after the portrait by Benjamin Ferrers, from Beveridge's *Private Thoughts upon Religion . . . ,* 9th ed. (London, 1719), frontispiece.

27. *Below, right:* Robert White, engraved portrait of John Lightfoot, from Lightfoot's *The Works of the Reverend and Learned John Lightfoot . . . ,* ed. George Bright, 2 vols. (London, 1684), frontispiece to vol. 1.

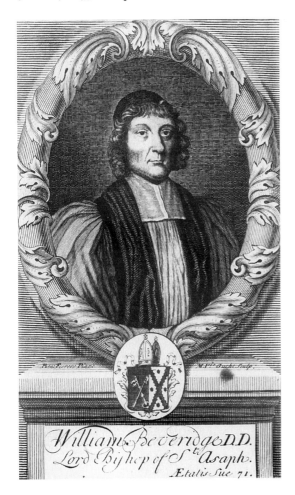

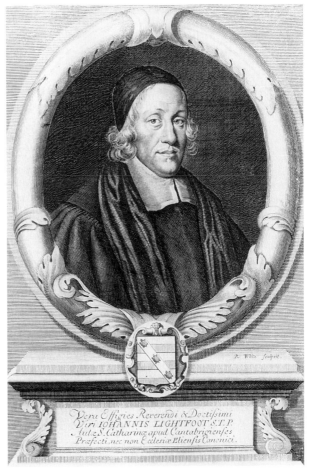

Christianity—the more primitive the better—and its detailed suggestions to that effect, had considerable impact on the commissioners' thinking.

Putting political differences aside, the high church Tory Hickes agreed with the recommendations of Vanbrugh the Whig. For example, Hickes concurred with "this famous Architect [Vanbrugh] not to make churches burying places, but to purchase Coemetaries in the [out]skirts of town." He qualified that approval somewhat, however, when he "condemned" ostentatious mausoleums for the rich, of the type Vanbrugh had in mind, preferring instead "large Cloysters, wᶜʰ would serve for a shelter in all ill weather for the people and render the walls of wᶜʰ monuments may be built." This idea sounds very similar to the third of Wren's recommendations (appendix 2), but the reference to them is too oblique to be certain. Hickes also approved Vanbrugh's suggestion about "the insular situations of churches," both on grounds of beauty and as a firebreak. But Hickes went further by stressing that if "money is not to be spared to make these buildings strong, gracefull and magnificent as this Architect observes," then "forty foot of ground more or less at the national charge," ought to be purchased so that the churches could be oriented east-west as in all early Christian ones. In this instance, Hickes would have strenuously objected to Wren's recommendation that stated somewhat cavalierly, "Nor are we, I think, too nicely to observe east or west in the position, unless it fall out properly." From Hickes's point of view, such a casual disregard for primitive Christian practice would have verged on anathema. The commissioners sided with Hickes when they ruled in one of their earliest regulations that "no scite ought to be pitched upon for the Erecting a New Church, where the same will not admit that the Church be placed East and West."[33]

Hickes's observations dwell a good deal on certain of his pet liturgical peeves such as incorrect methods of baptism, forms of pews, and inadequate housing for church officials. On the last of these points he proposed a sort of walled precinct about the churches that would include in "the circumferential parts of them such houses as are requisite, as one for the Sexton, who may be as a watchman to the church, and another for the minister, churchwardens, and parish officers to meet in." All this echoes the περίβολον mentioned by Beveridge and Cave and illustrated by Wheler (fig. 17). As for baptism, Hickes stressed that "the learned among the clergy" would prefer it to take place by immersion as in apostolic times, and in a separate baptistery. Hickes somewhat repeated himself by specifying a font indoors near the west end for infant baptism "as I have observed many ancient fonts to be." Finally, Hickes stressed and restressed his aversion to most box pews constructed in his day: they either were too high, were crowded too close together, or clacked shut too noisily during services. He started out his observations by remonstrating against mix-

ing of the sexes in the same pews as "contrary to ancient order and decency . . . a scandalous hindrance to devotion." He returned to the topic a second time to recommend segregation of the sexes in separate sections of pews "according to the ancient custome, wch cannot be unknown to the R[ight]. Reverend, Reverend and Learned clergymen nominated in the commission." Significantly, he liked best the pews at "St. Peters Cornhill, of wch the late learned Bishop Beverige was Rector." For the poorer parishioners, unable to rent pews, he wanted to install "moveable formes" that could roll out into the aisles along the lines of those he mentioned parenthetically in "ye midst of Choire at St. Pauls [Cathedral]." He wrote with fervor of "the noble and ignoble, the Rich, and poor being all equal in the house . . . of God." Wren's recommendations, incidentally, had bemoaned the same discriminatory but profitable and well-entrenched practice of pew rental. All in all, Hickes's observations mix high church conservatism in liturgical matters with humanitarian regard for all classes of society. They blend the thoughtfully kind with the uncompromisingly doctrinaire.

When the first commission reconvened in June 1712, some of its members had very much in mind the recommendations of Wren, Vanbrugh, and particularly Hickes. On 16 July the commission adopted eleven resolutions differing only slightly from the list of a dozen recommended to them by Smalridge's subcommittee on the eleventh (appendix 4). On that day Smalridge had taken the chair. Stanhope and Annesley were present, among others, but none of the architects were. Perhaps they absented themselves on purpose, having already made their views known. The twelve rules laid down correspond very closely to certain of Hickes's observations, especially concerning his preference for stone as an appropriate material for the churches, the placement of the font for "Baptism . . . by dipping, when desir'd," and the function of two eastern rooms, "One for the Vestments, another for the Vessells & other Consecrated things." The rule concerning the chancel reflects Hickes's thinking rather than Vanbrugh's or Wren's; neither of them mentions it at all. The subcommittee's resolution reads: "That, the Chancels be raised three Steps above the Nave or Body of the Churches." Hickes had suggested two or three steps. Most conclusively, Hickes's ideas on reforming "indecent" pews were implicitly followed, and his phrase about "moveable formes" was quoted exactly. By stressing pews "so low" that worshipers "may be seen, either Kneeling or Sitting," the commissioners answered Hickes's implied warning about the "deplorable irreverence" of high box pews that hid those Puritans who refused to kneel. There can therefore be no doubt that the subcommittee had paid attention to what Hickes had written, even though the commission's papers do not preserve the final version of his observations, nor do the minutes mention him by

name. This omission proves once again how frequently minutes of meetings leave out crucial bits of the conversation.[34]

Up to this point in the commission's proceedings, architectural design as such had come up in discussion only once; but thereafter the emphasis shifted.[35] The very first of the commission's rules required that "one general design or Forme be agreed upon for all the fifty New intended Churches." In its meeting of 23 July the commissioners required Hawksmoor to submit a "plan of a Church conformable" to their eleven rules adopted the week before. No such plan was available on the thirtieth, and they gave him until Christmas to come up with one.[36] These rather unusual stipulations may reflect the attitude of Smalridge as chair of the building subcommittee. In a sermon he had expressed the opinion that "an able and skillful artist, before he undertakes any curious work, . . . doth in the first place form in his mind a model of what he intends, according to which he shapes his work, and gives it all its proper dimensions and proportions."[37] The ambiguity of the word "model" is worth a moment's digression. Of course the sermon writer had in mind an ideal form, not a physical model such as the famous one of the temple by Rabbi Leon, discussed in the previous chapter. But real as opposed to conceptual models do begin to figure prominently in the commission's deliberating process. At the same meeting on 30 July the commission mentioned "Designs & Modells." By the end of 1712 the first written mention occurs of Hawksmoor in conjunction with wooden models of the churches. Eventually at least seventeen such wooden models were prepared for the commission over the years, three of them for Hawksmoor's first church, Saint Alphege's Greenwich, another for Saint Anne's Limehouse, and a fifth for his Saint George's-in-the-East. This is not the place to go into a detailed discussion of them, since they have been well dealt with and illustrated elsewhere.[38] Unfortunately none of them survive, and the two-dimensional images that exist hardly do justice to the three-dimensional models built according to Hawksmoor's designs. Nevertheless, Smalridge's apparent concern for establishing a very concrete ideal design for the commissioners' churches as a whole, in addition to having individual models prepared, must have shaped Hawksmoor's initial parti.

In preparation for the design phase, the initial energies of the commission focused almost entirely on selecting sites. The one at Greenwich needed no further discussion, having sparked off the commission in the first place. On that score the commissioners moved quickly ahead on 30 July 1712 despite the absence of Hawksmoor's ideal church design.[39] In addition to Greenwich, forty other possible locations were apportioned out to various parishes, including five (the largest single allocation) for Saint Dunstan's parish, Stepney.

One of the five was called Hare Fields in the hamlet of Bethnal Green. The land belonged to a lawyer, a certain Thomas Sclater. At its second meeting in October 1711, Smalridge's subcommittee approved the site and Sclater's selling price of £200. On 16 November some unspecified objections by the inhabitants of Bethnal Green were overruled. On the twentieth Hawksmoor received orders to examine approach routes to Hare Fields. Finally, on 29 July 1712 the subcommittee instructed him to "Sett out the Ground to be purchased of M.ʳ Sclater." Then the trail suddenly goes cold. Nothing more is heard about the site for years.[40] In this instance, however, the papers of the commission yield a precious extra piece of the puzzle in the form of a sheet of paper fourteen and a half inches square. On the verso is Sclater's "proposal," or offer of sale, dated 30 November 1711. A remarkable Hawksmoor site plan incorporating Sclater's land occupies the recto (fig. 28). Thus, almost certainly, the back provides the terminus ante quem for the undated freehand drawing on the

28. Nicholas Hawksmoor, drawing of the plan of "The Basilica after the Primitive Christians" (Lambeth Palace Library, L.P.L., MS 2750/16).

front.[41] The plan shows Sclater's two-and-a-half-acre parcel with cross-hatching at the top left, and a breakdown of his total five-acre parcel occupies the bottom right. All this information on the recto further confirms that the drawing postdates the 30 November 1711 offer of sale by only a short time. At the latest it would have to predate the mid-July 1712 rules set out by the commission, a number of which it sidesteps, notably the regulation number of steps up into the chancel. In most other respects, however, the drawing takes into account the recommendations of Wren and Vanbrugh, Hickes's observations, and much else besides.

Hawksmoor deftly depicted a sprawling church and graveyard complex using pencil, sepia ink, and a thin band of blue wash to highlight the sacred precinct. He titled his drawing twice. On the right he called it, evocatively, "The Basilica after the Primitive Christians." On the left he headed his list of marginalia with the words "Manner of Building the Church—as it was in ye fourth century." And he qualified that phrase with the words "in ye purest times of Christianity," no doubt thinking back to Hickes's constant refrain about postapostolic architecture as evoked in the early writings of Eusebius. Hawksmoor went on to write, "No burying in ye Church—or nere it on ye outside—but separately." Agreeing with Wren, Vanbrugh, and Hickes, the commissioners sanctioned this manner of burial in their November 1711 deliberations, about the time Hawksmoor executed the drawing.[42] Downes realized the significance of these fascinating marginalia in his 1959 pioneering Hawksmoor monograph. Though he did not know about Hickes's observations at the time, he presciently linked the plan's long marginalia with Wheler's *Account.* With reference to the same marginalia, Howard Colvin noted that an amateur theologian and future client of Hawksmoor's, Peter King (1669–1734), served as a commissioner and had written *An Enquiry into the Constitution, Discipline, Unity and Worship . . . of the Primitive Church . . .* (London, 1691).[43] Both Colvin and Downes were on the right track, but they only scratched the surface. A detailed examination of the marginalia shows the depth of Hawksmoor's familiarity with writings on primitive Christianity by contemporary divines.

Beginning with the first of the marginalia, lettered A, Hawksmoor specified "The Church East and West." Hickes, remember, had insisted on east-west orientation. As he put it, "One would presume, yt all Christians, who have any veneration for primitive Christian Antiquity and practise should not be indifferent wth respect to the primitive Custome which the writers of the IV century regard among the Apostolical [practices]." The commission had stipulated proper orientation on 21 November 1711. Two days later Smalridge's subcommittee drove home the point by requiring that "Surveyors have each of them a Coppey of the resolution of the Commissioners relating to the plac-

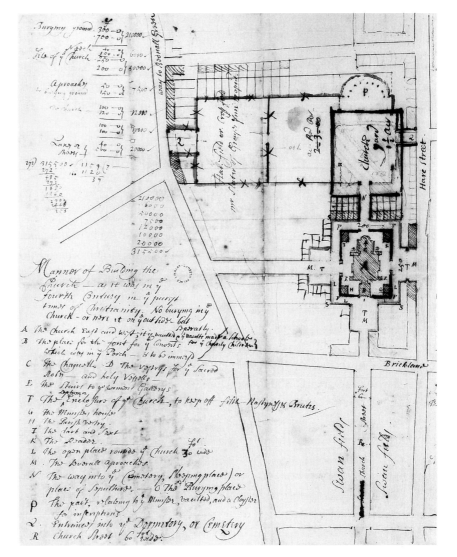

29. Nicholas Hawksmoor, drawing of the plan of "The Basilica after the Primitive Christians" (Lambeth Palace Library, L.P.L., MS 2750/16), detail.

ing the Churches East and West."[44] Hawksmoor went on at B to conflate Hickes's requirements for a separate baptistery and a western font by creating "The place for the font for yᵉ Converts which was in yᵉ Porch—& to be immers'd." Although the provision for the chancel at C omits the several steps required by Hickes and later by the commission, Hawksmoor did follow Hickes in another regard at D. There he located "The vestrys for yᵉ Sacred Robes and holy Vessells." He paraphrased closely Hickes's words "sacerdotal Robes, and holy vessels," later incorporated less literally into the commission's fourth rule. Hawksmoor went on to provide at P a "Cloyster for inscriptions," and at N the entrance to the "Coemetery," using the same words and spellings as Hickes (fig. 29). The marginalia at G, H, and I, respectively, call for a minister's house, a parish vestry building, and a house for the clerk and sexton, just

as Hickes had suggested. At K Hawksmoor placed an additional building for the "Reader," so that he could complete the foursquare symmetry of his enclosure wall at F. Hawksmoor saved his most colorful prose for this "Enclosure of yᵉ Church, to keep off filth—Nastyness & Brutes." There is nothing quite like the pungency of this phrase in all Hickes's observations.[45]

Immediately before the phrase about filth, nastiness, and brutes, Hawksmoor interpolated into his marginalia a term unaccounted for anywhere in the texts of Hickes, Wren, or Vanbrugh. As an afterthought Hawksmoor placed a caret before the word "Enclosure," and above it in a slightly darker ink he wrote the word "Septum," coming from the Latin for enclosed space. Identifying the ultimate origin of the expression necessitates jumping from source to source in a game of literary hopscotch. An informative footnote provides the first clue. Although it appeared in print too late to have influenced Hawksmoor's drawing, it occurs in a now familiar source: Prideaux's *Old and New Testament Connected . . .* (London, 1718). The passage refers to the "sept[um] called the Chel" in the Temple of Jerusalem, "within which no uncircumcised person was to pass." Prideaux aided the detective work by citing his source as chapter 17 of Lightfoot's book on the temple. Lightfoot in turn cited as his ultimate authority a passage from Flavius Josephus's *Jewish War* (bk. 5, chap. 14). Josephus's description of the temple likens the *septum* to a wall, "curiously wrought" according to Lightfoot's translation from the original. Pillars or bollards interspersed along the wall had notices inscribed in Latin and Greek warning all non-Jews not to enter the holy precinct.[46] The architect's use of such a specific term as *septum* needs stressing. It may, of course, simply represent another instance of his love of everything Latin. More likely, in view of its being added slightly later than the rest of the marginalia, its presence suggests that he heard about it from some learned informant who had thumbed through the Latin translation of Josephus from the Greek. A six-letter word such as *septum* can have broad implications. It signifies that the search for an ideal Anglican church extended back to the precedent of the Temple of Jerusalem as well as to writings about the primitive Christians.

Another hitherto unaccounted for marginal note by Hawksmoor concerns the crypt of the church. He wrote that it would be vaulted, and "yᵉ vaults made [into] a School for yᵉ Charity Children." He attached the comment as an afterthought to A in a slightly darker ink. Nowhere do the commissions' minutes or Wren's, Vanbrugh's, or Hickes's proposals mention such a school. But the commissioners themselves almost universally favored free religious education for poor children, which was "the favorite form of practical piety" in London at that period.[47] Francis Atterbury called it "an admirable design."

George Smalridge praised the charity schools in a sermon of 1710 delivered at a gathering of their alumni. He mentioned that the queen herself favored the schools to the extent of founding one at Kensington (designed by Hawksmoor in 1711–12).[48] And as Michael Port has pointed out, two members of Smalridge's subcommittee, the banker Henry Hoare and Edward Jennings, M.P., were trustees of the London Charity Schools.[49] Any one of these people could have impressed on Hawksmoor at the last minute the need to include a charity school in the church destined for Bethnal Green. But by far the greatest public champion of the charity schools was the Reverend White Kennett (1660–1728), a liberal churchman who might be described as enemy number one of the "high flyers" in the Lower House of Convocation. In 1706 Kennett published *The Charity of Schools for Poor Children Recommended . . .*, in which he praised the schools as havens from everything "idle, and ignorant, and vicious."[50] As dean of Peterborough and subsequently as its bishop, Kennett served in the third or 1715 commission. The charity school issue illustrates once again how high church and low church commissioners cooperated in the common cause of building the new churches.

A final item of Hawksmoor marginalia at E eludes any direct connection with Wren, Vanbrugh, Hickes, or the rules of the commission. This is Hawksmoor's provision of projecting towers to each side of the west facade containing "Stairs to yᵉ Womens Gallerys." It is true that Hickes and Wheler had both spoken out at different times in favor of segregation of the sexes. Their predecessor William Cave had similarly stressed the separation of men and women "lest . . . unchaste and irregular appetites should be kindled by a promiscuous interfering with one another."[51] None of them, however, had specified where women should sit in church. Grelot's travel account of Hagia Sophia had mentioned women's galleries upstairs and had used the correct architectural term for them, *gynaikeia*.[52] Hawksmoor may have known and read this book. As previously seen, the Wren library had both the original edition and the English translation. But another source is closer at hand, and Hickes's observations provide the bibliographical reference to it. As with his theological writings reliant on scriptural exegesis, his discussion of architecture summoned up original texts, such as Eusebius, buttressed by secondary sources, such as the one he called "the third vol. of Mr. Bingham's Ecclesiastical Antiquities." In the Reverend Joseph Bingham's *Origines Ecclesiasticae* he found four heavily footnoted pages that document the ancient practice of separating the sexes. (Bingham abandoned the marginalia of past Anglican divines in preference for copious, alphabetically arranged footnotes.) In his turn Bingham cited the patristic writings of Saint Gregory Nazianzen and Paul the Silentiary to prove that in the Eastern church at any rate "men . . . sit below,

and the women in porticoes or galleries above them, on the left side of the church, if not on the right also."[53] As luck would have it, the third volume appeared the very year Hickes needed to refer to it. As I will show, Hawksmoor followed up on his suggestion for further reading.

Joseph Bingham (1668–1723) attended Oxford a little later than Atterbury and Smalridge. A controversial sermon he delivered at Christ Church in 1695 caused Bingham's virtual banishment from the university. Seclusion in a rural parish, with access to the major theological library at Winchester cathedral, enabled him to embark on his greatest life's work, *Origines Ecclesiasticae, or The Antiquities of the Christian Church*. Its ten volumes began to come out in 1708 and ended the year before his death. He dedicated the first volume to his bishop, the Reverend Sir Jonathan Trelawney (1650–1721). Significantly enough, Atterbury acted as intermediary between the dedicator and the dedicatee. A letter of 14 June 1707 from Atterbury to Trelawney, his longtime protector and fellow commissioner, praised Bingham as a "learned person," parts of whose forthcoming book Atterbury had read in manuscript. Not surprisingly, his library contained a printed copy.[54] Bingham also counted Smalridge as a friend.[55] So when his third volume, the one most exclusively concerned with church architecture, came out as if by design in 1711, it found a ready readership and warm reception among the commissioners, their advisers like Hickes, and their surveyor, Nicholas Hawksmoor. A compendium rather than a work of original scholarly research, the *Origines* ushered in a silver age of Anglican ecclesiastical historians on the heels of the golden age of Mead, Lightfoot, Beveridge, Cave, and Wheler.

The *Origines* by Bingham is a kind of summa of early church history. On the one hand it collects the oldest authorities relating to every imaginable aspect of Christian life. On the other hand its discussion extends to the most up-to-date theological scholarship. It adopts a relatively neutral point of view and recounts opposing views with equanimity. Thus in a typical passage it presents the view that the early Christians had no fixed places of worship and then contrasts that view with the scholarly refutation of it contained in Joseph Mead's book *Churches, That Is Appropriate Places for Christian Worship . . .* (London, 1638).[56] Elsewhere it addresses the general practice of strict east-west orientation, noting evidence to the contrary that proves not all early Christian churches could adhere to "precisely . . . one form."[57] Despite the variety, Bingham maintained that the oblong form prevailed. To prove his point, he inserted in his text a copy of the plate engraved the previous century for Schelstrate's *Sacrum Antiochenum concilium . . .* (fig. 30; cf. fig. 14). Bingham's commentary and engraving helped further Hickes's and the commissioners' quest for the architectural equivalent of the Holy Grail.

Starting with the periphery of ancient churches, Bingham's ideas of the various structures around the perimeter were implicitly acknowledged by Hickes and then by Hawksmoor. Obviously they did not always follow him to the letter, and they often went back to the same original sources as he had, but the similarities are nevertheless striking. Take Bingham's discussion of burial grounds, which he defines as "*coemeteria*, dormitories, or sleeping places."[58] Although this information did not appear until his last volume in 1722, Hawksmoor's drawing of "The Basilica after the Primitive Christians" uses virtually the same words at N to refer to "The way into yᵉ Coemetery, Sleep-

30. Joseph Bingham, engraved plans of ideal early Christian churches by various authors after Emanuel Schelstrate's *Sacrum Antiochenum concilium . . .*, from Bingham's *Origines Ecclesiasticae . . .*, 10 vols. (London, 1708–22), plate opposite 3:148.

ing place or place of Sepulture." It is as if both writers had consulted the same standard dictionary entry. Moving inward, the *Origines* (page 232) cited Eusebius on the existence of a περίβολον, or "outward enclosure of the church," just as Beveridge and Wheler had done earlier. Perhaps Bingham's statement that "monsters" and "monstrous sinners" were exiled outside these enclosures inspired Hawksmoor's word "brutes."[59] Or perhaps the architect foresaw the hoardings to keep off thieves from his construction sites. In either event, Peter Ackroyd's 1985 novel *Hawksmoor* cunningly mimics these eighteenth-century sources when its chief protagonist speaks of a church wall "to hinder the Rabble and idle Mobb from getting in and finding ways to do continual Mischief."[60]

Within the outer perimeter wall, the *Origines* locates various buildings for church officials, as did Hickes and Hawksmoor. Refuting Jean-Étienne Durant's *De ritibus ecclesiae . . .* (Leiden, 1595), it establishes the *pastophorium* as a separate structure or structures for the clergy, analogous, it says, to the houses for the priests and Levites around the Temple of Jerusalem. Citing William Cave as its authority, it includes a freestanding baptistery along the lines later suggested by Hickes. Hawksmoor and the commissioners sidestepped the baptistery issue in favor of a font placed in the porch, as recommended by Beveridge and sanctioned by centuries of practice.[61] Baptisteries, according to the *Origines,* had served as places in which "penitents" and "catechumens or first learners of Christianity" congregated. As such, they did double duty as libraries or Sunday schools. The book mentions in this context that the tradition of charity schools went back to the time of the sixth Council of Constantinople.[62] Here again Hawksmoor took inspiration from Bingham, as did the many commissioners favorable to the charity schools movement.

Having dealt with the outlying parts of the primitive Christian church, Bingham focused on the main building. He produced a plan (fig. 31) representing the precinct and church at Tyre, the same one described by Eusebius that had served as the basis for Wheler's two engravings (cf. figs. 16 and 17). As in Wheler's previous book, Bingham shows the static, unimaginative kind of plan one might expect from a scholar rather than an architect: rich in terminology, poor in design. In other respects the designs differ considerably, though Bingham's also contains a western atrium courtyard surrounded with cloisters (numbered 4). Within the narthex it sets apart two areas (numbered 9, 10) identified in a helpful key to the plan as reserved for catechumens, hearers, and penitents. Turning to the eastern end of the church, Bingham singled out the *prothesis* and *diaconicum* as Hickes and Hawksmoor had done, though they had simply called them vestries. Bingham also discussed the origins of the word "chancel," with its railings (numbered 15), and the fact that the apse

should be ascended to. He failed, however, to specify the number of steps up to the altar, or *bema*.[63] In short, he did the commissioners a great service by synthesizing the "massively learned" tomes of seventeenth-century theology devoted to the physical setting of the early church.[64]

Finally, to the right and the left of the central reading desk (numbered 11) Bingham's plan confusingly represents seating for women simultaneously with that for men. The key to the plan, however, elucidates that he intended "upper galleries for women" that would have floated on pillars over the men's heads. He must have imagined an arrangement similar to Wren's galleried interiors, such as Archbishop Tenison's former parish church of Saint James's Piccadilly. For all its ineptness, Bingham's plan certainly improves on Jacques Goar's lop-

31. Joseph Bingham, engraved plan of an ideal early Christian church, from Bingham's *Origines Ecclesiasticae . . .*, 4th ed., 9 vols. (London, 1843–45), plate opposite 3:400.

sided arrangement of the women's section, or "locus mulierum," with its asymmetrical side entrance (fig. 30, bottom left, at Y). Goar's awkward solution bears as little relation to sophisticated Anglican churches as it does to surviving paleo-Christian ones in the Near East, whose symmetry and simple yet elegant lines show the strength of the classical tradition. That this classicism is also reflected in the commissioners' churches demonstrates how they continued the same tradition without being hemmed in by the rules of the commissioners and the recommendations of their advisers.

Considering that theologians' ungainly church plans such as Goar's did not profit Hawksmoor a great deal, what prototypes helped him transcend them? Although his involvement with the City of London churches came relatively late in their construction, he had considerable experience aiding Wren with the many steeples that needed designing. Right at the beginning of their association in 1680, when Hawksmoor was a young man in the office, he would have witnessed nearing completion Wren's most original early steeple: the one for Saint Mary-le-Bow, Cheapside. Some forty years later Hawksmoor drew it in plan, elevation, and section for the engraver Henry Hulsbergh (fig. 32).[65] For the same purpose and at the same time Hawksmoor also drew a perspective of the whole church.[66] Typically, he titled the perspective drawing in Latin "Basilica sive Templum Sant. Mariae ab Arcubus"—the significance of the word "basilica" will become apparent shortly. So there can be no doubt that this particular steeple remained fresh in the younger architect's memory. Indeed, it would be hard for anyone to forget. Two hundred and twenty-five feet of Portland limestone rise above Cheapside in gradual stages, each more intricate than the previous one, culminating in a large metal weather vane in the shape of a dragon. Lower down, atop the belfry level, Wren designed scroll-like buttresses—classical in form yet medieval in feeling—intended to resemble the bows that gave the church its name. All this inventiveness proved an excellent schooling for Hawksmoor when he came to design steeples for the commissioners' churches.

Aside from their steeples, the Wren churches lent themselves poorly to the requirements of the commission. Almost none had enough land around them to be "insulate" or porticoed as the commissioners desired. There were a few exceptions. One would have occupied a freestanding site in the middle of Lincoln's Inn Fields had it been built. Designed during the reign of William and Mary but then abandoned, it resurfaced in discussion briefly during the early days of the commission, only to disappear again.[67] As conceived by Wren, it had a square plan seventy-five feet on a side, divided internally into a perfect Greek cross. Pairs of coupled columns screened the four arms from the central crossing. Spiral staircases and vestries would have occupied the resid-

32. Nicholas Hawksmoor, engraved plans, elevation, and section of the steeple of Saint Mary-le-Bow, London, from *A Catalogue of the Churches of the City of London ...* (London, 1749?), pl. 14.

ual four corners, topped with lead helms that recall Wren schemes for the courtyard of Hampton Court Palace. The central hemispherical dome with a spire on top resembled early designs for the cupola of Saint Paul's Cathedral. The previously discussed church of Saint James's Piccadilly, cited by Wren in his recommendations, is another exception by virtue of its large site outside the walls of the cramped City. Similarly extramural and not hemmed in, Saint Clement's Danes sits isolated in the middle of the Strand. A plan (fig. 33, top

half) shows the church nearly as executed from 1679 to 1685. It comes from among the Wren drawings in the Bute collection acquired at auction by Tweet Kimball in 1951. Red ink outlines indicating the angular medieval walls of the previous church contrast with the curving walls and apse of its successor, colored with gray wash. Such a design might well have influenced the thinking of the commissioners and of Hawksmoor in 1711.[68]

When the Bute collection of Wren drawings went on sale in 1951 after their rediscovery, Mrs. Kimball acquired fourteen sheets. They stayed in her possession and constitute the largest group of Wren material outside England.[69] Soon after she bought them she had them arranged and framed ac-

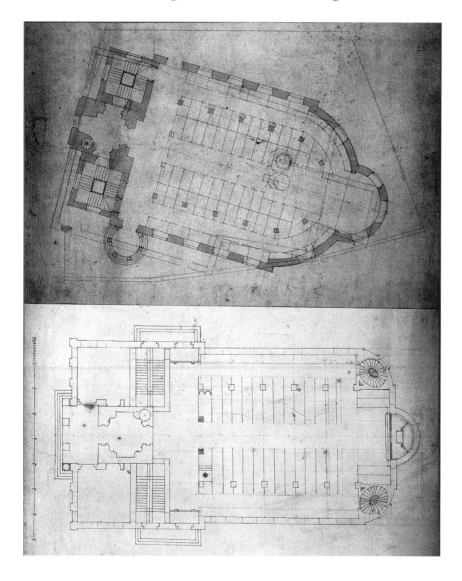

33. Office of Christopher Wren, drawings of the plan of Saint Clement's Danes, London (top half), and of an unidentified church (bottom half) (Cherokee Ranch and Castle Foundation, Sedalia, Colorado).

cording to the identification provided in the sale catalog. Thus she had the plan of Saint Clement's just discussed framed together with another plan identified by the auction house as an early design for the same church (fig. 33, bottom half). The measurements of the two buildings depicted do correspond quite closely, as do the insular locations permitting entrance from the sides as well as the front. In many other respects, however, the interior dispositions of the two differ. The second one, whether or not it really represents Saint Clement's, includes features that follow many of the eleven rules set down by the commission in 1712. Starting from the west and moving eastward, the second church plan has a portico and the base of a tower nestled between two large rooms with fireplaces, probably intended as vestries. Beyond, in the nave of the church, the anonymous draftsman has somewhat crudely indicated the position of a churchwardens' pew of some sort to the north and directly across the central aisle a font with steps leading up to it, perhaps to make baptism by immersion easier. Farther ahead two oval rooms occupy the dramatic curving eastern end. (Notice that at a later date a more traditional flat end has been lightly sketched in pencil.) The spokelike pattern within the oval rooms is conventionally used in drafting to represent the treads of a spiral staircase, but it might conceivably represent a floor or ceiling pattern, in which case these spaces could correspond to the *prothesis* and *diaconicum* of early Christian churches as depicted by Bingham. Even more compelling evidence exists in the central apse. Two steps lead up to it, in keeping with the commission's dictates, and a balustraded railing separates the altar area from the rest of the interior. Clearly this plan, in a way similar to William Beveridge's Saint Peter's Cornhill, anticipates a number of the commissioners' concerns with liturgical arrangements (chapter 1).

Speaking of Saint Peter's, its steeple closely resembles the one on the most ambitious, most finished, and largest of the fourteen drawings in the Kimball collection (fig. 34). It has traditionally been identified as a preliminary design for Saint Clement's because the projections and recessions of its facade, its width, its scale of one and a half inches to ten feet, and even its watermark all correspond with the second of the plans just discussed (cf. fig. 33, bottom half). But the draftsmanship of this west facade elevation is entirely different and more assured—so much so that I tend to agree with the proposal recently put forward by Anthony Geraghty. His unpublished 1999 Cambridge University doctoral disertation, "New Light on the Wren City Churches," attributes the plan to an unidentified hand in the Wren office and the elevation to Robert Hooke. Whether or not Hooke definitively drew it, Hawksmoor certainly knew and copied it, or something very like it. Although he slightly increased its central temple front from tetrastyle to hexastyle and raised it on a higher

podium, he nevertheless used its lowest level as the basis for an amazing commissioners' church design with an upper steeple in the form of the Mausoleum at Halicarnassus (fig. 35, and cf. fig. 2). As Kerry Downes succinctly put it: "His delight in putting objects on pedestals here reached its peak."[70] What better proof than this drawing could there be of Hawksmoor's unfailing debt to his early training with Wren and their joint fascination with the Seven Wonders of the World?

Hawksmoor's pseudo-Halicarnassus church design bears the marks of his mature draftsmanship such as strong cross-hatching and sprightly freehand rooftop figures, urns, tiny dormers up the pyramid's sides, and atop it the quadriga that Pliny the Elder had described. The drawing repays close inspection, because some of its subtleties do not reproduce clearly in a photo-

34. *Below, left:* Attributed to Robert Hooke, elevation drawing of an unidentified church corresponding to the bottom half of figure 33 (Cherokee Ranch and Castle Foundation, Sedalia, Colorado).

35. *Below:* Nicholas Hawksmoor, preliminary elevation drawing for Saint George's Bloomsbury (AS, vol. 4, item 62; Warden and Fellows of All Souls College, Oxford).

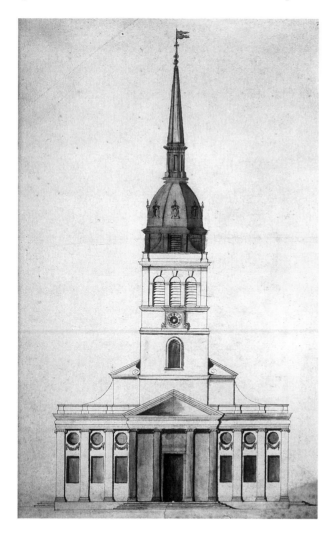

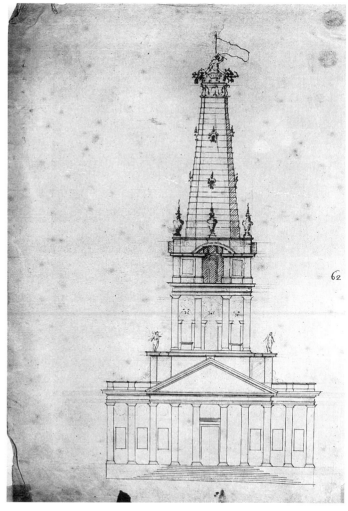

graph. To begin with, the verso bears an old inscription attributing it to the architect. A row of bull's-eye windows on the lower facade, hard to make out, derives directly from those in the earlier elevation without the decorative garlands underneath. Barely perceptible sketches in pencil indicate an alternative treatment to either side of the attic above the main pediment and a slightly higher positioning of the quadriga.[71] Furthermore, underneath the forceful strokes of pen and ink delineating the stepped pyramid, faint pencil lines depict an altogether different solution for the final stage of the steeple in the form of a tapering spire. The drawing could have been a study for the facade of Christ Church Spitalfields with its characteristic spire (plate 8), later transformed into a study for Saint George's Bloomsbury with its equally characteristic stepped pyramid (plate 12). The main point to remember is that this study for a commissioners' church looked to the past in two ways. First, its main superstructure rose on the firm foundations laid down by Wren in the previous century, modified according to the commission's specifications. Second, in the composition of its steeple, the principle of imaginary restitution encouraged greater experimentation. Hawksmoor's designing was conceptually as well as literally two-tiered, a fact borne out by the first of his executed churches.

Queen Anne died on 1 August 1714. The collapse of the Tory ministry of Robert Harley, the pro–high church earl of Oxford, drew nigh.

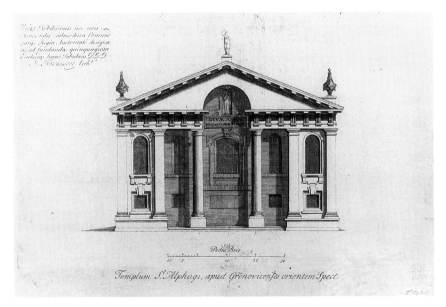

36. Nicholas Hawksmoor, engraved east elevation of Saint Alphege's Greenwich, 1714.

Sometime in the seven months preceding the sovereign's death a pair of engravings appeared celebrating Nicholas Hawksmoor's designs for Saint Alphege's Greenwich. One engraving depicts a statue of the queen above the central window in the east elevation (fig. 36). In a flowery Latin inscription Hawksmoor dedicated this engraving of the "Templum St. Alphagi" to the commission for building fifty new churches.

Despite the commission's slow process of deliberation, as already seen, the construction of Saint Alphege's pressed ahead with all possible speed, as if in anticipation of an unfavorable turn of events on the political scene. The only delay involved Hawksmoor's improving his designs according to suggestions made by Thomas Archer, the commissioner-architect.[72] No new site needed

purchasing, so building started right away in 1712. First the roofless old church was demolished. It had faced east toward Wren and Hawksmoor's incomplete royal hospital, and the western side with the tower had faced away from the center of town. For greater accessibility the new church should logically have been oriented the same way around, which the commission regarded as the wrong way around liturgically. Its first church clearly could not contravene its often-repeated regulation about proper east-west orientation. Hawksmoor solved the problem by turning the east facade into an unusually magnificent auxiliary entrance. As befitted the side of the church facing the royal hospital, he created an eye-catching, appropriately regal three-part Serliana opening with doorways tucked in at either side out of sight. At the best of times late-comers entering through these doorways behind the high altar would have disturbed services far worse than the noisy box pews Hickes complained about. The peculiar facade arrangement adopted at Saint Alphege's shows the lengths to which the commissioners pushed Hawksmoor in the direction of reviving early Christian practices.

The second of the Saint Alphege's engravings, a plan and north elevation, bears the date 1714 (fig. 37). Its title, "Basilica Grenoviciana," recalls two similar instances in which Hawksmoor used the word "basilica": once to describe his plan "after the Primitive Christians," and once to describe his perspective drawing of Saint Mary-le-Bow, previously mentioned. This repetition of the term may have as its source Bingham's *Origines Ecclesiasticae*. Bingham began

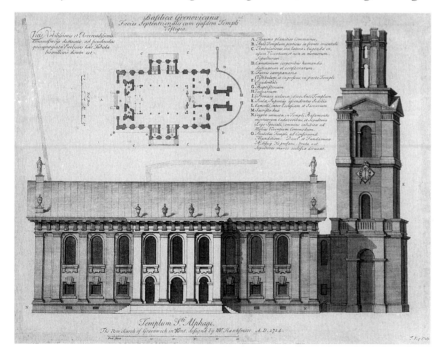

37. Nicholas Hawksmoor, engraved plan and north elevation of Saint Alphege's Greenwich, 1714.

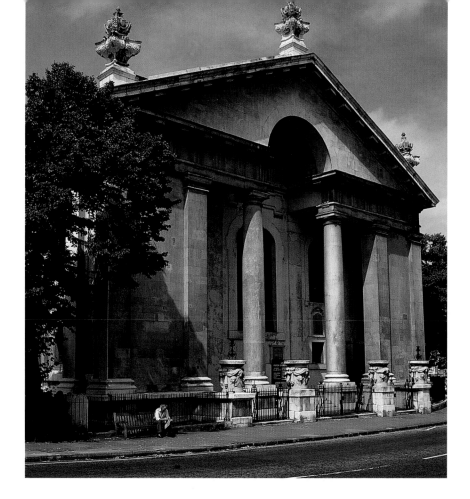

Plate 1. Saint Alphege's Greenwich, east facade.

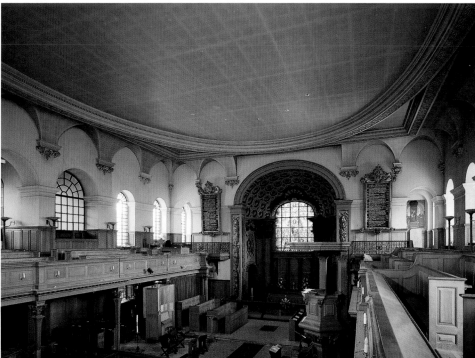

Plate 2. Saint Alphege's Greenwich, interior looking from the gallery toward the east. Photograph by Angelo Hornak.

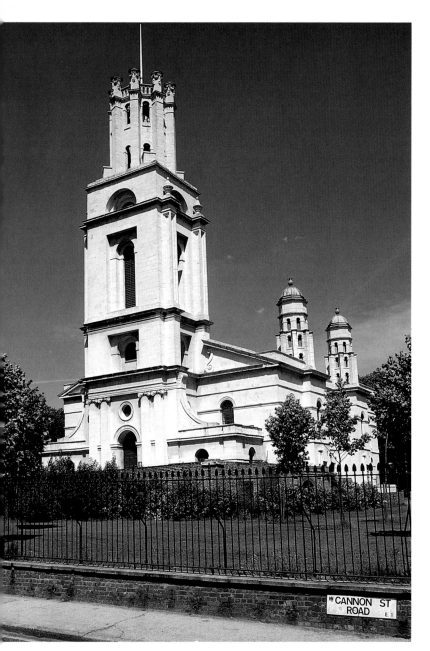

Plate 3. Saint George's-in-the-East, west and south facades.

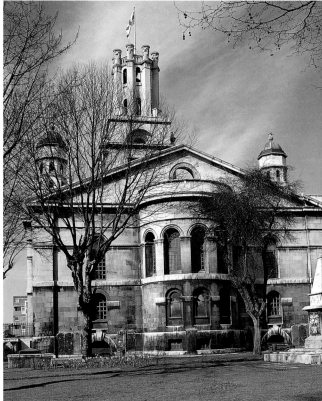

Plate 4. Saint George's-in-the-East, east facade.

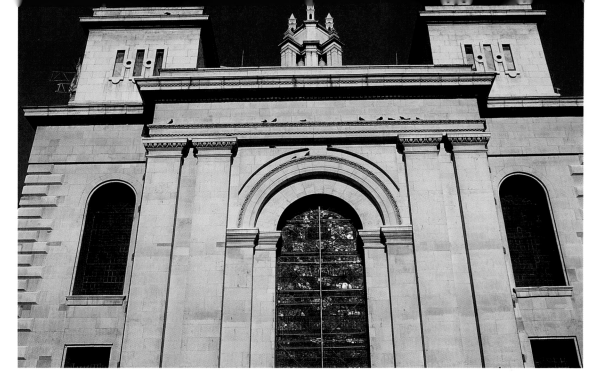

Plate 5. Saint Anne's Limehouse, east facade.

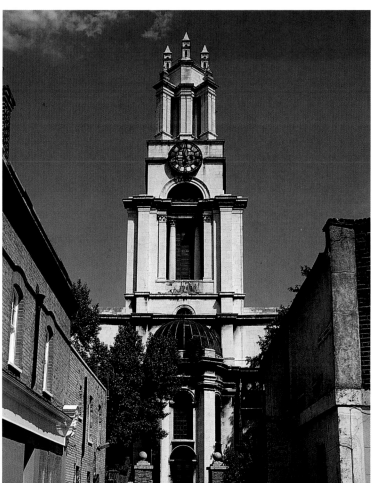

Plate 6. Saint Anne's Limehouse, west facade.

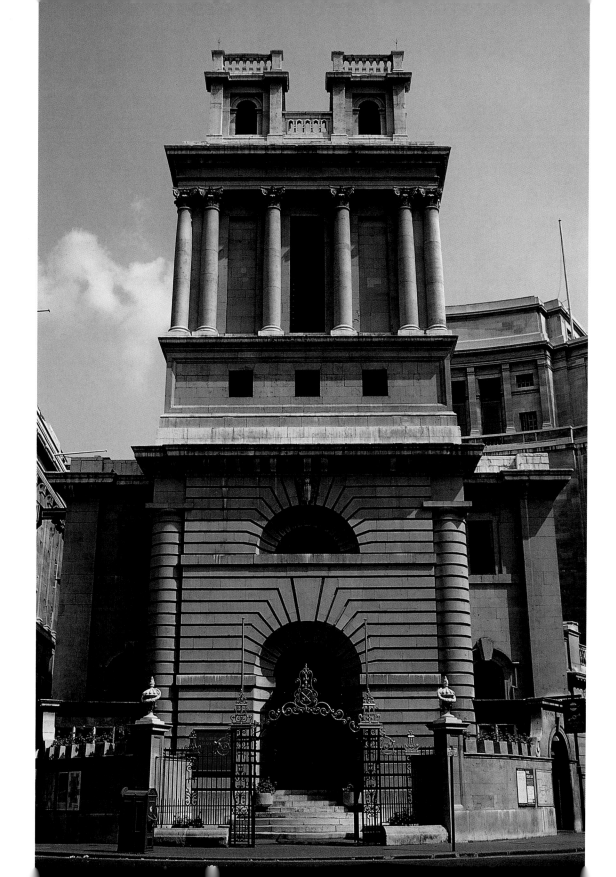

Plate 9. *Opposite:* Saint Mary's Woolnoth, west facade.

Plate 10. *Above:* Saint Mary's Woolnoth, detail of west facade rustication.

Plate 11. Saint George's Bloomsbury, south portico.

Plate 12. Saint George's Bloomsbury, steeple.

book 8 with a section discussing the various terms by which early Christians had described their churches. He pointed out that such words as "ecclesia," "temple," and "basilica" had for a long time been synonymous with "church" in its broadest sense.[73] This generic use of "basilica," of course, explains what Hawksmoor really meant by titling his drawing a "Basilica after the Primitive Christians." He referred not to a Roman basilican plan type, as some recent architectural historians have assumed, but to a church in general.[74] Thus Bingham's writings resolve an apparent contradiction between the nonbasilican plan type Hawksmoor depicted and the word by which he described it. Other terms familiar from Bingham and Hickes also recur in the text of the Latin legend to the right of Hawksmoor's plan, such as *coemeterium, baptisterium,* and *cancelli.* There would be two sacristies behind the high altar and a separate vestry room at H across from the baptistery at the west end. Sets of stairs on the north and south, at K, would lead to upper-level seating. No mention is made of Hawksmoor's earlier provision for separate women's galleries, which must have struck everyone as too extreme a departure from accepted tradition. But the last entry on the legend has a familiar ring. It refers to the enclosure at the east end as a "peribolus templi . . . ne profani, bruta aut sepultores muros ecclesia diruant," which simply translates into politer church Latin Hawksmoor's pungent phrase about "filth—Nastyness & Brutes." Obviously Hawksmoor had not forgotten "The Basilica after the Primitive Christians." On the contrary, the drawing had continual relevance to the commissioners' churches as built and, as I will show, provides a key to understanding the architect's meaning behind them.

It is worth noting that certain elements in Hawksmoor's Saint Alphege's, such as the western tower, the enclosure wall, and the interior arrangement, recur in his later churches for the commissioners and elsewhere in his work. The western tower, for example, was never executed to the design shown in the engraving but was built to another provided in 1730 by John James. In the end the medieval tower was salvaged and cased in new masonry. Perhaps this scheme to retain the tower explains why Hawksmoor appears at first sight to have crenellated the topmost lantern section. Closer inspection of the engraving, however, shows that the projecting piers of the lantern stage have distinct capitals. And the crenellations they support have a triple grooved surface, analogous to the triglyph blocks on the Doric entablature around the church but transported into midair. Hawksmoor cunningly united his new church with the old tower by creating the pseudomedieval effect of the tower using purely classical elements. Prevented from carrying out his intentions at Greenwich, he revived the tower solution in modified form a couple of years later at Wapping (see chapter 3) and about the same time at All Souls College, Oxford. The

central detail of a prodigious twenty-foot-long drawing of the college, datable to early 1715 (fig. 38), shows the Saint Alphege's lantern reused in a pair of towers over the fellows' common room facing west toward Catte Street across the north quadrangle.[75] Slight differences between the treatment of the college and that of the church are significant. The battlements atop the college have proper pointed arches carved on them, not triple grooves like the triglyph blocks on the church. Such subtle variations as these indicate that Hawksmoor sought to evoke at Saint Alphege's an architectural halfway point between the classical and the Gothic.

As finally completed in 1719, the east facade of the church (plate 1) differed somewhat from the engraved design by omitting the outer windows intended to light the two entry vestibules from that side. Another apparently insignificant alteration relates to the perimeter wall, or "peribolus" as Hawksmoor called it. The engraving by Kip faintly indicates at O a railing along the north facade and part of the east facade. In reality the railing stretches all across the east end and is punctuated by four very large circular objects resting on pedestals that jut out from the base of the Serliana opening. These cylinders function like bollards, commonly used to mark off public spaces, such as the adjacent Greenwich marketplace or the *septum* at the Temple of Jerusalem as mentioned by Josephus. But no normal bollard ever looked quite like this! Hawksmoor's are four feet tall and all Portland limestone. They are carved with swags of drapery and the heads and wings of putti (fig. 39). As such they intentionally recall ancient sacrificial altars.[76] If the metal lamp standards still sitting on two of them formed part of the original scheme, that would only have contributed to the image of smoke issuing from burnt offerings. What on earth are sacrificial altars—"altars defiled with impure burnt sacrifices," as Eusebius called them—doing here outside a commissioners' church?[77]

Once again Bingham's third volume of the *Origines Ecclesiasticae* supplies a possible answer. In the section immediately preceding the crucial one in which he included his two foldout plates (figs. 30 and 31), he wrote about the conversion of pagan temples into Christian churches. He started by discussing Emperor Constantine and his successors. Then, turning his attention northward to "temples here among the Saxons," Bingham discussed the situation in

38. Nicholas Hawksmoor, preliminary elevation drawing for the north quadrangle, All Souls College, Oxford, detail (The Bodleian Library, University of Oxford, MS Gough Plans 7).

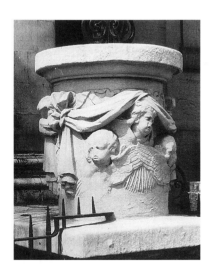

39. Saint Alphege's Greenwich, detail of an altar/bollard on the east facade (© Crown copyright. NMR).

Britain: "If they were well built they should not be destroyed, but only be converted from the worship of devils to the service of the true God. . . . Sometimes the temples were pulled down, and the materials were given to the church, out of which new edifices were erected."[78] The noted Anglo-Saxon scholar Hickes would no doubt have applauded this instance of Bingham's wide-ranging erudition. If Hawksmoor followed Hickes's recommendation and also read Bingham, that would explain how the architect seized upon the special portent of this passage for Saint Alphege's. As the commissioners had no doubt impressed on him, Saint Alphege was a Saxon archbishop of Canterbury martyred at Greenwich in 1012. Hawksmoor simply put the two pieces of the equation together. His sacrificial altars surely represent fragments of some dismantled Romano-British temple as described by Bingham, reused by Saxons to create a Christian church of their own. In the "Basilica Grenoviciana," therefore, Hawksmoor took the decisive step from imaginary restitution to imaginative reconstruction.

Saint Alphege's remained relatively unscathed until the Second World War, when a bombing raid severely damaged it. Reopened in 1953, it was sensitively restored by Sir Albert Richardson, who tried to respect the original character of the interior as much as possible.[79] As it stands today in the heart of Greenwich, it preserves the commissioners' typical internal arrangement better than the rest of Hawksmoor's churches (plate 2). Galleries to each side and at the west end hover above the floor of the nave as in many a Wren church, but in a lighter, more effortless fashion. Light pours in unobstructed from all sides, drawing attention to the vast expanse of ceiling, a remarkable feature in all Hawksmoor churches. In this case an oval frame in molded plaster rests on a series of corbels carrying shallow arches along the walls. Originally a plaster rosette ornamented the center of the surface and subtly emphasized it—a task now performed by a recently added brass chandelier. The arrangement of the pews once accentuated the centrality in a similar way. An aisle running between the majestic north and south entrance lobbies across the pews and another down the middle from east to west intersected at right angles to form a cross directly under the ceiling rosette. The pulpit and lectern did not stand where they do at present but balanced each other at each side of the chancel arch. Steps and railings separate the nave from the chancel, illusionistically painted by James Thornhill to appear deeper than it is. To its right and left a wrought iron musicians' gallery overhangs the space. Grinling Gibbons carved much of the woodwork, including the reredos, as he had done at Wren's Saint James's. In a number of other respects the church looks back to that sumptuously furnished one on Piccadilly, but at the same time its simplicity creates a greater feeling of spaciousness. Saint Alphege's has an unde-

niably regal quality about it, a quality accentuated by the addition of musicians'
galleries, ideal for sounding a trumpet voluntary. To a man the commissioners
must have been justifiably proud—Francis Atterbury above all the rest.

At the inception of the fifty churches project in 1711, Atterbury addressed
to Queen Anne a "Representation of the State of Religion." He optimistically
remarked, "God be thanked . . . great sums of money were by public authority
provided, and applied for the building, supporting, and adorning of churches:
and we cannot but hope but this glorious work . . . will be speedily accom-
plished."[80] In many ways Atterbury hoped in vain. Even the completion of
Saint Alphege's, the vanguard church of the commission, dragged on for years.
Yet Atterbury himself tasted the fruits of his efforts for one sweet moment be-
fore his banishment. As bishop of Rochester since 1713, the church of Saint
Alphege's happened to fall within his diocese. On 29 September 1719 he there-
fore presided over its consecration. An eyewitness account describes the cere-
mony as more worthy of a "cathedral" than a parish church.[81] The bishop took
the service himself, baptized two children, and as dean of Westminster Abbey
had his choristers sing the anthem just to reinforce the high church pomp. Al-
though he was not Saint Alphege's architect, he certainly masterminded the
legislation that led to its building. It and the other commissioners' churches
remain the most enduring and endearing monument to his role as ace among
the "high flying" Anglican divines.

HAWKSMOOR'S ASPIRING STEEPLES

"Yea, there be men, who will . . . establish a sect . . . and yet, toward making of the tabernacle, will not offer a shekel to the work."[1] This chapter, like the previous one, begins with a quotation from a sermon. The preacher this time, however, was the Reverend Thomas Bisse (d. 1731), not Thomas Tenison the future archbishop of Canterbury. Nor did the sermon take place near London's fashionable Piccadilly; it was given at Saint Mary's in Southampton on Christmas Day 1711. Published the next year as *The Merit and Usefulness of Building Churches,* the sermon had a timely title in view of events taking place in the capital at that moment—events the author had obviously heard all about. He was well placed to do so because his elder brother was the Right Reverend Philip Bisse (1667–1721), bishop of Saint David's and of Hereford, soon to be nominated a member of the second, or 1712, commission for building fifty new churches. Despite the passage of twenty years, various lengthy sections from the sermons of Bisse and Tenison read almost as if written by the same person. Both rail against "schismatics" and argue that a proliferation of Anglican churches, built with the "beauty of holiness" according to Bisse, would turn back the tide of Dissenters.

Bisse's reliance on the Old Testament extended beyond biblical-sounding turns of phrase to concrete Solomonic temple imagery. He likened the mercy seat of the "supreme of architects" to the enlarged chancel at Saint Mary's, an allusion that would have been approved by the Hebraist John Lightfoot, not to mention Archbishop Laud, had they been alive. Bisse made an indirect allusion to Queen Anne when speaking of Solomon's father, King David, "by whose bounty so great a fund was given [for] the building of churches."[2] This then led Bisse to the climactic second section of the sermon on the theme "grandeur and welfare of a nation." He stated that the "memory of some nations . . . is preserved by the fame of their temples." According to him Saint Paul's Cathedral resembled Solomon's Temple "on Mount Zion overlooking the towers and walls of Jerusalem." To drive home the comparison he concluded: "But as if that august palace for the Lord God has been but a small

thing, it is succeeded by a late unparalleled instance of public zeal, shown . . . by a national senate which by a decree worthy of themselves, have ordained the erection of fifty churches. They have with a generous piety resembling David's . . . established a fund answerable to the design."[3] Bisse's vision of London as the new Holy City anticipated by almost a century the poet William Blake's famous lines:

> I will not cease from mental fight,
> Nor shall the sword sleep in my hand,
> Till we have built Jerusalem
> In England's green and pleasant land.

News of the commission's activities had spread quickly from London. In fact Bisse gave his sermon the day after the first commissioners submitted their initial fact-finding report. Despite the still fluid state of the deliberations Bisse, and many others no doubt, already had a clear picture of London as the New Jerusalem with its "towers and walls." They based their idea on the existing London skyline of 1711, bristling with fifty or more towers and church steeples, many of them, such as Saint Mary-le-Bow's (fig. 32), executed during the time when Hawksmoor worked closely with Wren. To that number the commission would add another twelve, for the most part in the nearby suburbs, but some as far east as Greenwich and Deptford, of which half are securely documented as wholly designed by Hawksmoor. With their massive bulk, soaring height, and idiosyncratic form, the six make an unmistakable impression up both banks of the Thames. Those visible from the river because of their all-white limestone steeples stand out especially. Perhaps, as the poet Iain Sinclair has suggested, Hawksmoor conceived of them as an interrelated group; certainly they ring changes on the theme of primitive Christian purity that he first experimented with at Saint Alphege's.[4] Indeed, right from the beginning there had never been any question about the important role lofty steeples would play as belfries and as landmarks. It was a role enshrined in the act of Parliament that specified "fifty new churches of stone, and other proper materials, with towers or steeples to each of them."[5] With respect to the steeples, one of the most significant alterations to the rules for churches laid down by Smalridge's building subcommittee occurred when the full body of commissioners adopted them on 16 July 1712. To the subcommittee's opening paragraph, reading "That one General Modell be made and Agreed upon for all the fifty New intended Churches," were added the words "The Steeples or Towers excepted" (appendix 4). In this way the commissioners clarified that the tower of the model church they had in mind must needs vary from parish to parish so that each would present a distinctive silhouette against the sky according to the precedent of Wren.

As I indicated previously, Hawksmoor had been given until Christmas 1712 to come up with an ideal "Modell," "Design or Forme." But that had not stopped the commencement of Saint Alphege's. Starting the work at Greenwich effectively precluded any real possibility of a prototypical church along the lines Hawksmoor had sketched earlier (fig. 28). The building subcommittee forced Hawksmoor's hand that August by requiring him to hasten completion of the wooden model, to produce contract drawings based on it, and to submit an estimate for the whole new building.[6] Presumably all this excluded the cost of the unresolved tower. As early as August 1712, when the overall dimensions of Saint Alphege's were firmly established, the only portico mentioned was at the east end, not at the west. As late as 1718, with the work on the church drawing to a close, the question of repairing the old western tower still remained undecided, and it continued to be so for another decade.[7] Between those dates of 1712 and 1718, of course, Hawksmoor's print of the side elevation of the church had appeared (fig. 37), complete with his design for the west end. The blocky plan and lower elevations of the western tower, however, indicate that Hawksmoor intended to reface the medieval structure. Set back from the rest of the north facade, partly hidden amid the engraving's cast shadows, it retires from view, except for its already discussed lantern. It was never built by Hawksmoor, but the architect returned to his rejected tower design and combined it with elements from the "basilica" intended for Bethnal Green when plans for another church came into the offing. Resourceful architects rarely let good ideas go to waste, realizing that they come at a premium.

In midsummer 1714, after the rejection of the Bethnal Green site, the commissioners approved construction farther to the south at Spitalfields, Wapping, and Limehouse—three new Hawksmoor churches they created within the old Saint Dunstan's parish in the Stepney district. Not only did Hawksmoor reuse earlier ideas, he reutilized his sheets of drawings time and again to conserve the costly handmade paper. They preserve a record of his creative process far better than the commission's minutes, increasingly preoccupied with contracts and with matters of construction rather than design. Take, for example, a Hawksmoor ground plan and cross section related to the church of Saint George's-in-the-East at Wapping (fig. 40). The plan, with its four corner towers leading to galleries, immediately recalls the Bethnal Green scheme (cf. fig. 28). And the provision of the charity school among the marginalia on that earlier sketch is echoed in the legend on the left of the later plan at the place marked H. But nothing corresponds to H on the plan. This is because Hawksmoor covered over that letter when, to decrease the projection of the western tower, he pasted over the original drawing a small rectangular piece of paper, which shows up slightly darker in the photograph. Signifi-

cantly, most of the architect's changes affect the tower base and the roofing—the upper parts of his churches always fascinated him the most. In a similar change of design, the cross section farther to the left depicts a dome over the nave, and the first of the inscriptions all the way over on the right confirms the intention to cover the center with what it calls a "hemisphere." A smudgy circular shape hatched in pencil does occupy the center of the plan, but Hawksmoor drew over it in darker sepia ink the X-shaped indication of a groin vault, like the one actually built inside Saint George's.

In many respects Hawksmoor simply modified the interior arrangement of Saint Alphege's (plate 2) when he carried into execution the plan of Saint George's as amended in his drawing. He established a similar central point under the middle of the ceiling, but this time instead of erecting a flat oval frame he chose a groin vault. He proposed supporting it either on four columns or on four square piers, shown in darker sepia ink on the drawing. These were obviously still in flux at the time of the amendments to the drawing, but they finally took the form of enriched though unfluted Doric shafts, rising from pedestals and supporting the north, south, and west galleries.

40. Nicholas Hawksmoor, drawing of a preliminary plan and partial cross section of the roof for Saint George's-in-the-East (BL, King's Maps, K. Top. XXIII–21-2–a; by permission of the British Library).

Parishioners living to the north or south of the church had ready access to these galleries from the four separate spiral staircases, clearly shown by Hawksmoor. Unlike Saint Alphege's, the only other entrance was from the west, because a large semicircular apse occupied the east-facing interior wall of Saint George's. The drawing does not clearly indicate the arrangement at the chancel end, but archival photographs of the interior before its destruction during World War II show the requisite number of three steps and an altar rail. It must have provided an even more majestic spatial experience than the slightly earlier Saint Alphege's.

The plan and cross section of Saint George's just considered is only one of sixteen related sheets drawn, redrawn, and inscribed all over. It can be dated to after 17 June 1714 when, in the interests of "Diminution of Schism," the commissioners decided to proceed with construction of a church at Wapping.[8] They finally accepted Hawksmoor's design six weeks later, three days before the death of Queen Anne.[9] Construction dragged on and on, hampered to some extent by the theft of building materials and harm done "by the Mob to ye Building." (Fear of damage or loss prompted enclosure walls and temporary hoardings around the commissioners' churches at least as much as the example of the primitive Christian περίβολον.) Although the church was more or less complete by 1725, its consecration did not take place until 19 July 1729, slightly earlier than the two other Stepney churches whose construction had also begun in 1714.[10] The site chosen lay to the north of the street called the Ratcliff Highway, near its intersection with Cannon Street (plate 3). Especially since the Blitz leveled the adjacent houses to the west and south, it enjoys the finest situation of the entire twelve churches. Although it always rose above its low-lying surroundings like a tall white lily growing among weeds, its gleaming Portland limestone now dominates the neighborhood as never before; the four gallery entrances and the western one beckon parishioners to approach by whatever route they find shortest.

The only securely dated drawing related to Saint George's is the elevation inscribed "The West Front of Waping Stepney Aug.st 1714" (fig. 41). It is a messy but wonderfully vigorous example of Hawksmoor's draftsmanship, with plenty of the bold hatching and cavernous areas of shading so characteristic of him. The levels below the main cornice line resemble the west facade pretty well as erected except for the staircase arrangement, which changed several times in the course of the designing and has been altered in more recent times (fig. 42). The higher up the drawing the eye travels, the more drastic are the departures from the existing structure. Even within the drawing, differences occur between the pedimented left hand side resembling the executed solution and that on the right, with its curling volute, stepped pyramid roof, and

41. *Left:* Nicholas Hawksmoor, preliminary elevation drawing for the west facade of Saint George's-in-the-East, August 1714 (BL, King's Maps, K. Top. XXIII–21-2–h; by permission of the British Library).

42. *Below, left:* Saint George's-in-the-East, engraving of west elevation, from John Britton and Augustus Pugin's *Illustrations of the Public Buildings of London*, 2 vols. (London, 1825–28), plate opposite 2:98.

43. *Below:* Nicholas Hawksmoor, preliminary elevation drawing for the west facade of Saint George's-in-the-East (BL, King's Maps, K. Top. XXIII–21-2–k; by permission of the British Library).

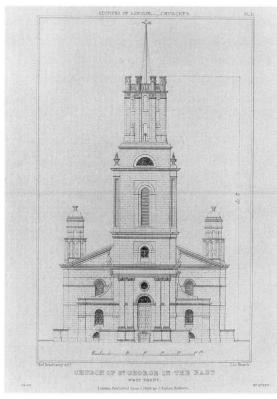

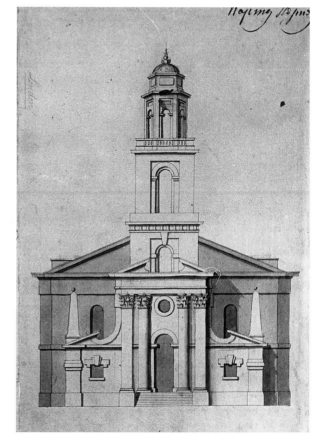

turret in the shape of what Kerry Downes calls a "pepper pot." The central western tower looks somewhat squat in proportion to the facade as depicted, and it is so faintly penciled in that it appears as if enveloped in mist rising from the nearby Thames.

Fortunately a preparatory drawing in ink and gray wash records the same tower design much more distinctly (fig. 43). It comes slightly earlier in the design process, judging from its narrower width when compared with the church as built and the elevation dated in August. This narrower version of the west facade has rather heavy rectangular windows and a column to either side of the entrance door, which are superseded by flat pilasters and a more harmonious solution of repeated arched openings in the outer bays of the slightly later drawing. The lower stage of the tower has an accentuated keystone over the central arch—a leitmotif Hawksmoor returned to with great effect on the side elevations. The belfry level is fairly plain, and the octagonal lantern stage supports a domed top. Already in these two relatively preliminary drawings Hawksmoor seems to be mustering his design forces level by level for the final assault, at least three years later, on the tower itself.

Turning to the south facade, Hawksmoor produced a line drawing of the elevation, contemporary with the dated one for the west facade (fig. 44). It has the same combination of a lunette opening surmounted by a round-headed window in the area of the west tower. It too shows the tower penciled in, and in agreement with the early plan before its modification (cf. fig. 40), the whole penciled composition stands farther to the west. Using ink, Hawksmoor sub-

44. Nicholas Hawksmoor, preliminary elevation drawing for the south facade of Saint George's-in-the-East (BL, King's Maps, K. Top. XXIII–21-2–i; by permission of the British Library).

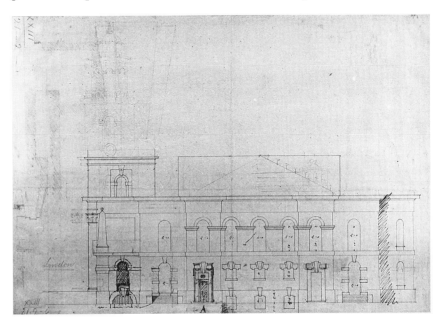

sequently redrew the corner facade pilaster and the base of the tower in their definitive position six feet back to the right, or east. In a similar juxtaposition of alternative solutions, he drew in ink the outline of a normal pitched roof over the nave, and in pencil beside it he lightly sketched the somewhat bizarre effect a pyramidal roof and adjacent stair turret would produce. Down below at A Hawksmoor developed his ideas for the side entrances that he had sketched in a barely discernible form on the far left hand side of the same sheet. On the verso in an ink over graphite elevation corresponding to A, he went into even greater detail with the door frames, showing them in their final form with exaggerated keystones. He drew this "Dore into one of the Turrets" directly over an early pencil version of the narrower ground plan. Therefore the recto and verso represent successive phases of the designer's thinking all jumbled together on one sheet. It charts the way his imagination roamed up and down the elevations and back and forth over the different planning possibilities. All these amendments simply underscore the fluidity of his whole approach to the design process.

Obviously, at this point Hawksmoor had not fully resolved the upper part of his elevations. He therefore proceeded to draw another south elevation in many respects identical with the previous one, at least in the lower level's simple combination of arched windows with rectangular ones and doors characterized by the heavy keystone motif (fig. 45). Notice, however, that the eastern apse has acquired a sequence of arched upper windows all in a row and is therefore one step closer to the church as completed. Directly above the center of his elevation Hawksmoor pasted a movable flap of paper, presumably well before the end of the 1716 building campaign when the upper walls were ready to receive the roofing.[11] With the flap raised the elevation reveals the low pepper pot turrets flanking a stepped pyramid of the type that Hawksmoor used elsewhere more successfully (cf. figs. 35, 46). With the flap lowered into position he could judge the replacement of the pepper pots with much taller crenellated turrets, close in height to those actually executed. As far as can be deciphered from the faint penciling, the form he now proposed greatly resembled the rejected lantern design for Saint Alphege's. This drawing, like the others for Saint George's, has an experimental quality that bears out the insight of the twentieth-century architect James Stirling (1926–92), who once remarked admiringly on Hawksmoor's "ad hoc technique."[12]

The view of Saint George's from the east (plate 4) shows that the pepper pots in their final form amalgamate elements from each of the alternatives discussed. They incorporate piers all around and are lit by tiered openings, just as originally proposed for the church at Greenwich. But on top of them sits the familiar domical cupola from the earlier Saint George's projects instead of the

45. Nicholas Hawksmoor, preliminary elevation drawing for the south facade of Saint George's-in-the-East, with the movable flap lowered (BL, King's Maps, K. Top. XXIII–21-2–e; by permission of the British Library).

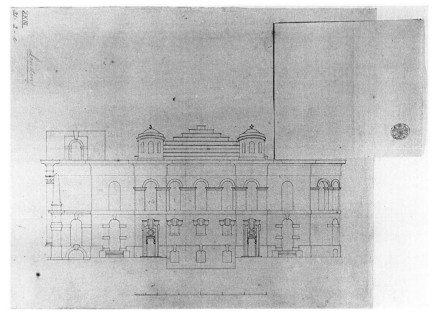

46. Nicholas Hawksmoor, preliminary elevation drawing for the south facade of Saint George's-in-the-East, with the movable flap raised (BL, King's Maps, K. Top. XXIII–21-2–e; by permission of the British Library).

triple-grooved block intended to look like crenellations at Saint Alphege's. From this vantage point in the grassy eastern churchyard, Saint George's presents a simpler aspect than on the more classical Ionic pilastered west facade, flanked by curving volutes (plate 3 and fig. 42). In some ways the east facade's

"Manner of Building" comes close to that practiced by primitive Christians twelve hundred or more years earlier, although Hawksmoor could only have guessed at it. His Saint George's recalls the paleo-Christian and early Byzantine churches of northern Syria, in their reliance on massive, symmetrical expanses of exquisitely cut limestone with a minimum of classical detailing. Their curving apses, like his, often echo their frequent arched window openings. Their blocky rectangularity often contrasts with a triangular gable, tying the whole composition together. As well as any early Christian master builder, Hawksmoor understood this simple device of playing one geometric shape off against another. In addition to this age-old design formula, he introduced from the medieval tradition the element of the tower. With congruence of elements uppermost in his mind, the buttressing of the pepper pot towers prepares the eye for the buttresses atop the main tower, shooting upward 149 feet to soar above the peak of the broad eastern pediment.[13]

After so much experimenting with the roofline of Saint George's, Hawksmoor finally decided to place on the topmost stage of the western tower the octagonal lantern design he had not used at Saint Alphege's. The decision came by 1718 at the latest, since by then the respective heights of the main tower and the four pepper pots had been determined. A report made in March of that year by Hawksmoor's cosurveyor, John James, notes that the pepper pots were to be heightened by several feet, presumably to keep them in proportion with the western tower, which already reached more than sixteen feet above the roof. Construction continued four more years until completion in 1722–23.[14] A pre-1718 ink and gray wash elevation of the tower, with plans of each of its three stages, records the state of the design at the outset of this final process (fig. 47). It differs considerably from the earlier schemes (figs. 41 and 43), but it agrees in almost every respect with a measured west elevation of the church as completed (fig. 42). Very soon after this the tower construction went ahead. Only minor modifications were made to some of the sculptural ornaments, such as the urns and the elaborate console brackets to each side of the split pediment. Even at this late phase in the designing, however, Hawksmoor seems to have contemplated yet more ad hoc alterations, to borrow Stirling's apt phrase. Beside the topmost stage and the words "38´ [feet] in toto" he also wrote "Fig. I," implying that at least a second proposal, "Fig. II," once existed. If it did, it has not survived.

Apart from the tower drawing's fine draftsmanship, with plenty of freehand touches that add to the liveliness, it has additional significance relating to its provenance. The verso bears the numeral 148 and a heavily crossed out inscription reading "24 Drawings of Deptford Church and St. Johns Chapple Wapping by N. Hawksmoor." The number and the wording correspond to the

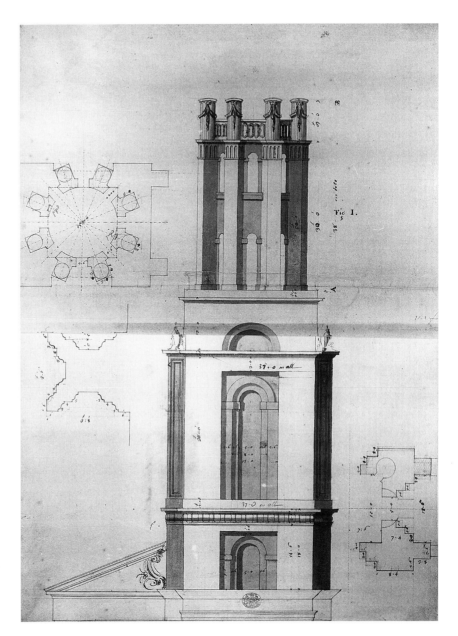

47. Nicholas Hawksmoor, elevation drawing of the west tower of Saint George's-in-the-East (BL, King's Maps, K. Top. XXIII–21-2–f; by permission of the British Library).

entry for lot 148 in the 1740 sale catalog of Hawksmoor's possessions. Here is proof positive that the sixty-seven Hawksmoor church drawings in the Map Room of the British Library, or at least a good number of them, came from his sale.[15] Returning to the recto of the same sheet, the octagonal upper stage modifies the Saint Alphege's scheme in one important respect. The protruding piers articulating the eight sides as at Saint Alphege's are treated as though they were pilasters with triple-grooved triglyphs in place of capitals. Above the

triglyphs Hawksmoor had originally wished to place other triple-grooved free-standing blocks, which would have resembled crenellations when seen from a distance. At first in the drawing with the movable flap (fig. 45) he wanted to achieve this castellated effect on the pepper pots at Saint George's, but he abandoned the idea for that position and transferred it to the main tower. In the process, he replaced the triglyphs with sacrificial altars, similar in form if not in position to those acting like bollards at the east entrance to Saint Alphege's (and cf. fig. 39). The drawing clearly depicts the fluted sides of the altars swagged with drapery. Moreover, the mason Edward Strong's bill of 1722–23 specifically refers to them as eight "Altars" and charges £80 for the carving.[16] As carried out (fig. 48), Strong's sacrificial altars, perched above piers buttressing the tower and framed against the sky, look like crenellations from afar. They incorporate into the commission's program a conscious reference to medieval belfries as emblematic bastions of a purer, more primitive faith.

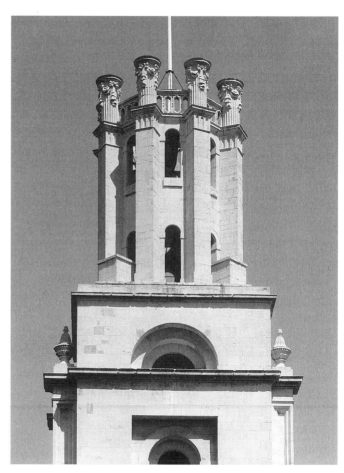

48. Saint George's-in-the-East, detail of the west tower. Photograph by Angelo Hornak.

The altars at Saint George's, like those at Saint Alphege's, constitute the key to understanding Hawksmoor's intention that his churches resemble primitive Christian ones as he imagined they must have looked. Keeping in mind his close working association with the Atterbury-Smalridge clique and their historian allies like Hickes and Bingham, consider the import of a long letter from Hawksmoor to the Reverend Joseph Wilcocks, Atterbury's successor as dean of Westminster Abbey. Hawksmoor wrote:

> The primitive Christians wanted Churches, [but] they wou'd not, or cou'd not make use of the Temples of the Gentiles . . . for the Cell[a]s of their Temples, were small and dark . . . as at Ephesus. . . . Indeed there were some Temples of other forms, capacious enough, as at Rome the Temple of peace [Basilica of Maxentius], the Pantheon and others, but most of them were either demollish'd or the Christians then esteemd 'em prophane. They did make use of some of the Basilica's for Churches, as, St. John Lateran, and St. Mary Major, at Rome, and the Emperour Constantine built the Basilica of St. Peter in the Vatican, from the Ruins of severall other Buildings, but in a very unskillfull manner.[17]

At the time he wrote these words most of the divines he worked with, or whose works he read, had died. With the passage of time the picture of the primitive church in the Greek East had grown fainter, while that of the church in the Latin West grew stronger. The word "basilica" now took on for him a more architecturally precise and less generic meaning than it had in his sketch of "The Basilica after the Primitive Christians." But Hawksmoor retained the central idea that wherever the churches were constructed they would be in keeping with what the Reverend William Cave called the "simplicity of those days."[18] This notion of primitive simplicity accounts for the relatively stark and astylar treatment of the lower elevations of Saint George's. Except for its pilastered west facade, the others lack the orders, which is not to say that their plain surfaces juxtaposed with massive keystoned doors and windows lack for interest.

An explanation for the more complicated tower of Saint George's emerges slightly later in the letter to the dean of Westminster. Concerning early Christian building practices, Hawksmoor continued:

> They made use of a different sort of Building with stones of less dimensions, and what they coud easily transport or raise upon their fabricks, and sometimes patch'd up aukward Buildings, out of the Ruins of Old Magnificent Structures. This was what was afterwards calld Gothick.[19]

Seen in the light of this passage, the tower of Saint George's becomes an exposition in stone of Hawksmoor's admittedly garbled account of the history of architecture from antiquity to the Middle Ages. It vividly conjures up a picture of early Christians ripping down temples and with elements "they coud easily transport"—movable things such as redundant sacrificial altars—they would "raise them upon their fabricks." In just this almost "aukward" way the Saint George's altars, no longer grounded as previously at Saint Alphege's, elevate their message into the sky. Hawksmoor went on to assert that the early Christian manner evolved into the styles he lumped together as "Gothick." Hence, presumably, the undeniable yet hard to pin down medieval impression created by Hawksmoor's purely classical elements—round arches, triglyph blocks, and sacrificial altars. Critics and historians have long puzzled over the sources for this visual effect. They have suggested the octagon at Ely cathedral or the so-called stump of Boston parish church in Lincolnshire as possible inspirations.[20] Certainly Hawksmoor had an extensive knowledge of medieval buildings in Britain. His letter to Dean Wilcocks is full of references to Saxon and Norman churches. But all this may be beside the point. To Hawksmoor, Saint George's symbolized more than anything else a transitional moment in

the evolution of ecclesiastical architecture when the pagan past was on the wane and a waxing medieval mode was rising phoenixlike from the ashes.

Farther to the east of Wapping, in the heart of London's former docklands, the church of Saint Anne's Limehouse shows a design process very similar to that of Saint George's. In a number of respects these two East End buildings are twins. The church's dates of commencement (1714), roofing (1717), steeple construction (1718–19), and consecration (12 September 1730) coincide with those of Saint George's. And an inscription by Hawksmoor on his plan for Saint George's (fig. 40, lower right) has been pointed out by Downes as reflecting the architect's intention to make the roofing of the two structurally interchangeable, perhaps in keeping with the commission's wish for a universal model.[21] In execution the churches turned out looking quite different, however, owing in part to site considerations, in part to Hawksmoor's ad hoc method of designing. From the relatively meager evidence of his six surviving preparatory drawings, it seems even clearer that the zone of his principal interest and experimentation occurs above the roofline. The lower side elevations, consisting of rows of round-headed windows with fewer exaggerated keystones, are established quite early and change even less than at Saint George's. It also seems that the designing anticipated the commission's official approval to go ahead in June 1714, the same date on which it approved erecting Saint George's. Hawksmoor had been ruminating over solutions ever since 25 June 1712 when the commissioners had accepted his report on two competing sites and had chosen the one situated at Westfield on the western outskirts of the hamlet.

The site in Westfield backed onto Three Colt Street and therefore called for an entrance to the church from the east end behind the altar, as had previously happened at Saint Alphege's. This necessitated a more elaborate treatment than the apse at Saint George's (plate 4), and Hawksmoor quickly turned his attention to the problem. He produced a most unusual design, reminiscent of the engraved east elevation of Saint Alphege's in that it featured a centrally placed statue of the queen wearing a crown and carrying the scepter and orb (fig. 49; cf. fig. 36). (Presumably the parallel between the pious Queen Anne and the titular saint of the church was quite deliberate.)[22] In its initial burst of gratitude to the monarch, the commission decreed that such a statue with an appropriate inscription should grace a "conspicuous part" of every one of the proposed fifty churches. When the cost of such an extravagant move finally dawned, a further decree the following April reduced the statues down to a single bronze to be placed in the Strand in front of the commission's sumptuous flagship church of Saint Mary's.[23] If Hawksmoor respected the commissioners' dictates, and there is every indication that he did, then his east eleva-

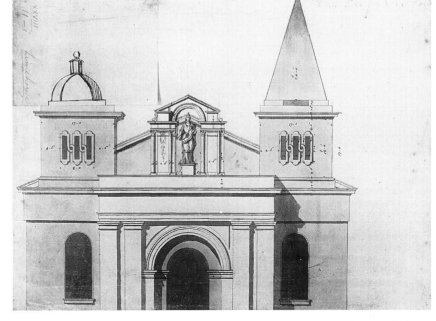

49. Nicholas Hawksmoor, preliminary elevation drawing for the east facade of Saint Anne's Limehouse (BL, King's Maps, K. Top. XXVIII–11–i; by permission of the British Library).

tion of Saint Anne's Limehouse must for the most part predate mid-April 1714. Initially he made the extraordinary proposal of flanking the statue with two minipyramids. He replaced one of them with a low dome later on, perhaps in the summer, when he pasted a movable flap onto the drawing. Neither the domed nor the pyramidal version saw the light of day, although the tall pedestals to receive these elements were built (plate 5).

The narrowness of Three Colt Street permits only a raking view of Saint Anne's when viewed head on. The refinement of the glistening limestone surfaces, however, improves upon the impression created by the bland lower half of the east elevation drawing. The corners of the recently cleaned building are actually quoined, as are those on the west facade, and the central window molding is enriched with carving, as is the Doric pilaster order. One interesting feature of the rooftop pedestals, common to both the drawing and the color photograph, is that rectangular panels of dark stone are arranged within a trio of interlaced carved frames, standing side by side as if holding hands. This motif so delighted Hawksmoor that he reused it for the balustrading between the sacrificial altars on the top of Saint George's (fig. 48) and elsewhere at Saint Anne's, as will be seen. The present tower is just high enough that it peeps over the top of the cornice between the two pedestals where the statue of Anne, had it been installed, would have detracted from the view. The statue's omission turned out to be a blessing in disguise. It made way for a surprise vista of the tower. Hawksmoor gauged the thrilling effect perfectly.

The top of the steeple at Saint Anne's, with its faintly medieval-looking

pinnacles, results from a lengthy process of consideration and reconsideration. At first, in an elevation of the north facade, Hawksmoor balanced the eastern pyramids with a western tower twice as tall, reached by a flight of steps leading up to an elegant bowed vestibule similar to one finally carried out (plate 6). He penciled in the pyramids on this elevation drawing, so it appears that they came as an afterthought.[24] But he already had a pretty clear idea of the tower design at this point, because he repeated it almost exactly in another, more informative, drawing (fig. 50). To this one he added a statue, probably Queen Anne's, which suggests that this sheet dates from before the commission's interdiction against such figures in the spring of 1714. The belfry stage has pilasters with the sort of grooved capitals the architect preferred. Above rises a strange contraption unlike any other tower design by Hawksmoor. It consists of an arcaded balustrade running between two pedestals supporting what may be round sacrificial altars. Between them under a little hipped roof all its own stands a tall rectangular block, paneled on each side with the same leitmotif of the three interlaced panels seen on the eastern pyramid bases. This conglomerate composition—once again Hawksmoor's adjective "aukward" comes to mind—may express the idea of early Christian builders' piecing together a church tower out of *spolia* taken from antique temples.

Slightly later in the design process the restless Hawksmoor settled upon roofing the bowed vestibule with the lead-covered half dome eventually executed. A partial west elevation shows it in position at the bottom of the sheet (fig. 51). Directly behind the ornamental urn, Hawksmoor penciled in the shapes of a circle and a semicircle that he played with until he decided in favor of the lunette. The arch with ornamental keystone above was eliminated from the final design in favor of a flat cornice. His sepia ink outlines stop at the cornice of the belfry stage, and from there on pencil takes over. The only feature of this version to survive in the executed form is the penciled arch and oculus above the belfry columns. All the rest changes radically, and for the better. Notice that the finial cross and orb sit on top of an Ionic capital with a fluted, flared shaft spreading downward. Again this seems to hint at early Christians' adapting antique carved ele-

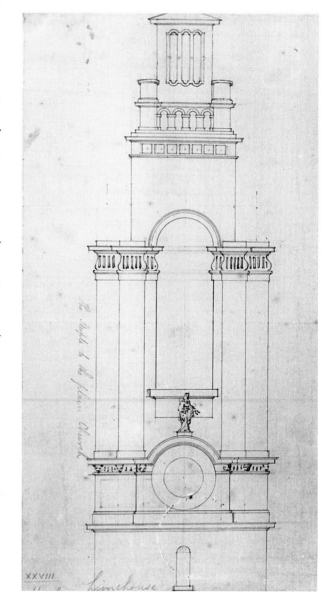

50. Nicholas Hawksmoor, preliminary elevation drawing for the west tower of Saint Anne's Limehouse (BL, King's Maps, K. Top. XXVIII–11–e; by permission of the British Library).

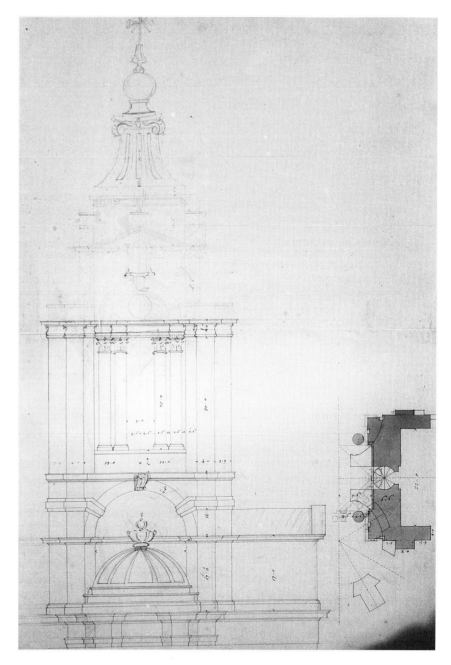

51. Nicholas Hawksmoor, preliminary elevation drawing for the west tower of Saint Anne's Limehouse (Victoria and Albert Museum, E. 417-1951; V&A Picture Library).

ments to their own ends. A further point of interest about this drawing is its provenance, which differs from the others'. This one came to the Victoria and Albert Museum from the Bute sale and therefore must have once been in the Wren drawings collection.[25] It is tempting to speculate that Hawksmoor asked Wren's advice and forgot to retrieve the drawing.

Two additional drawings in the British Library reproduce the belfry stage of the tower exactly as built (plate 6). Its great arched opening looms above the narrow western access road pierced through terraces of houses lying to both sides. These low dwellings have survived the London Blitz and the fire of 1850 that gutted the interior of Saint Anne's. They preserve best of all the Hawksmoor examples the domestic scale of the neighborhood and its original relationship to the church. Saint Anne's Limehouse looks much taller than Saint George's in proportion to its surroundings. Contributing to the sensation of height is the way each stage diminishes in size as the tower mounts upward, like an extended telescope. This elegant solution came about as a result of considerable trial and error. At first the architect crowned the belfry stage with an octagonal lantern resembling the one he designed for Worcester College, Oxford, which he claimed he had based on the Tower of the Winds at Athens, described in the writings of the classical traveler Pausanias.[26] Next he produced a line drawing of similar sort but pasted a piece of paper over the lantern stage. On it he drew the final version in pen and ink heightened with gray wash. Only the topmost finials differ slightly from those executed. Hawksmoor showed them as eight pedestals, each carrying an urn.[27]

In the course of 1717 or 1718 the lantern stage at Saint Anne's took its final form (fig. 52). Disfigured by a later clock face, the steeple nevertheless is one of Hawksmoor's most intricate yet satisfying designs, the fruit of much experimentation. In keeping with such late Wren steeples as Saint James's Garlickhill in the City (1713–17), it clusters the orders in groups set at an angle to the central core, suggesting that Hawksmoor learned from these earlier examples and may even have helped design them. At Saint Anne's the pilaster clusters move in and out, creating a syncopated rhythm. Hawksmoor simplified them by substituting triple grooved blocks for the full-blown Ionic capitals used in the City church. He may have wished to subtly indicate a difference in tone between the metropolitan location of the one building and the suburban site of the other. In addition, the simplification of the orders might render Saint Anne's more accessible to the ship chandlers, rope makers, and mariners of Limehouse, unused to the classical language of architecture but accustomed to medieval towers on ecclesiastical buildings. Moving up the steeple, the pinnacles themselves look convincingly Gothic from a distance, in much the same way the sacrificial altars at Saint George's appear as crenellations when seen from afar. But once again Hawksmoor created a medieval appearance using classical means. The pinnacles consist of pedestals supporting miniature replicas of the pyramids Hawksmoor had omitted from the east facade. Way up in the air, and pierced to show the sky beyond, they convey the aspiring quality of medieval architecture without copying it.[28]

As for the interior arrangement at Saint Anne's, it took into account single entrances from the west, south, and north as well as the twin entrances from beside the eastern altar. More or less faithfully reconstructed to Hawksmoor's designs after the nineteenth-century fire, the nave combines the solutions he had tried at Saint Alphege's and Saint George's. The ceiling is oval and flat as in the former church, and it is carried on tall columns as in the latter building. Taller pedestals than at Saint George's support the galleries, above which rise the four slender shafts of the Composite order. All in all the effect is higher, as are the side clerestory windows, so that dazzling light floods the interior. Wren in his recommendations to a commissioner had stressed ample illumination (appendix 2). In all likelihood, however, he had in mind a smaller space than Hawksmoor's. The human voice really has to strain to be heard all the way from the pulpit to the back row of pews. Wren had foreseen the occupational hazard of dysphonia, commonly called parson's throat; Hawksmoor overlooked it in the interest of greater space and light.

The third and last of Hawksmoor's Stepney churches erected by the commission, partially replaced the Reverend George Wheler's temporary tabernacle that had combated the spread of Nonconformity in Spitalfields since the end of the previous century. They gave it the name Christ Church, a predictable choice considering how many old boys from the Oxford college of the same name served as commissioners.[29] Started in the same year as Saint Anne's and Saint George's-in-the-East, Christ Church was not consecrated until 1729, partly because the construction of steeple—the most overtly medieval looking in Hawksmoor's oeuvre—dragged on from 1724 to 1727. The complex building history, marred by work stoppages owing to lack of funds, is reflected in the complicated series of twenty-eight drawings in the British Library pertaining to the various schemes and counterschemes. One of these sheets (K. Top. XXIII–11–s) bears the numeral 166 and an inscription related to the lot bearing that number in the 1740 Hawksmoor sale. According to the sale catalog entry there were thirty drawings

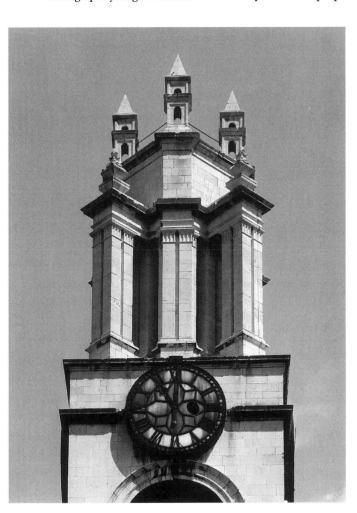

52. Saint Anne's Limehouse, detail of the steeple. Photograph by Angelo Hornak.

of Christ Church and Saint Anne's in the lot, so the figures more or less tally.[30] The inscription indicates again that with few exceptions the architect kept his drawings instead of depositing them with the commission, as he did his lost wooden models.

The building history of Christ Church has been discussed extensively by Downes and by the Survey of London volume dedicated to Spitalfields.[31] Only a brief summary is necessary here as a prelude to analyzing the steeple's design process and its significance. Work began auspiciously enough in July 1714 and proceeded smoothly until 1722. Then it ceased altogether with the church only partly roofed and no steeple in place above the belfry level. Early the next year the completion of the steeple hung in the balance as the commission debated whether it could be "deferrd."[32] (Usually in such straitened budgetary circumstances the ominous notion of deferral amounted to sure cancellation.) Preliminary plans and elevations, some of them published in a guide to the church, call for relatively flat north and south elevations and a west facade with a plain tower supporting a low lantern.[33] None of the surviving drawings from before 1721 give much evidence that the architect had fully thought out the appearance that the west end or its steeple would finally take. An elevation of the east facade, however, not only states the principal themes that Hawksmoor developed for the treatment of the side facades but also foretells the eventual appearance of the western entrance portico. Hawksmoor's design process may have been fluid, but the final compositions it produced possessed great coherence.

The elevation drawing just mentioned resembles in most respects the east facade in its present form (plate 7). For one thing, it features an unusual series of porthole windows that stretch along the top and continue all across the north and south facades. Below stand plain round-headed windows, similar to those at Saint George's and at Saint Anne's. These windows continue along the other elevations, but they are elegantly paneled back within relieving arches set in a row. The central eastern window, above the high altar, followed a precedent established by Inigo Jones at Saint James's Palace chapel and by Wren at Saint James's Piccadilly. Like them, Hawksmoor gave it the triple form of the typical Serliana opening, a motif he had already used on the east facade of Saint Alphege's Greenwich (plate 1). (Hawksmoor owned a 1663 Venetian edition of the writings of Sebastiano Serlio [1475–1554], after whom the Serliana is named.)[34] To top off this stunningly abstract composition, a lunette window under a pediment surmounts the Serliana. Here, once again, Hawksmoor returned to salvage a previous idea, a rejected preliminary one for the main facade of his Saint George's Bloomsbury (fig. 61).

The nineteenth-century widening of Commercial Street and construc-

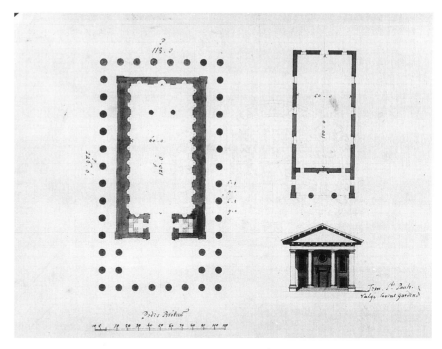

53. Office of Nicholas Hawksmoor, drawing of the plan and east elevation of Saint Paul's Covent Garden, London, and plan of the Temple of Bacchus at Baalbec (The Provost and Fellows of Worcester College, Oxford, 321 c).

tion of the Spitalfields fruit market directly across from Christ Church made possible an unobstructed view of its west facade (plate 8). From there, from the contemporary houses in Fournier Street (plate 7), or better yet from a train window on the nearby elevated branch line, the dramatic impact of the church makes itself felt full force. Here, perhaps, was what Vanbrugh had in mind when he recommended in his letter to a commissioner straight streets leading up to churches of "most Solemn and Awfull Appearance." Most striking is the lunging pyramidal spire, the only one of its kind Hawksmoor built. Below that the belfry has a tall tripartite composition like a Serliana. Echoing it lower down, the majestic projecting portico also takes the form of a Serliana—simplified in its order from the version at Saint Alphege's. Timothy Rub has pointed out that the change from enriched Doric at Greenwich to severe Tuscan at Spitalfields may have to do with the parishes' locations. Both are suburban, but Saint Alphege's served the royal enclave within the Greenwich Hospital grounds and had a royal pew, whereas Christ Church served a predominantly lower-middle-class population including many Huguenot silk weavers.[35]

As I discussed in chapter 1, Hawksmoor knew all about the Tuscan order in an ecclesiastical context from the portico of Saint Paul's Covent Garden, built a century earlier by Inigo Jones. Hawksmoor had measured drawings made of it, which he compared with the Temple of Bacchus at Baalbec, both buildings measured according to the same scale (fig. 53; cf. figs. 4–5). He then

sent the undated drawings to his correspondent and exact contemporary Dr. George Clarke (1661–1736), M.P. for Oxford University and a member of the second group of commissioners. Hawksmoor may also have known about the humble implications of the Tuscan from the well-known dictum attributed to Jones, who reputedly claimed that Saint Paul's was the "handsomest barn in England."[36] Whatever the exact connotations for Hawksmoor, he achieved remarkable coherence between the front and the back of Christ Church, and at the same time contrast between the inside and the outside. The big Tuscan Serliana at the west he repeated in the smaller one at the east. But in the nave interior he switched to files of majestic Composite columns supporting barrel vaults that carry the clerestory and the flat-beamed ceiling. At the east end, framing the Serliana, he set up a freestanding Composite colonnade to form a giant chancel screen that, like the one at All Hallows, emulated early Christian precedent (fig. 15).

No hint of the portico Serliana is to be seen in a Hawksmoor preliminary drawing for the west facade and steeple of Christ Church (fig. 54). Here the architect continued to depict the lower elevation in the simple way seen in other early drawings. The three rectangular western openings do not even have an identifiable order of architecture, although a telltale semicircle faintly drawn in pencil above the central pair of columns foretells the Serliana to come. The only dated sheet in the series, a portico construction drawing of 1726, at least provides a loose terminus ante quem.[37] Atop this very unprepossessing facade Hawksmoor proposed to raise the extraordinary belfry stage in close to its executed form, crowned by an even more extraordinary steeple, or more correctly two possible alternatives. The one on a flap shows a rather short broach spire with boldly chamfered sides and a tiny ornamental dormer on one of them. The general appearance of the spire, especially in view of its dormer, resembles one of Hawksmoor's most youthful schemes, that for rebuilding the western tower of the Gothic church of Saint Mary's in Warwick about 1694.[38] The design under the flap is slightly wider and has a higher and simpler central arch, but it stops short at the level of the four little arches seen on the flap.

54. Nicholas Hawksmoor, preliminary elevation drawing for the west facade of Christ Church, Spitalfields, with the movable flap lowered (BL, King's Maps, K. Top. XXIII–11–r; by permission of the British Library).

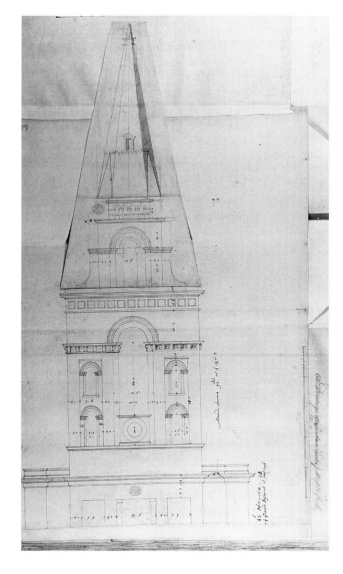

This miniature arcade is reminiscent of the same crowning feature on the design for Saint Anne's proposed in 1714 (fig. 50), which again illustrates how the architect took ideas rejected for one church steeple and used them on another.

A final drawing of the west facade and steeple in close to executed form shows three rather than four tiny arches below the broach spire (fig. 55). In consequence the proportions of the tapering spire became taller and more pointed. The lugged dormer window frames increase to three per side. Each carries an urn slightly smaller than the one on the dormer below. Flamelike projections running up the sides represent foliate crockets nestled within the crevices of the chamfering, like weeds growing out of the stonework. The crockets impart a truly medieval aspect to the whole. But Hawksmoor could easily rationalize their presence within an otherwise classical-inspired design. He did so by equating the two terms "Crockets (or Calceoli)" in an inscription he wrote on a much later drawing for the entrance gate to the north quadrangle of All Souls College, Oxford. His inscription tries to establish crockets as synonymous with the leaves that distinguish a Corinthian capital, except that he forgot to check his own copy of Perrault's Vitruvius (bk. 4, chap. 1) for the correct spelling of *cauliculi,* the Latin word for acanthus stalks. He intended to explain the apparently contradictory way the medieval crockets in his design met in a finial shaped like a classical capital with real *cauliculi,* similar to the one he proposed earlier for the steeple at Saint Anne's (fig. 51).[39]

Shorn of its dormers and crockets by the effects of weather, the present spire of Christ Church looks less medieval than it once did (fig. 56). The tapering top now resembles an obelisk as much as a medieval spire, which helps to convey Hawksmoor's underlying intention. He saw the Middle Ages growing out of the classical period as organically, as symbiotically, as the crockets that had

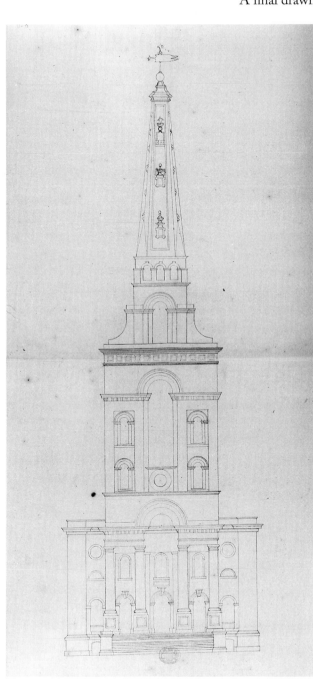

55. Nicholas Hawksmoor, elevation drawing of the west facade of Christ Church, Spitalfields (BL, King's Maps, K. Top. XXIII–11–0; by permission of the British Library).

once emerged from the stonework. He countenanced no hard and fast breaks in the history of architecture. According to his letter to Dean Wilcocks, the early Christians had salvaged from the Romans whatever remains they could, and this, he wrote, "was afterwards calld Gothick." He saw the classical tradition and the Gothic flowing into one another. And after all, Hawksmoor's interpretation of history as a continuum may not be all that garbled. As smoothly as he could, he created a transition from Christ Church's classical Serliana entrance portico to the pointed obelisk-spire on top (plate 8). He succeeded largely because of his repetitive use of round-headed arches that carried the double meaning of Roman or Romanesque. Up above, the whole composition bursts forth in a Gothic flourish.

None of the steeples previously discussed is as chronologically all-encompassing in scope as that of Christ Church. With each successive rise in height, it carefully develops a sophisticated progression from the ancient to the more modern. The earlier steeples hinted at something of the sort as they grew increasingly spiky and more overtly medieval in feeling. Perhaps Hawksmoor viewed his Stepney churches as a trilogy, each one moving a rung higher up a kind of stylistic Jacob's ladder. If he did have such an overall architectural parti in mind from the start, it would accord well with what the Reverend George Smalridge had praised as "unity of design." According to one of Smalridge's published sermons,

> In the several works of art there is nothing which more shows the skill of the artificer than unity of design.... Whether a picture is to be drawn, or a poem to be composed, or a building to be framed, the contriver's first business is to form in his fancy what he designs: this he takes care to have in his view through the whole course of his work.... [and] if they do not contribute to the carrying on one and the same design; [then] the whole is condemned by men of judgment.[40]

In a lighter vein, Smalridge suggested in sermon nineteen tempering "harsh, rigid, and severe" attitudes with "innocent and inoffensive mirth and cheerfulness." Something of this same mixture of high seriousness with wit emerges in the buildings and writings of Hawksmoor. His tower drawings give the impression of a painstaking exposition of how prim-

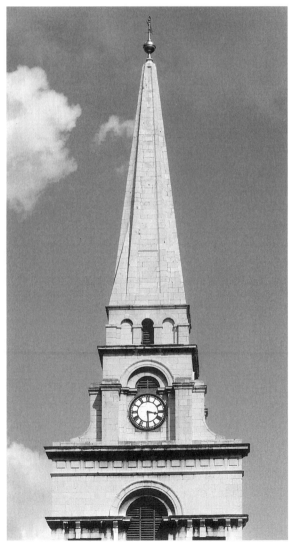

56. Christ Church, Spitalfields, detail of the steeple. Photograph by Angelo Hornak.

itive Christian architecture in its various modes might apply to contemporary churches. But at the same time his ad hoc, trial and error method of piling element upon element implies the mirthful artistic joy Smalridge sanctioned. The notion of the early Christians' freewheeling architectural practices encouraged Hawksmoor to depart, as they had done, from the canon of the classical tradition. He combined this almost playful freedom to explore solution after solution with a serious mission to infuse architecture with theological meaning.

To end with a lighthearted postscript on Christ Church, such as Smalridge would have approved, the discussion returns full circle to the Temple of

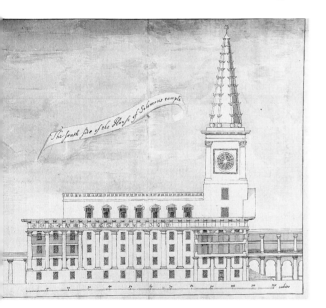

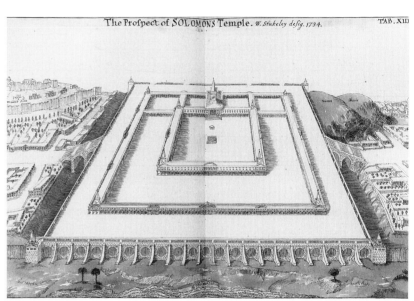

57. *Above:* William Stukeley, imaginary restitution drawing of the Temple of Solomon in Jerusalem, side elevation (The Bodleian Library, University of Oxford, Gough Maps 41ʳ, 132).

58. *Above, right:* William Stukeley, imaginary restitution drawing of the Temple of Solomon in Jerusalem, aerial perspective (The Bodleian Library, University of Oxford, MS Top. Gen. b. 52, fols. 46v–47r).

Jerusalem. An imaginary restitution of it drawn by the Reverend William Stukeley, FRS (1687–1765), is basically a version of Christ Church, portico, steeple, and all (figs. 57, 58). The gifted artist was a clergyman-scientist-antiquary whose speculations about the temple began during the 1720s in friendly rivalry with Sir Isaac Newton (appendix 1). Newton's ideas were published posthumously, but Stukeley's never saw print, although he continued to labor on them. In the end he produced thirty-seven quite accomplished drawings now preserved in the Bodleian Library.[41] Stukeley's fine aerial perspective, dated 1734, compares favorably with Hollar's etching of some sixty years earlier (cf. figs. 58 and 12). To transform Christ Church into the temple, all Stukeley had to do was place a series of courtyards around his central building and change Hawksmoor's crockets running up the edges of the spire into rows of winged cherubs (fig. 57).

Turning to Hawksmoor's final pair of churches, a distinct shift in style takes place, no doubt owing to their metropolitan locations. The first to be considered, Saint Mary's Woolnoth, returned the architect to the scene of his earliest experiences assisting Wren with some of the fifty new City churches rebuilt after the Great Fire of London. *Parentalia* briefly mentions that Wren had repaired Saint Mary's after its near destruction. Then the text goes on to add that "the ingenious and skillful architect Mr. Nicholas Hawksmoor" had subsequently rebuilt it from the ground up with money provided by the commissioners.[42] The discussion in *Parentalia* immediately follows a much lengthier one of Wren's Saint Mary-le-Bow. Similarities have often been noted between the doorway in the Wren tower, well known to Hawksmoor from the measured drawings he made of it, and his treatment of the west facade of Saint Mary's Woolnoth (cf. plate 9 and fig. 32). The rustication patterns around the two arches resemble each other closely, though Hawksmoor's extends across the entire elevation, engulfing the Tuscan attached column running up each edge. Then, in one of his most brilliant flashes of inspiration, Hawksmoor repeated the rusticated arch motif around the corner to the left. He compensated for the absence of real play of light and shade on the north facade by producing a powerful Baroque chiaroscuro effect with three massive aedicular frames set inside the concavity of arches. The brio of this genial piece of design is reflected in modern historians' and architects' loud praise for it. One of them, Alison Shepherd, drew a startling axonometric projection of the church (fig. 59). It looks down on the building in such a way as to bring out its underlying cubic geometry and the role played by the three blank aedicules facing Lombard Street.[43] But everyone so far has failed to realize that the rustication is not the only feature of the church connected with Saint Mary-le-Bow.

When Henry Hulsbergh engraved Hawksmoor's perspective of Saint Mary-le-Bow in the 1720s, an inscription in Latin and English appeared along the bottom margin declaring that the remains of a Roman temple had been unearthed during the excavations for the church. *Parentalia* repeats the story except that it calls the temple "a very ancient church, about the early time of the Roman colony."[44] Almost exactly the same sort of anecdote is related by

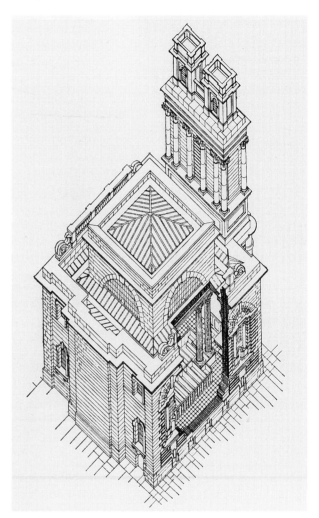

59. Saint Mary's Woolnoth, axonometric projection drawing by Alison Shepherd from John Summerson, *Georgian London.* (London, 1945).

early nineteenth-century writers on Saint Mary's Woolnoth. According to one of them, the elder George Godwin, "The discovery of many fragments of antiquity . . . led to the belief that a temple, probably that which was dedicated to Concord, at one time occupied the site."[45] The coincidental discovery of archaeological remains at both church sites may well have prompted Hawksmoor to evoke Saint Mary-le-Bow when designing Saint Mary's Woolnoth. Historically minded as he was, it would also have intrigued him to learn that his new church's foundations stood where worship had gone on continuously since Roman times. That fact, in combination with its distinctly urban and mercantile surroundings, no doubt caused him to design Saint Mary's differently from the Stepney churches, although its topmost balustrading repeats the motif of the intertwined panels familiar from Saint Anne's (cf. plates 9 and 5). Somewhat in keeping with his approach to Saint Alphege's, Hawksmoor sought a way to celebrate a spot hallowed by such a long tradition of Christianity in Britain. He found the solution in creating a twin-towered westwork, bespeaking a northern medieval character but enunciated through the classical language of architecture.[46]

Saint Mary's Woolnoth is not only the smallest of the commissioners' churches but a special case in other respects. Specific mention of its dilapidated state was made in a second bill of 1712 to extend the original commission's mandate, just as the legislation of the previous year had singled out Saint Alphege's.[47] Four years went by until in 1716 the commission requested designs for Saint Mary's. Out of fairness to John James, Hawksmoor's cosurveyor, Downes stresses that the two men played a joint role at Saint Mary's. But the design was principally Hawksmoor's, as is manifest from the twenty surviving drawings for the church in the British Library. They show his characteristic use of ink and gray wash and carry such typical inscriptions as "Cornice Like that in ye Temple of M[ars]. Vindicator."[48] In this case the architect had additional justification for emphasizing the continuity of the classical tradition. Digging the foundations in the summer of 1716, he had found Roman temple remains underground. His new church, therefore, rose directly out of antiquity.

Several detailed drawings of Saint Mary's focus on the superb rustication that Hawksmoor clearly loved, which coincidentally resembles the stratified layers of earth in an archaeological excavation (plate 10). Generally the lower elevations concerned him to an extent not seen before, because the church's cramped location in the heart of the City allowed less room for substantial foundations and therefore less freedom to maneuver above the roofline. In a letter of 5 March 1719 he intimated as much to the commission by stating, "The steeple cannot rise high, being on ye plann but 14 ft. broad one way."[49]

Most of the elevations either omit the steeple altogether (K. Top. XXIII–28-3–1) or represent the twin-towered solution in close to executed form. But one west facade elevation (K. Top. XXIII–28-3–0), datable to 1716 or 1717 at the latest, portrays something quite extraordinary above the Martian cornice line. An obelisk on each outer corner of the facade flanks a central Serliana window to which it is joined by curving volutes, like those in the 1714 elevation for Saint George's (fig. 41). Above this level a tall, but apparently thin, two-story pedimented screen substitutes for the broad-columned belfry arrangement finally chosen. In this sense, at least, the designs reflect Hawksmoor's general tendency to move to ever simpler solutions for his steeples; none is simpler or more satisfying than Saint Mary's, completed in 1723.

In contrast to the placement of other churches considered thus far, Saint Mary's hemmed-in site also proved a real challenge to its architect in terms of interior lighting. Like many a later architect working in the City—think of John Soane's Bank of England interiors built around the corner from Saint Mary's—Hawksmoor resorted to top lighting (fig. 60). As seen in an early nineteenth-century engraving from Godwin's book, ample sunshine comes down into the central area from four large clerestory windows arranged on the sides of the large cubical box that rises out of the larger cubical body of the church. The general arrangement resembles most closely that of Christ Church. In both interiors benches ran down the central aisle. Those illustrated by Godwin could well be examples of the "Moveable formes" that Hickes recommended to the commission for just such a location (appendix 3). As at Christ Church, their removal later in the nineteenth century, along with the galleries, purifies the spatial effect in a not altogether displeasing way. The triads of stop-fluted Corinthian columns at each of the church's internal corners now stand unobstructed by the galleries so that the load and support framework is clearer, as it appears in the portion of Shepherd's drawing cut away to reveal the inner logic of Hawksmoor's building (fig. 59). But a positively Baroque sensation must have been produced as the eye penetrated from the lower galleried side spaces to the higher central core. At the end of the view, rich plaster decoration frames the twisted Solomonic columns supporting a wooden baldachin, inspired by Bernini's at Saint Peter's and ultimately by the Temple of Jerusalem. If Hawksmoor's inspiration for the internal arrangement came from Perrault's plate illustrating the Egyptian hall as described by Vitruvius, then this and the Solomonic references show how much the architect relied on his early exposure in Wren's office to Perrault and to the tradition of architectural restitution.[50]

As noted in the previous chapters, Hawksmoor's Saint George's Bloomsbury forms the culmination of his tendency to turn restitutions on paper into

60. *Opposite:* Saint Mary's Woolnoth, engraved perspective of the interior looking east, from George Godwin and John Britton *The Churches of London . . . ,* 2 vols. (London, 1839), vol. 2.

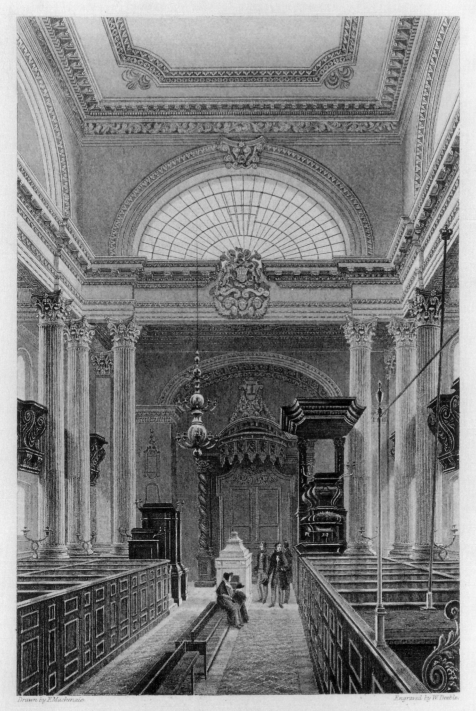

Drawn by E.Mackenzie.　　　　　　　Engraved by W.Deeble.

ST MARY WOOLNOTH,
Lombard Street.

reconstructions in stone. Unfortunately, few drawings related to the church survive, the roofing model has disappeared, and documentation on the design process is slight compared with that for the other churches. Most of the documentary information concerns the trouble the commissioners had finding an appropriate site in so relatively built-up a part of the burgeoning parish of Westminster. Various proposals from landowners came and went, as did those from architects. James Gibbs, Hawksmoor's cosurveyor at the time, presented a design in March 1714. Vanbrugh followed suit the following spring, and the commissioners initially accepted his scheme for a church, though they later passed him over in favor of Hawksmoor. All along, Hawksmoor contended for the job. It has been suggested that his skill in contriving a properly oriented church on the site eventually won the day over Vanbrugh's design, which faced north-south "as it cannot conveniently be built any other way."[51] The commissioners did not intend to bend their rule regarding proper orientation. They ordered copies of this particular rule issued to the surveyors.[52]

A preliminary design exists from this early period (fig. 61). Its partially torn inscription "Bloomsbury Ch[urch] prop[osal]" seems to be missing a numeral at the end and suggests that Hawksmoor submitted other proposals to the commission.[53] It shows a remarkable central plan building, resembling the early schemes for Saint Peter's Basilica by the Sangallo clan, with the domed crossing surrounded by semicircular walled-in walkways. The plan quite clearly includes the regulation steps up to the eastern chancel, with even the indication of some sort of a screen across it, most likely a communion rail. Pepper pots reminiscent of those at Saint George's-in-the-East—perhaps four were also intended for Bloomsbury—grace the skyline to each side of a Serliana. As at the east facade of Christ Church (plate 7), a disengaged pediment floats above, reminiscent of the ancient Roman *fastigium domus* motif with its imperial connotations. In a Christian context the three-part opening obviously took on Trinitarian meaning, but the regal aspect of a *fastigium* would reinforce Christ's role as divine king.[54] Moreover, the Corinthian order of the Serliana and adjacent colonnades had its own associations with rulership stretching back into antiquity. The use of the Corinthian immediately sets this design apart from the exterior treatment of the rest of the churches, except for the other one dedicated to George, the knightly patron saint of England and namesake of its reigning monarch. In fact, all six of the churches employ diverse types of columns. Much like the variation of the steeple designs, the varying of the orders surely connotes an overall design strategy on Hawksmoor's part.[55]

The approval to build Hawksmoor's design at Bloomsbury came at long last in June 1716, at the same moment demolition started on the old church of

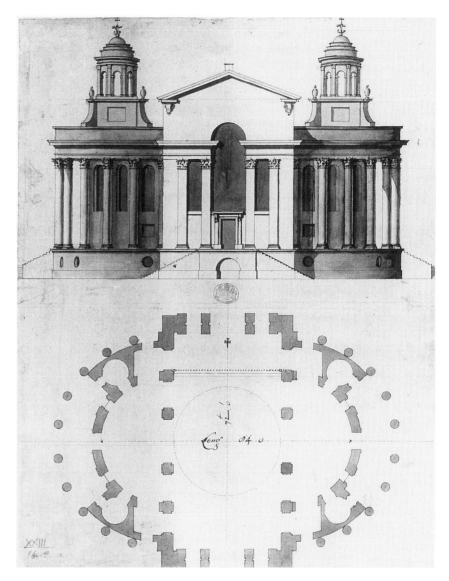

61. Nicholas Hawksmoor,
preliminary plan and elevation
drawing for Saint George's Bloomsbury
(BL, King's Maps, K. Top.
XXIII–16-2–a; by permission
of the British Library).

Saint Mary's Woolnoth.[56] This makes Saint George's the last of the six undisputed Hawksmoor commissioners' churches to be constructed and consecrated (1731). The commissioners chose a rectangular plan with the long axis running north-south and the eastern altar on the short axis directly opposite the main western entrance underneath the bell tower. A rectangular central core rises out of the middle of the central crossing area, an oblong version of the cubical arrangement at Saint Mary's. The entrances from the west, despite their justification in terms of correct liturgical orientation, always remained psychologically subservient to the much more prominent staircase and portico on Bloomsbury Way to the south. The southern entrance, of course, led into

the church along an axis at right angles to the eastern apse and necessitated an awkward right-angle turn for a parishioner to face the altar. The commission's impractical interior solution did not survive for more than fifty years after the consecration, by which time the ideological fixation on orientation had obviously lost its significance. Hopefully the altar of Saint George's may one day return to its original east-facing position under its beautifully stuccoed vault, all aflutter with winged cherubs.

From 1781 until the present the altar has occupied the space once set aside for the north gallery which, along with the southern one, was completely banished during nineteenth-century alterations. At that time the original altar recess became a somewhat redundant side chapel.[57] Apart from the clerestory lighting system, therefore, the most significant surviving features of the interior are the coupled Corinthian columns on the north and the south, spaced in such a way as to form Serlianas, the same motif intended for the west facade as originally proposed (fig. 61). In this case, unlike the situation within the more coherently organized Christ Church, the internal arrangement in no way echoed the porticoed southern entrance, let alone the western steeple—the most unconventional of all the six Hawksmoor produced. The exterior's somewhat heterogeneous appearance, however, belies the architect's coherent approach to symbolic content and massing in relation to interior function.

Taking the last of these points first, the extraordinarily cohesive way Hawksmoor played off the gable on the church's clerestory against the pedimented portico below signifies his command of design, though the effect could hardly have been appreciated from pavement level. Before a high-rise building blocked the view from across the street, A. F. Kersting took a photograph that captured the church at its best and also encapsulated two hundred years of Bloomsbury architecture (fig. 62). On the right side of Kersting's composition, the Arts and Crafts–inspired oriel windows of a hotel protrude into the picture. Behind rises the low metal dome of the slightly earlier British Library, where Hawksmoor's drawings resided for so many years. And farther back still looms the tower block of London University's Senate House, built between the world wars. What a testimony to Hawksmoor's genius that his eighteenth-century church holds its own against all this competition and, indeed, remains one of the most bizarre sights on the modern-day horizon! It is to London's skyline what Francesco Borromini's extravagant stepped dome and helical spire of Sant'Ivo alla Sapienza are to Rome. The analogy is not at all far-fetched. Both architects used historical restitution to enrich their meaning: Borromini looked to Villalpando's visionary Temple of Jerusalem; Hawksmoor drew inspiration from the mausoleum of King Mausolus at Halicarnassus and the Temple of Bacchus at Baalbec as he imagined them.[58]

62. *Opposite:* Saint George's Bloomsbury, south facade. Photograph by A. F. Kersting.

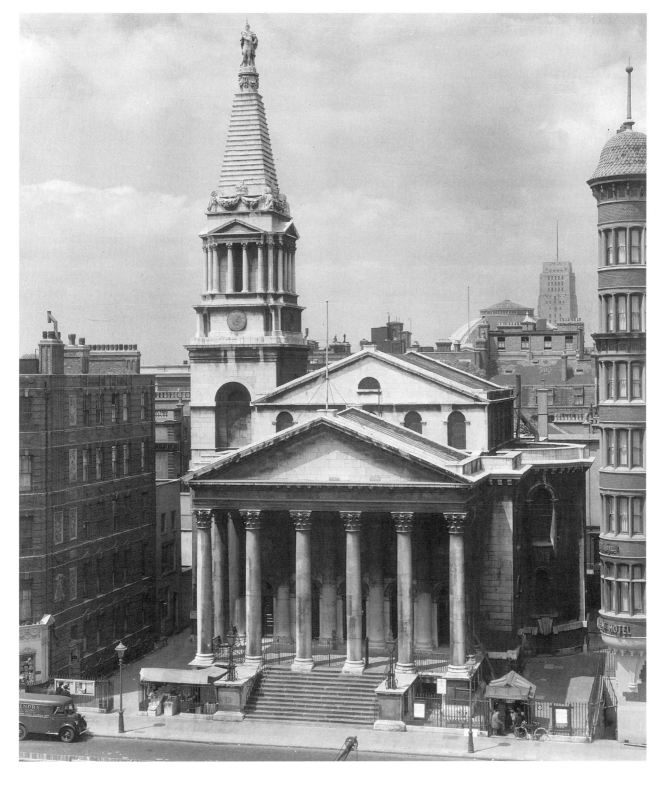

Hawksmoor's knowledge of Baalbec via the medium of engravings and oral reports was established in chapter 1 (figs. 4–5) and has been augmented by the evidence of the Baalbec drawings he sent to Dr. George Clarke (fig. 54). But none of these restitutions on paper has quite the stunning effect of the portico, its meticulous details recently redeemed from sooty blackness by a stone cleaning (plate 11). A diary entry of 17 February 1750, written by the Reverend William Stukeley, provides a near contemporary authority for making the connection between Saint George's and the Bacchus Temple at Baalbec. And who better to report the anecdote than Stukeley, the antiquarian clergyman of nearby Saint George's Queen Square? He stressed that the church portico was intended to be "in imitation, and the size, of that of Balbeck": in other words a full-scale replica, one of the first of its kind attempted in the eighteenth century.[59] His statement verges on gross exaggeration. The two main temples at Baalbec not only dominate their flat surroundings in the Bekaa valley of Lebanon but rival the grandeur of the distant snowcapped peaks. In reality the columns of Saint George's measure a little less than half the sixty-three-foot height of the shafts at the Bacchus Temple and cannot match the daring of their monolithic construction. But Hawksmoor got the proportions right and achieved the same delicate refinement in his Corinthian order as his late antique predecessors had attained. Best of all, perhaps, he realized the importance they accorded to a long ascent up steps to reach the elevated level of a temple's podium. Low eighteenth-century terrace housing to either side of Saint George's, as seen in a Thomas Malton aquatint of 1799, would have helped set the raised portico appropriately apart from the world of the thoroughfare.[60]

Hawksmoor's fascination since his student days with mausoleums in general, and Mausolus's in particular (fig. 2), culminated in Saint George's. At some stage, surely during his employment by the commissioners, he transformed a Wren church facade design into one featuring a steeple in the form of the stepped pyramid at Halicarnassus, accoutered with small dormers as at Christ Church (fig. 35). A pencil version of this drawing, identical except for the absence of the quadriga on top, has an inscription in a later hand identifying it as "Studies for St. Edmond the King / Bloomsbury."[61] No such church exists. Clearly the annotator meant Saint George's and intended the word "studies" in the plural to refer to the subsequent three drawings as well. Two of them, numbered 63 and 64 (figs. 63 and 64) relate less obviously to the design for a church and more to Hawksmoor's imaginary restitution of the mausoleum drawn years before. The first of the pair is so narrow that it has the character of a garden building or a purely academic exercise in architectural imagination. Its pediment sculptures depict a scene of combat, appropriate

63. *Opposite:* Nicholas Hawksmoor, imaginary restitution drawing of the Mausoleum at Halicarnassus, elevation (AS, vol. 4, item 63; Warden and Fellows of All Souls College, Oxford).

64. *Opposite, right:* Nicholas Hawksmoor, imaginary restitution drawing of the Mausoleum at Halicarnassus, elevation (AS, vol. 4, item 64; Warden and Fellows of All Souls College, Oxford).

enough neoantique subject matter but hardly usual on a church. The drawing is a particularly nice example of Hawksmoor's freehand draftsmanship at its best. Judicious use of gray wash heightens the plasticity of the portico, the numerous statues, and the spirited depiction of the quadriga on top of the pyramid's twenty-four risers. In the second version (fig. 64) a decastyle colonnade of the Composite order replaces hexastyle Ionic. (The wider building could conceivably relate to a church.) According to Wren's careful analysis in *Parentalia*, however, the wonder of the ancient world described by Pliny would have had Doric columns, not Ionic or Composite.[62] Why did Hawksmoor depart so radically from both his antique source and his mentor?

Wren's restitution of the Halicarnassan wonder of the world resembled a careful mathematical equation based on Pliny's description and the ratios of the orders as handed down by Vitruvius. What mattered most was to balance out the relative dimensions of the whole and its parts. Much the same spirit infused Wren's fascination with the construction of the Egyptian pyramids

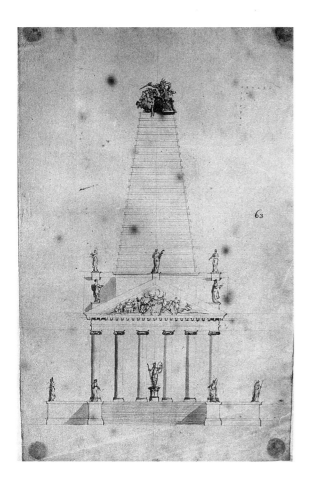

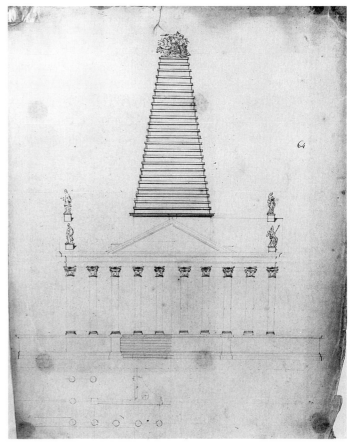

and the Temple of Jerusalem. He loved quantifying materials, dimensions, and amounts of manpower. Hawksmoor cared a good deal less for this sort of thing when left to his own devices. Restitution as a scholarly preoccupation interested him, but it did not curb his flights of imagination; on the contrary, it encouraged them. What had probably started out as a request from Wren for some help, or as a jeu d'esprit posed by the master to his pupil, soon took on a life of its own. Hawksmoor returned to the theme on several occasions, each time giving a novel twist to the basic facts handed down from antiquity. In due course the courage of his convictions enabled him to take the next step—to apply the historical data to new creative solutions. He may wisely have realized that short of substantial excavations the truth about the mausoleum's appearance would never be conclusively known. He proved to be correct—the search for the answer to the riddle of Halicarnassus continues to this day. But he also realized that in that uncertainty lay part of the mausoleum's charm. Pliny the Elder's description of it turned out to be almost as fruitful a source of architectural speculation as the long-lost villas described by his nephew, Pliny the Younger.[63]

At Saint George's, restitution fulfilled its most valuable role within the architectural learning process. It helped Hawksmoor to liberate his creativity. His clients enabled him to build a steeple embodying some of the wildest Plinian fantasies he had committed to paper (plate 12). The commissioners' decision to proceed in 1724 perhaps surprised him as much as it has generations ever since. In was nothing short of an act of foolish extravagance considering the financial constraints that began to arise more and more frequently as the churches moved toward completion.[64] And yet the commissioners stood by their decision. The only sour note involved the truly extraordinary sculptural program of the steeple, most of it removed from the church in a sadly deteriorated condition in 1871. Hawksmoor had ordered it carved by Edward Strong without first obtaining the commissioners' consent. They threatened to charge the costs to the architect if he ever took anything like that into his own hands again.[65] Their consternation is understandable. The part of the bill they undertook to cover came to the large sum of £368, compared with the modest £80 the same Strong had charged two years earlier for the sacrificial altars on the tower of Saint George's-in-the-East. Saint George's Bloomsbury also has a sacrificial altar by Strong, but this one surmounts the steeple and has a statue of George I instead of Mausolus perched on top. Lower down, larger than life-sized lions and unicorns supporting the royal coat of arms once scampered nimbly up the north and south sides of the pyramid. This gives further proof of Hawksmoor's unusual turn of mind—serious in its pursuit of neoantique reconstruction, yet playful too. Again the Italian architect Borro-

mini comes to mind, with his witty decorative use of heraldic elements. Did both architects have their tongues very much in their cheeks? It is hard to imagine they did not!

The humor of Hawksmoor's Saint George's did not escape notice; in fact it inspired ripostes in kind. No less a social satirist than the artist William Hogarth placed the steeple in the background of his well-known *Gin Lane* print to heighten the drunken depravity of the scene depicted. With reference to Hogarth's inclusion of the steeple, the architect Charles Robert Cockerell (1788–1863) remarked: "Hawksmoor was scarcely sober when he designed it."[66] And the steeple also prompted an anonymous wit to write the following bemused pasquinade of the sort the Roman Borromini might have enjoyed:

> When Harry the Eighth left the pope in the lurch
> His parliament made him the head of the church.
> But George's good subject, the Bloomsbury people,
> Instead of the church, made *him* head of the steeple.[67]

Much more recently, during the 1971 campaign by irate Bloomsburyites against the proposed expansion of the British Library, I collected a cartoon of the offending government minister pompously standing on the top of the steeple in place of King George.[68]

Putting to one side all this fun at Hawksmoor's expense, how does his Saint George's fit in with the very different earlier churches? The answer may be simpler than it first appears, and the differences more apparent than fundamental. The note of humor at Saint George's does not conflict with the high seriousness of the other churches' pursuit of Anglican rejuvenation through emulation of the early Christians' primitive purity. On the contrary, it seems that Hawksmoor and the commissioners simply made a logical distinction in their minds. At Saint George's-in-the-East, for example, the parishioners could easily be seen as the humble counterparts of early Christians zealously ripping down the remains of classical buildings and recombining their salvageable elements to create a new architecture. But the primitive Christians the commissioners had in mind in sophisticated Bloomsbury moved whole funeral pyramids and temple porticoes instead of just sacrificial altars and the like. More daringly than elsewhere in his ecclesiastical buildings, Hawksmoor's Saint George's Bloomsbury juxtaposes whole Near Eastern reconstructions—Halicarnassus above, Baalbec below.

Even so, history did not weigh Hawksmoor down with precedents from the past. Instead it helped him free his approach to architectural design. After all, in Hawksmoor's day no architects or theologians really knew how the early Christians had built their churches. Therefore the paradigm of primitive

Christian practice offered a springboard from which to launch a new style appropriate to the eighteenth-century Anglican Church's search for its early Christian roots. The style he subsequently evolved offered freedom from classical constraints and greater variety. It was a style that could range from classical to medieval allusions all within the same building, a polyglot style capable of speaking bluntly or suavely depending on its perceived audience. The commissioners and Hawksmoor were not naive. They rightly sensed that an architecture for sailors or silk weavers at Greenwich, Wapping, Limehouse, and Spitalfields—the modern-day equivalents of Christ's working-class disciples—might not suit worshipers in the cosmopolitan purlieus of Bloomsbury or at Saint Mary's in the conservative City. For the benefit of different parishioners, the architect sought to vary his language. In the East End of London he could afford to speak a kind of architectural cockney; powerful and direct just like the common Koine Greek, the language of the Gospels. In the City and the West End such a pidgin dialect might have sounded the wrong note. For a more educated public something subtler and wittier, laced with allusions to ancient Greek or church Latin, would better fill the bill.

All this came about because of a rare conjunction in the history of architecture. On the one hand there was Hawksmoor, an architect of genius, historically minded but also progressive; on the other, the learned body of his clients who fervently believed in the relevance of the purer faith of the early Christians and who enabled those theological aspirations to be translated into stone. Putting these two elements together generated six of the most original and profoundly moving churches produced by the eighteenth century or any other age.

CONCLUSION

As Hawksmoor lay dying in 1736, he could take comfort from the thought that he had lived to see his six churches for the commission reach completion. In many ways they represented for him the high point of his architectural achievement. Their location in and around London brought him the greatest public recognition. In them, more than in his other works, he emerged as an independent artistic genius, unobscured by any hint of collaboration with Wren or Vanbrugh. The churches also stand out from others created in the eighteenth century in combining variety with unity of intent. Despite the many differences that distinguish them from one another, such as their deliberately individualistic steeples, they share the same precepts laid down by the commission at the outset: the interior planning motivated by liturgical concerns; the emphasis on visibility from afar; the use of Portland limestone; the impressive appearance regardless of size; and the more or less overtly Gothic overtones mixed with classical references, often coexisting within the same building.

Hawksmoor's churches are nearly contemporary with the German ones of the Asam bothers or Domenikus Zimmerman, the Bohemian ones of the Dienztenhofer dynasty, the Italian ones of Bernardo Vittone in Piedmont, or the Austrian ones of Johann Bernhard Fischer von Erlach. But these architects' churches, individually brilliant though they are, lack Hawksmoor's thematic unity—his consistency combined with diversity—derived from the unique make-up of the commission. This body of individuals included political movers and shakers able to allocate the necessary funds, churchmen imbued with a common theological interest in the relevance of primitive Christian practice to religious renewal in their own day, and a group of architects who helped award the lion's share of the spoils to Hawksmoor.

The repository of the commission's deliberations is Lambeth Palace Library, upstream on the Thames from most of its churches but within sight of several of them until modern skyscrapers obscured the view. Lambeth preserves the records of one of the most ambitious and conscientiously documented of all eighteenth-century church-building campaigns and perhaps of those of all time. It would have pleased the commissioners to think that noth-

ing has really equaled their sense of purpose, powers of organization, and political savvy since Constantine the Great's similar activities in Rome, Byzantium, and the Holy Land. The first church historian, Bishop Eusebius of Caesarea, had celebrated those halcyon days of early Christianity, and the commissioners had to some degree consciously sought to recapture that moment when church and state worked hand in hand.

Seen against the backdrop of the tumultuous post-Reformation period in British history, the commission's churches represent an extraordinary affirmation of hope. They rose in the aftermath of over a century and a half's turmoil within the church and the monarchy: doctrinal disputes, sectarian violence, plots, beheadings, the regicide of one divinely anointed king and the overthrow of another. Mother Nature aided the doomsayers by providing plenty of portents: severe winters that froze the Thames; the bubonic plague; the Great Fire of London and a slightly later one in Southwark; plus hurricanes, comets, and a total eclipse of the sun over London on 22 April 1715. If the coming of the new millennium and predictions of the end of the world have such a powerful hold on the imagination of today's society, how much more impact would such events have had in an age much less scientifically aware, more susceptible to rumor and superstition!

In addition to all this, the commission asserted itself in the face of increasing worldliness, the defection of worshipers to other faiths, and the movement of people from the countryside to the big cities. Boldly, if perhaps unrealistically, the commission hoped to stem the rising tide of social, political, and religious change by returning for inspiration to the perceived purity of a past age. The diminishing pace of the commission's work in the late 1720s and 1730s and its quiet demise in 1759 testify that the campaign had long ceased to inspire the same confidence as when it came into being in 1711. Nevertheless, many of its liturgical ideals and its search for renewal, if not the neo-Byzantine flavor, came back a century later at the time of the next great Anglican church-building movement. Another commission, enacted in 1818 in response to the city-planning ills of the early Industrial Revolution, built the so-called million churches. That is another story, and it has been well told. But the same could not be said until now of the aims of the commissioners for building fifty new churches, especially their theological orientation toward an early Christian model.

Would Hawksmoor's churches have looked the same without the directions he received from the commission? The question begs for a more detailed comparison between Hawksmoor's religious and nonreligious buildings than falls within the scope of this book. Many of the architect's characteristic design features recur elsewhere, however, especially in his collegiate structures.

As I have pointed out, there is much in common between the towers of All Souls College, Oxford, and Saint George's-in-the-East or Saint Alphege's as originally proposed. Moreover, the rustication on the west facade of Saint Mary's Woolnoth helps link Hawksmoor to the heavily rusticated orangery at Kensington Palace, for which no securely documented attribution exists. Such stylistic consistency seems to suggest that Hawksmoor might have developed the same way despite the opportunity the commission gave him, but that the importance the commission laid on historical precedent meshed well with and encouraged his own predilections and eccentricities. Like his master before him, he had an inveterate penchant for imaginary restitutions of the lost wonders of the ancient world. This fascination, which he shared not only with Wren but also with Hooke and Vanbrugh, made it easy and natural for him to enter into the spirit of the commission's aspirations, giving three-dimensional shape to their preoccupation with early Christian liturgical practices.

Remember also that Wren and Vanbrugh served as commissioners and made lengthy recommendations to their fellow members. This connection reinforces the links between Hawksmoor and his clients' architectural program as set out in the committee and subcommittee minutes. The rhetoric contained in those documents seems to show that high and low churchmen alike favored the search for primitive Christian purity and that this set Hawksmoor off on a remarkably fruitful course of speculation. It inspired him to imagine the many ways primitive Christians might have adapted the classical tradition in architecture to their own liturgical needs. What saved the whole high-minded exercise from academic pedantry was first and foremost Hawksmoor's giving free rein to his creative imagination. Second, the commissioners' genuine idealism communicated to the venture an element of hope in the redemptive value of the project for future betterment embodied in a new church architecture. And third, the speculative nature of what constituted early Christian architecture played into Hawksmoor's hands. It enabled him to convince the commissioners that his imaginative reconstructions, unusual in appearance and slightly odd by contemporary London standards, should be construed not as architectural ravings but as a rational attempt to recapture a long-lost ideal based on scientific historical analysis.

Twenty-eight years after Nicholas Hawksmoor's death, there appeared in print a carefully structured account of the evolution of church architecture, which far outstripped Hawksmoor's wonderfully garbled attempts. As I mentioned in chapter 1, it took the form of a little book with a long title, not unlike the one by Allacci with which I began my discussion of Hawksmoor. Its author, Julien-David Leroy, timed his publication to coincide with the 1764 cornerstone laying at the church of Sainte Geneviève in Paris. Not surpris-

ingly, Louis XV received a copy while officiating at the ceremony, and legend has it another was placed in the cavity within the stone. Leroy made a point of tracing church design from earliest times "jusqu'à nous," and a ground plan of Sainte Geneviève figures prominently on the one large foldout illustration that accompanied his text. On the plate Leroy grouped a series of plans and corresponding cross sections depicting a representative selection of churches dating from about A.D. 320 right up until 1764 (fig. 65). He arranged the seventeen individual illustrations in several parallel columns, and in descending order of antiquity starting from the top of the page. As might be suspected, pride of place went to Jacques-Germain Soufflot's Sainte Geneviève, and also the church of La Madeleine, which had just been designed by Pierre Contant d'Ivry. They occupy the bottom left and right hand corners of the plate, respectively, just as they grace the left and right banks of the Seine to this day.

Leroy topped his architectural menu with a plan and section of Hagia Sophia, sandwiched between an ancient Roman basilica and a typical early Christian basilican plan of the Constantinian variety. From there he worked his way down the ages chronologically, skipping over the Middle Ages entirely except for Saint Mark's in Venice. Accompanying scale bars let one judge the buildings' relative size, although Leroy manipulated the results somewhat to his own ends. For example, Wren's Saint Paul's appears toward the bottom, drawn to the same scale as the chapels at Les Invalides in Paris and at the royal château of Versailles. But lower down, Leroy reproduced the plans of Sainte Geneviève and La Madeleine at a larger scale to make them look more impressive than Wren's cathedral, though they are in fact smaller. Layout may have been a consideration, but Gallic chauvinism probably also played its part.

Despite some historical gaps and inconsistencies in organization, Leroy's engraved plate began perfecting the pedagogical method known in architecture circles the world over as the *parallèle,* or parallel. He probably took his inspiration from illustrations in earlier architectural treatises that arranged the various orders in a single row like soldiers standing at attention. In common with some of these precedents, he experimented with employing the same uniform scale for ease of comparison. Leroy's parallel of 1764 provided a brilliantly synoptic, logical, and visually arresting image. It set in motion the comparative method of architectural analysis that has prevailed ever since. The idea has influenced many books, not least Banister Fletcher's often-reprinted *History of Architecture on the Comparative Method,* which remained a mainstay of architectural education throughout the English-speaking world for almost half a century after it first appeared in 1896. Fletcher's illustrations, and the comparison/contrast slide tests that grew out of them, became the inspiration for many an examiner and the bane of many an examinee. Like any pedagogical system,

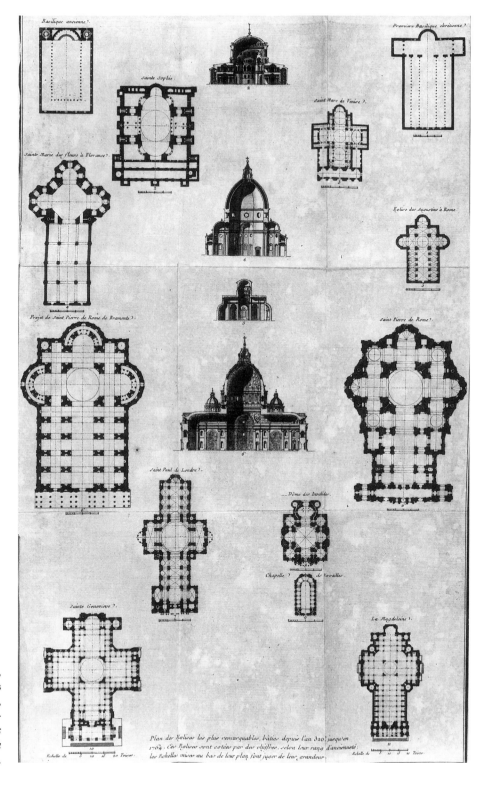

65. Julien-David Leroy, engraved parallel of various church plans and cross sections, from Leroy's *Histoire de la disposition et des formes différentes que les chrétiens ont données à leurs temples . . .* (Paris, 1764).

this one had its inherent faults. Under the guise of logic, all-inclusiveness, and a lack of apparent bias, the parallel tended to lead to foregone conclusions, as when Leroy himself stacked the cards in favor of French ecclesiastical architecture in order to demonstrate its superiority. Despite these drawbacks, however, Leroy's clear and graphically simple presentation grew out of and clarified Hawksmoor's more subjective, hit-or-miss, view of the history of architecture.

Like Wren, or their great counterpart Fischer von Erlach, Hawksmoor in his architectural history writings set out to construct an interpretation of the development of religious architecture along rational lines. Had not Robert Hooke specifically used the word "rationall" to explain how his own considerable powers of observation would improve upon Wren's restitution of Porsenna's tomb (fig. 6)? The commissioners' wish that their surveyors formulate a universally applicable church plan follows in this same rational line of thinking. What for the Englishmen remained somewhat fumbling attempts, despite the tradition of empirical scientific investigation within the Royal Society, had evolved by the time Fischer published his *Entwurf* in 1725. It improved still further when Leroy's little *Histoire* suppressed the disorganization of Wren's "tracts" and diminished the element of guesswork that characterizes Hawksmoor's written speculations. What a contrast—speaking of contrasts—between the tidy images of Leroy, organized in neat rows, and the unruly sketches and bold churches of Hawksmoor, seeking to express a primitive Christian style of architecture arising from the detritus of the classical past.

Perhaps Hawksmoor's failings as a historian were the saving grace of his churches. His unwillingness to systematically disentwine classical, Jewish, and Christian sources proved a blessing in disguise. It left him unfettered in a way that eluded the more sophisticated historian Leroy and the many who have followed in his wake. Hawksmoor's historically unsubstantiated leaps of the imagination—some perhaps intuitively quite sound—resulted in brilliant insights. Each church he produced was different, as befitted its physical location and the social status of its parishioners, yet all partook of what he saw as the unity of the classical and Judeo-Christian traditions. Charting his course astutely, he avoided the shoals created by the commissions' stipulations, on which a less resourceful architect might have foundered. Those stipulations, far from hampering Hawksmoor's artistry, served as the springboard for some of the most inspired churches ever designed in the British Isles.

Chronological List of Representations of the Temple of Jerusalem in the English Language, 1627–1741

Edited by SHANNON BAGG from entries prepared by HILLARY BARRON, EUN-HYE CHUNG, PIERRE DU PREY, SALLY HICKSON, MEGAN LINDENBACH, and ALEXANDRA SHARMA

JOSEPH MEAD (1586–1638), *Clavis apocalyptica*... (Cambridge, 1627) and *The Key to the Revelation* ... (London, 1643). Mead was a Cambridge Hebraist and polymath with an interest in anatomy, botany, astrology, Egyptology, and the origins of the Semitic religions. He wrote several popular works concerned with contemporary debates over the establishment of church ritual in England, including *The Reverence of God's House* (London, 1638) and *Churches, That Is, Appropriate Places for Christian Worship* (London, 1638). His most influential work was the *Clavis apocalyptica* (first published privately at Cambridge in 1627), translated sixteen years later by Richard More for an English edition, *The Key to the Revelation* (London, 1643). The *Key* is Mead's statement of his theories on the millennium foretold in Revelation and was formulated as his response to the popular wave of millennial thought that had permeated England since the Reformation. Both the *Clavis apocalyptica* and the *Key to the Revelation* include a small woodcut illustration of the Temple of Jerusalem according to biblical sources (this volume, fig. 10), to illustrate what Mead described as the "apocalyptic theater" in which John received the prophecies outlined in the Book of Revelation. In Mead's interpretation, the two courts of the Temple described in Revelation were the inner court of the priests and the outer court of the Israelites. Mead's scheme places the temple itself at the center of these two courts. In this way the inner court of the priests becomes the anteroom to the temple proper, which is divided between the holy place and the holy of holies (sanctum sanctorum). The plan, overall, establishes the tripartite division between the temple spaces that was later depicted by Lightfoot (q.v.). [Entry contributed by Sally Hickson.]

JOHN LIGHTFOOT (1602–75), *The Temple Especially as It Stood in the Days of Our Savior* (London, 1650). Lightfoot was a Cambridge Hebraist and a vocal

member of the Assembly of Westminster Divines, the parliamentary body formed under Oliver Cromwell in 1643 to standardize rituals and establish a governing body for the Reformed Church in England. His work on the temple is primarily concerned with describing its physical layout and the ritual functions performed in its courts and precincts, using these as models for the architectural, ritualistic, and political reorganization of the church in England. In the preface to the first edition of his *Temple Service*... (London, 1649), Lightfoot lamented that he had been unable to secure engravings of his temple plan and map of Canaan, both of which were printed for the first time in the collected edition of his *Works* (London, 1684 [see this volume, fig. 11]; a later edition, in Latin, was printed at Rotterdam in 1686). Lightfoot's ground plan is modeled on earlier published plans by Constantijn L'Empereur (1630) and Louis Cappel (1634) and on engravings made after the models by Rabbi Jacob Judah Leon (ca. 1642). All of these plans, drawn from Jewish sources, were concerned with accurately representing the temple according to the Jewish historical record. Accordingly, all position the temple asymmetrically within the outer court. Lightfoot's plan is essentially tripartite, proceeding from the inner court of the priests to the anteroom of the temple and then to the holy of holies, with staircases between them to indicate a clear hierarchical ascent through progressively more sacred spaces. His preoccupation with temple ritual led him to include small schematic drawings of the brazen altar and ritual furnishings. Although Lightfoot's intention was to depict the Jewish temple, it also clearly reflects his contemporary Cambridge environment by including elevations of collegiate Gothic towers, used to punctuate the outer perimeter wall and to mark the entrances to the outer court and temple. [Entry contributed by Sally Hickson.]

THOMAS FULLER (1608–61), *A Pisgah-Sight of Palestine*... (London, 1650). Fuller was a well-known London polygraph who wrote histories of the church in England and of Cambridge University as well as a popular compendium called *The History of the Worthies of England* (published posthumously in 1662). His *Pisgah-Sight* is primarily a geography of the Holy Land and contains a large engraved map of Canaan as well as several smaller maps devoted to the twelve tribes of Israel. The work also includes several engraved plates of the Temple of Jerusalem, including a bird's-eye view of the temple complex (from an oblique angle) incorporating a temple structure clearly borrowed from Arias Montanus (Polyglott Bible [Antwerp, 1583]) into a wholly original view of the courts and other temple buildings. His equally original ground plan corresponds directly to his imaginative integration of Montanus's temple into his own reconstruction of the temple courts. The *Pisgah-*

Sight also includes plates depicting Jewish costumes and a "collage" of ritual instruments used in temple ceremonies, making it an encyclopedic compendium of Jewish history and customs. All the plates are dedicated to individual sponsors, for the book was partly financed through subscriptions, one of the earliest examples of this kind of financing in the history of English publishing. [Entry contributed by Sally Hickson.]

WENCESLAUS HOLLAR (1607–77), *Biblia Sacra Polyglotta . . .* , 6 vols. (London, 1653–57). A prolific and meticulous Bohemian-born etcher, Wenceslaus Hollar completed approximately 2,700 etchings in his lifetime. Of this total, six represent the temple of Jerusalem. Four of them can be found in the *Biblia Sacra Polyglotta.* These images include the ark of the covenant (dated 1656), various elevations of the temple (dated 1657), the temple plan and architectural details (dated 1657) as designed by Juan Bautista Villalpando, and an etching of the temple based on a design by Louis Cappel. The printed source in which the two remaining etchings appeared, a bird's-eye view of the temple (dated 1659; see this volume, fig. 12) and an image of offerings being burned in the courtyard of the temple (dated 1660), is uncertain. Although a claim is made in Richard Pennington's *Descriptive Catalogue of the Etched Work of Wenceslaus Hollar* (Cambridge, 1982), 199–200 that the etchings were published in the Restoration Bible printed by John Field (Cambridge, 1660), they are not contained in Cambridge University's copy of that publication. What is certain is that Hollar fashioned the etchings based on Villalpando's architectural vision of the temple. Hollar's designs were later copied by various artists, including Johann Bernhard Fischer von Erlach (1656–1723). [Entry contributed by Alexandra Sharma.]

SAMUEL LEE (1625–91), *Orbis Miraculum, or The Temple of Solomon Portrayed by Scripture Light* (London, 1659). Lee was an Oxford-educated radical Puritan divine. His first published work was the *Orbis Miraculum, or The Temple of Solomon,* which he wrote as a direct response to plans of the temple that appeared for the first time in Bishop Bryan Walton's *Biblia Sacra Polyglotta . . . ,* published in London in 1653–57 (see Hollar, above). The London polyglot Bible contained a single engraved sheet illustrating Louis Cappel's Τρισάγιον, *sive Templi Hierosolymitani triplex delineato,* which depicts two ground plans, one of the temple described by Josephus, the other of the temple as described by Maimonides. Lee objected because no illustration in the *Biblia Sacra Polyglotta . . .* attempted to depict the temple built by Solomon, according to Old Testament accounts. His *Orbis Miraculum* contains thirteen crudely executed woodblock illustrations (not including the special engraved fron-

tispiece, illustrating Moses and Aaron in the desert, flanking a small model of the temple). Most of these illustrations are modeled after woodcuts made by Montanus for the Antwerp Polyglott Bible (1583), and they include rather crude interpretations of Montanus's bird's-eye view of the temple complex as well as his side view of the temple elevations. Several plates are details of the cherubim of the holy of holies and of the ritual instruments and ceremonial furnishings. Lee was undoubtedly motivated to use the Montanus illustrations from the Antwerp Polyglott Bible as a direct rebuke to the editors of the London polyglot Bible, but he was also following a precedent set in English temple scholarship by his contemporary Thomas Fuller (q.v.), who commissioned plates of the temple modeled on Montanus's woodcuts for the illustration of his *Pisgah-Sight of Palestine* (London, 1650). [Entry contributed by Sally Hickson.]

HUMPHREY PRIDEAUX (1648–1724), *The Old and New Testament Connected in the History of the Jews and Neighboring Nations, from the Declension of the Kingdoms of Israel and Judah to the Time of Christ*, 4th ed., 2 vols. (London, 1716–18). Prideaux's text relies heavily on Jewish sources such as the Talmud and Mishnah Torah, and on the Bible. The publication contains two images: a ground plan of the Temple of Jerusalem (this volume, fig. 9) and an illustration of the altar of burnt offerings. In the ground plan (whose source is the Talmud), the temple is placed asymmetrically within the courtyard. The square area before the entrance of the temple incorporates a Greek cross. On each side of the image is a description of the plan. The design is not new but derives from an image from Constantijn L'Empereur's book *Talmudis Babylonici codex Middoth, sive, De mensuris templi* (Leiden, 1630). The illustration of the altar of burnt offerings is based on John Lightfoot's description of the altar in his book, *The Temple Especially as It Stood in the Days of Our Savior* (q.v.). A similar image and a likely source for Prideaux's design is an illustration by either Hugo Willem Goeree (d. 1643) or Willem Goeree (1635–1711), titled *The Brazen Altar after Maimonides and Others.* Goeree's illustration was published in Petrus Cunaeus's book *Republijk der Hebreen* (Amsterdam, 1683). [Entry contributed by Megan Lindenbach.]

ISAAC NEWTON (1643–1727), *The Chronology of Ancient Kingdoms Amended . . .* (London, 1728). Published by John Conduitt a year after Newton's death, *The Chronology of Ancient Kingdoms Amended . . .* contains a chapter titled "A Description of the Temple of Solomon." Newton's text includes specific measurements of the temple based primarily on the prophecies of Ezekiel as well as detailed descriptions of the function of the temple's chambers and the du-

ties of elders and priests. Also, illustrations are found at the end of the chapter. They include a general ground plan that situates the temple within a square court, a ground plan of the inner court and buildings, and a ground plan showing one of the gates of the people's court. In Newton's restitution the temple is placed within the square court, thus ignoring the Jewish tradition as popularized by Rabbi Jacob Judah Leon (known as Templo). However, Newton's exclusive use of ground plans relates to the Judaic restitution by Maimonides (Moses ben Maimon, called Rambam, 1135–1204), who included a ground plan to accompany his text in the Mishnah Torah. The Cambridge University Library possesses two bound autograph manuscripts of the *Chronology*. The first lacks a chapter on the Temple of Solomon but ends with a reference to prophecies in Daniel, supporting the idea that the *Chronology* and interpretation of prophecy were meant to be connected somehow. In fact it is suggested that this work was intended as an introduction to an encyclopedia of the prophecies of the Old Testament. [Entry contributed by Eun-Hye Chung.]

ARTHUR BEDFORD (1668–1745), *The Scripture Chronology Demonstrated by Astronomical Calculations* . . . (London, 1730). The temple designs in Bedford's treatise are found at the end of his text, after the index, suggesting that the money to reproduce the images became available late in the printing stages. In the volume in Trinity College Library in Toronto, the plates are bound upside down. Although original in overall appearance, Bedford's work is a pastiche of the designs of others. His ground plan (this volume, fig. 8) derives directly from that of Juan Bautista Villalpando's *In Ezechielem explanationes* . . . (Rome, 1605). The basic shape of the structure in Bedford's *Prospect of the East Side of the Temple* corresponds to Humphrey Prideaux's design of the altar of burnt offerings (q.v.), including the addition of a sloping ramp that provides access to the different levels of the foundation. The influence of Prideaux as well as Lightfoot (q.v.) is further evident in the extraordinary ledges all around the temple in imitation of the same ledges on the altar. Bedford's inclusion of a cityscape originates from Bernard Lamy's third temple restitution in *De tabernaculo, foederis, de sancta civitate Jerusalem, et de templo ejus* (Paris, 1720). Bedford's temple facade is identical to Villalpando's, as is the number of buttresses used to support the foundation of the front of the temple. In addition to the plates that represent the temple mount and elevation, the publication includes a series of illustrations on one page. The illustrations include objects from the temple, plans intended to clarify the various temple terraces, and a bird's-eye view similar to the one by Goeree in Petrus Cunaeus's *Republijk der Hebreen* (Amsterdam, 1683). [Entry contributed by

WILLIAM STUKELEY (1623–1765). William Stukeley was best known as an antiquarian and a major pioneer in English archaeology. His friendship with Sir Isaac Newton (q.v.) is well known. In 1720 Stukeley had a discussion about the temple with Newton, and he apparently went back to the topic seven years later. But his response to *The Chronology of Ancient Kingdoms Amended . . .* (London, 1728) was very critical. He wrote to Robert Gale of the Society of Antiquaries on 17 February 1728: "Mr. Conduit has sent me Sir Isaac Newton's Chronology: I don't admire his contracting the spaces of time; he has pursued that fancy too farr. I am satisfied he has made severall names of different persons one, who really lived many ages asunder. He has come pretty near my ground plott of the temple of Solomon, but he gives us no uprights" (*The Family Memoirs of Rev. William Stukeley, M.D. . . .*, 3 vols., Surtees Society Publications, vols. 73, 76, 80 [Durham, Eng., 1882–87], 76:262). Stukeley's designs, held mainly in the Bodleian Library at Oxford University (BLO, MS Top. Gen. b. 52), include a ground plan, two bird's-eye views of the temple, two versions of the holy of holies, and several elevations inspired by contemporary English church architecture. The bird's-eye view of 1731 (this volume, fig. 58) depicts the temple with twelve courts, representing the twelve tribes of Israel. This is made explicit in the later ground plan by adding the names of the tribes in each of the courts. Significantly, the 1734 ground plan does not include the same division of courts but is based on Newton's design of the temple plan. [Entry contributed by Eun-Hye Chung.]

THOMAS STACKHOUSE (1677–1752), *A New History of the Holy Bible from the Beginning of the World, to the Establishment of Christianity*, 2 vols. (London, 1732–33). First released in 1733, *A New History of the Holy Bible* was published in a three-volume set in 1737. Another edition was published in London between 1742 and 1744. The first of Stackhouse's images is an elevation and ground plan of the temple copied from the designs of Juan Bautista Villalpando. The second is an image of the holy of holies copied from Bernard Lamy's illustration in his third book, *De tabernaculo, foederis, de sancta civitate Jerusalem, et de templo ejus* (Paris, 1720). A later edition of *A New History of the Holy Bible* published in 1752 contains four illustrations of the temple taken directly from Arthur Bedford's *Scripture Chronology* (q.v.). They are objects from the temple, the east prospect of the temple, the north prospect of the temple, and temple iconography, which consists of several plans intended to clarify the various temple terraces. In several instances a scriptural passage corresponding to the image

has been added to the reused copper plates of Bedford's book. Two later editions published in Kilmarneck in 1767 and in Glasgow in 1795 appear to share the same illustrations, including a plate relating to the temple. It is a combination of two images: an aerial view derived from Wenceslaus Hollar's design in Walton's *Biblia Sacra Polyglotta* (q.v.), and a plan taken from the one in the upper right hand corner of Arthur Bedford's plate representing the temple (this volume, fig. 8). An 1841 edition of *A New History of the Holy Bible* that was published in London contains an illustration titled *The Temple of Jerusalem.* The image is an exact copy of Bernard Lamy's ground plan of the Temple of Herod. [Entry contributed by Megan Lindenbach.]

WILLIAM WHISTON, trans. (1667–1752), *The Genuine Works of Flavius Josephus the Jewish Historian . . .* (London, 1737). The Cambridge-educated clergyman William Whiston was a professor of mathematics at his alma mater until he was dismissed in 1710 because of his unorthodox beliefs. Thereafter he became an itinerant preacher and lecturer largely living off his wits. He published prodigiously, and his writings unite the interest in the Temple of Jerusalem with the quest for primitive Christian virtues. Whiston turned that quest into almost a personal crusade. Some of his numerous books on the subject include *Primitive Infant Baptism Revived . . .* (London, 1711), *Primitive Christianity Revived . . .*, 4 vols. (London, 1711–12), and *Liturgy of the Church of England Reduced Nearer to the Primitive Standard* (London, 1713). Having once been Isaac Newton's protégé, Whiston later took exception to Newton's restitution of the temple, calling it a "sagacious romance" in his autobiographical memoirs (London, 1753). Nevertheless, when Whiston produced his own restitution in the late 1720s in the form of a wooden model, its plan took on a distinctly Newtonian character. This is particularly true of Whiston's proliferation of columns around the outer courtyard and his configuration of the inner courtyard with three deep entrances, each almost as big as the temple proper. The model served as a drawing card to his lectures, full of millennial predictions regarding the return of the Jews to the Holy Land and the end of the world. The only known representation of his temple appears in the large fold-out plate opposite page 689 in his translation of Josephus. The ground plan of the temple is embedded in profuse marginalia and bordered along the bottom with a strip of supplementary images. One of these vignettes, a crude aerial view, presumably records the ungainly appearance of Whiston's lost model with a spire on top, not unlike the one depicted by Stukeley (q.v.). [Entry contributed by Pierre du Prey.]

JOHN WOOD THE ELDER (1704–54), *Origin of the Building, or The Plagiarism of the*

Heathens Detected (Bath, 1741). Consisting of five books, *Origin of the Building* contains restitutions of the tabernacle, the court of the tabernacle, the Temple of Solomon, and the division of the city of the tribes of Israel according to the vision of Ezekiel, including plans of the camp of the Israelites, the camp of the tribe of Issachar, the camp of the tribe of Levi, and the camp of the Gershonites. The publication represents Wood's attempt to prove that the architecture of biblical times was divinely inspired and that it preceded the pagan origins of classical architecture. Wood believed that the advent of architecture could be traced to Moses and the tabernacle and that the classical tradition had merely plagiarized it. According to Wood, the Temple of Solomon was the stone magnification of the first architectural edifice, the wooden tabernacle. Although Wood simplified many of the problems associated with Solomon's Temple, he attempted to demonstrate that with a thorough knowledge of biblical history as he construed it one could reach an understanding of divine creation and achieve spiritual enlightenment. Although *Origin of Building* touches on British archaeology and the relation of the Druids to the Temple of Jerusalem, these theories were developed more fully in Wood's later book on the city of Bath. [Entry contributed by Hillary Barron.]

Sir Christopher Wren's Letter of Recommendations to a Friend on the Commission for Building Fifty New Churches

(The text is the one printed in *Parentalia* on pages 318–21; the original letter is presumed lost.)

SINCE PROVIDENCE, in great mercy, has protracted my age, to the finishing the cathedral church of St. Paul, and the parochial churches of London, in lieu of those demolished by the fire; (all which were executed during the fatigues of my employment in the service of the crown, from that time to the present happy reign;) and being now constituted one of the commissioners for building, pursuant to the late act, fifty more churches in London and Westminster; I shall presume to communicate briefly my sentiments, after long experience; and without further ceremony exhibit to better judgment, what at present occurs to me, in a transient view of this whole affair; not doubting but that the debates of the worthy commissioners may hereafter give me occasion to change, or add to these speculations.

1. First, I conceive the churches should be built, not where vacant ground may be cheapest purchased in the extremities of the suburbs, but among the thicker inhabitants, for convenience of the better sort, although the site of them should cost more; the better inhabitants contributing most to the future repairs, and the ministers and officers of the church, and charges of the parish.

2. I could wish that all burials in churches might be disallowed, which is not only unwholesome, but the pavements can never be kept even, nor pews upright. And if the church-yard be close about the church, this also is inconvenient, because the ground being continually raised by the graves, occasions, in time, a descent by steps into the church, which renders it damp, and the walls green, as appears evidently in all old churches.

3. It will be inquired, where then shall be the burials? I answer, in cemeteries seated in the outskirts of the town; and since it is become the fashion of the age to solemnize funerals by a train of coaches, (even where the deceased are of moderate condition) though the cemeteries should be half a mile, or more, distant from the church, the charge need be little or no more than usual; the service may be first performed in the church: but for the poor, and such as

must be interred at the parish charge, a public hearse of two wheels and one horse may be kept at small expense, the usual bearers to lead the horse, and take out the corpse at the grave. A piece of ground of two acres in the fields will be purchased for much less than two roods among the buildings: this being enclosed with a strong brick wall, and having a walk round, and two cross walks, decently planted with yew trees, the four quarters may serve four parishes, where the dead need not be disturbed at the pleasure of the sexton, or piled four or five upon one another, or bones thrown out to gain room. In these places beautiful monuments may be erected; but yet the dimensions should be regulated by an architect, and not left to the fancy of every mason; for thus the rich, with large marble tombs, would shoulder out the poor; when a pyramid, a good bust, or statue on a proper pedestal, will take up little room in the quarters, and be properer than figures lying on marble beds: the walls will contain escutcheons and memorials for the dead, and the area good air and walks for the living. It may be considered further, that if the cemeteries be thus thrown into the fields, they will bound the excessive growth of the city with a graceful border, which is now encircled with scavengers dung stalls.

4. As to the situation of the churches, I should propose they be brought as forward as possible into the larger and more open streets, not in obscure lanes, nor where coaches will be much obstructed in the passage. Nor are we, I think, too nicely to observe east or west in the position, unless it falls out properly: such fronts as shall happen to lie most open in view should be adorned with porticoes, both for beauty and convenience; which, together with handsome spires, or lanterns, rising in good proportion above the neighboring houses, (of which I have given several examples in the City of different forms) may be of sufficient ornament to the town, without a great expense for enriching the outward walls of the churches, in which plainness and duration ought principally, if not wholly, to be studied. When a parish is divided, I suppose it may be thought sufficient, if the mother-church has a tower large enough for a good ring of bells, and the other churches smaller towers for two or three bells; because great towers, and lofty steeples, are sometimes more than half the charge of the church.

5. I shall mention something of the materials for public fabrics. It is true, the mighty demand for the hasty works of thousands of houses at once, after the fire of London, and the frauds of those who built by the great, have so debased the value of materials, that good bricks are not to be now had, without greater prices than formerly, and indeed, if rightly made, will deserve them; but brick-makers spoil the earth in the mixing and hasty burning, till the bricks will hardly bear weight; though the earth about London, rightly managed, will yield as good brick as were the Roman bricks, (which I have often

found in the old ruins of the City) and will endure, in our air, beyond any stone our island affords; which, unless the quarries lie near the sea, are too dear for general use: the best is Portland, or Roche Abbey stone; but these are not without their faults. The next material is the lime; chalk lime is the constant practice, which, well mixed with good sand, is not amiss, though much worse than hard stone lime. The vaulting of St. Paul's is a rendering as hard as stone; it is composed of cockle-shell-lime well beaten with sand; the more labor in the beating, the better and stronger the mortar. I shall say nothing of marble, (though England, Scotland, and Ireland, afford good, and of beautiful colors) but this will prove too costly for our purpose, unless for altarpieces. In windows and doors Portland stone may be used, with good bricks, and stone quoins. As to roofs, good oak is certainly the best; because it will bear some negligence: the church wardens' care may be defective in speedy mending drips; they usually whitewash the church, and set up their names, but neglect to preserve the roof over their heads: it must be allowed, that the roof being more out of sight, is still more unminded. Next to oak is good yellow deal, which is a timber of length, and light, and makes excellent work at first, but if neglected will speedily perish, especially if gutters (which is a general fault in builders) be made to run upon the principal rafters, the ruin may be sudden. Our sea service for oak, and the wars in the North Sea, make timber at present of excessive price. I suppose 'ere long we must have recourse to the West Indies, where most excellent timber may be had for cutting and fetching. Our tiles are ill made, and our slate not good; lead is certainly the best and lightest covering, and being of our own growth and manufacture, and lasting, if properly laid, for many hundred years, is, without question, the most preferable; though I will not deny but an excellent tile may be made to be very durable; our artisans are not yet instructed in it, and it is not soon done to inform them.

6. The capacity and dimensions of the new churches may be determined by a calculation. It is, as I take it, pretty certain, that the number of inhabitants, for whom these churches are provided, are five times as many as those in the City, who were burnt out, and probably more than 400,000 grown persons that should come to church, for whom these fifty churches are to be provided, (besides some chapels already built, though too small to be made parochial.) Now, if the churches could hold each 2000, it would yet be very short of the necessary supply. The churches therefore must be large; but still, in our reformed religion, it should seem vain to make a parish church larger, than that all who are present can both hear and see. The Romanists, indeed, may build larger churches, it is enough if they hear the murmur of the mass, and see the elevation of the Host, but ours are to be fitted for auditories. I can hardly think it practicable to make a single room so capacious, with pews and galleries, as

to hold above 2000 persons, and all to hear the service, and both to hear distinctly, and see the preacher. I endeavored to effect this, in building the parish church of St. James's, Westminster, which, I presume, is the most capacious, with these qualifications, that hath yet been built; and yet at a solemn time, when the church was much crowded, I could not discern from a gallery that 2000 were present. In this church I mention, though very broad, and the middle nave arched up, yet as there are no walls of a second order, nor lanterns, nor buttresses, but the whole roof rests upon the pillars, as do also the galleries; I think it may be found beautiful and convenient, and as such, the cheapest of any form I could invent.

7. Concerning the placing of the pulpit, I shall observe—a moderate voice may be heard 50 feet distant before the preacher, 30 feet on each side, and 20 behind the pulpit, and not this, unless the pronunciation be distinct and equal, without losing the voice at the last word of the sentence, which is commonly emphatical, and if obscured spoils the whole sense. A Frenchman is heard further than an English preacher, because he raises his voice, and not sinks his last words: I mention this as an insufferable fault in the pronunciation of some of our otherwise excellent preachers; which school masters might correct in the young, as a vicious pronunciation, and not as the Roman orators spoke: for the principal verb is in Latin usually the last word; and if that be lost, what becomes of the sentence?

8. By what I have said, it may be thought reasonable, that the new church should be at least 60 feet broad, and 90 feet long, besides a chancel at one end, and the belfry and portico at the other. These proportions may be varied; but to build more room, than that every person may conveniently hear and see, is to create noise and confusion. A church should not be so filled with pews, but that the poor may have room enough to stand and sit in the alleys, for to them equally is the gospel preached. It were to be wished there were to be no pews, but benches; but there is no stemming the tide of profit, and the advantage of pew keepers; especially too since by pews, in the chapels of ease, the minister is chiefly supported. It is evident these fifty churches are not enough for the present inhabitants, and the town will continually grow; but it is to be hoped, that hereafter more may be added, as the wisdom of the government shall think fit; and therefore the parishes should be so divided, as to leave room for subdivisions, or at least for chapels of ease.

I cannot pass over mentioning the difficulties that may be found, in obtaining the ground proper for the sites of the churches among the buildings, and the cemeteries in the borders without the town; and therefore I shall recite the method that was taken for purchasing in ground at the north side of St. Paul's Cathedral, where in some places the houses were but 11 feet distant

from the fabric, exposing it to the continual danger of fires. The houses were seventeen, and contiguous, all in leasehold of the Bishop or Dean alone, or the Dean and Chapter, or the petty canons, with divers under tenants. First we treated with the superior landlords, who being perpetual bodies were to be recompensed in kind, with rents of the like value for them and their successors; but the tenants in possession for a valuable consideration; which to find what it amounted to, we learned by diligent inquiry, what the inheritance of houses in that quarter were usually held at: this we found was fifteen years purchase at the most, and proportionably to this the value of each lease was easily determined in a scheme, referring to a map. These rates, which we resolved not to stir from, were offered to each; and, to cut off much debate, which may be imagined every one would abound in, they were assured that we went by one uniform method, which could not be receded from. We found two or three reasonable men, who agreed to these terms: immediately we paid them, and took down their houses. Others who stood out at first, finding themselves in dust and rubbish, and that ready money was better, as the case stood, than to continue paying rent, repairs, and parish duties, easily came in. The whole ground at last was cleared, and all concerned were satisfied, and their writings given up. The greatest debate was about their charges for fitting up their new houses to their particular trades: for this we allowed one year's purchase, and gave leave to remove all their wainscot, reserving the materials of the fabric only. This was happily finished without a judicatory or jury; although in our present case, we may find it perhaps sometimes necessary to have recourse to Parliament.

George Hickes's Observations on John Vanbrugh's Proposals about Building the Fifty New Churches

BLY, Osborn/Hickes 17.363

BLY, Osborn/Hickes 17.363

OBSERVATIONS ON MR. VANBRUGGS PROPOSALS ABOUT BUILDINGE THE NEW CHURCHES [OBSERVATIONS UPON A PAPER SENT TO ONE IN COMMISSION FOR BUILDING THE NEW CHURCHES]

That people may not be disturbed in their devotions will depend upon the fabrick of seats, or pewes more than that of churches. Square pewes wherein in [*sic*] men, and women sit together, contrary to ancient order and decency, looking upon one another is not only a great but a scandalous hindrance to devotion, not to mention the almost constant clacking of locked pewes, which disturbes the whole congregation, and occasions the lesse devout to look, who it is that comes in. But the fabrick of pewes, hereafter mentioned, will also help very much, that the devotion of the people shall not be disturbed by too much crowding and heat.

The plans of the most primitive structure of churches, as described in Eusebius's history may be seen, not to mention other Authors in the third vol. of Mr. Bingham's Ecclesiastical Antiquities and there it will appear that the old way of building churches is capable of most if not all the state, and graces of Architecture, and as that way of building was the most ancient: so it is most fit to be imitated, and the same modelle will serve for building little, as well as great churches.

The Insular situation of churches w^th large, and spatious Areas about them (as this ingenious Architect [Vanbrugh] observes) is most convenient and that not only to secure them from fire, but for building the circumferential parts of them such houses as are requisite, as one for the Sexton, who may be as a watchman to the church, and another for the minister, churchwardens, and parish officers to meet in upon the parish-affaires, w^ch ought to be debated in the church or church-vestry, w^ch originally were designed for no other use, but for keeping the sacerdotal Robes, and holy vessels, and for the Robeing and unrobeing of the preists. And it being undoubtedly the intention of our church, y^t Adult persons should be immersed at baptisme, as well as infants; and it very frequently happning by the conversion of Jewes, Blacks, Quakers,

and the children of Antipaedobaptists etc. that the persons of riper years are to be baptised, I think also, that Baptisteries for that purpose, after the ancient manner ought to be built in the circumferential parts of those Areas: y^t the Apostolical institution, and practice of immersion may be revived in the Church of England, w^ch certainly the learned among the clergy (who know how many thousands of their Saxon Ancestors converted from Heathen sin were baptized in y^r manner) would be glad of.

And as the insular situation of churches is most convenient for the fore-said ends: so the situation of them East, and West according to the ancient manner of building churches ought to be observed. The learned clergy in the commission cannot but know, that the churches w^ch were first built after the Decennial persecution where in the IV^th century were all built East, and West. and so it is to be presumed were the churches built before it, because in their privat meeting-places, before they had publick churches, they worshiped God towards the East; w^ch was so universal, and constant a religious observation among them, that in their most ancient Apologies, they give an acc^t of it to the Gentiles, as of an inviolable rite, of their religion together w^th their faith, and worshiping of God through Jesus Christ. One would presume, y^t all Christians, who have any veneration for primitive Christian Antiquity and practise should not be indifferent w^th respect to the primitive Custome which the writers of the IV century regard among the Apostolical and the building of Churches conformeable to it, especially when the purchasing but of thirty, or forty foot of ground more or lesse at the national charge, will make it practicable in all places. If money is not to be spared to make these buildings strong, gracefull and magnificent as this Architect observes, neither is it to be spared to buy a little ground to make room for the situation of them in the way I propose.

If any of the churches are to be built of Brick, (tho stone is much more suitable to y^e magnificence requisite in such buildings) the Architects must take special care both of the Brick, and Cement, otherwise, as we shall see by daily examples of the new buildings in London since the fire, they will soon begin to mouldre and decay, and not like the Pyramids or Roman brick buildings last without violence, as the phrase is, to Eternity.

That the churches may not be too much crowded w^th pewes, nor the people too much crowded in them, I would recommend pewes of the narrow cubital structure w^th desks, for books, so narrow, that but one row of people can sit in them, and so low, y^t when they kneel, they may be but high enough to lean upon such kind of pewes, I think are in St. Peters Cornhill, of w^ch the late learned Bishop Beverige was Rector. Square, and high pewes are most indecent, and the occasion of much deplorable irreverence in churches, and ought

to be reformed. And while I am speaking my thoughts about pewes in churches, I cannot but wish for the honour of God, first that all pewes were of squat height, excepting those of magistrates (if they are to be excepted) wᶜʰ may be raised above others by two, or at most three steps, but not to be built higher. Secondly that no distinction of quality be made in churches by carpets, or other signes of worldly greatness, the noble and ignoble, the Rich, and poor being all equal in the house and worship and solemn presence of God, and I cannot think that Almighty God will accept of any man's devotion who affects state in his holy dwelling places. Thirdly, I cannot but wish, that in these new churches the Seats, or pewes for the men should be on one side, and those of the women in the other, according to the ancient custome, wᶜʰ cannot be unknown to the R[ight]. Reverend, Reverend and Learned clergymen nominated in the commission. Moveable formes ought also to be made for the empty spaces in the three ailes, for the poorer common sort, whose modesty will not let them sit among their betters, as also for those, who happen to come late to church, and these formes may be kept under the belfry, or on each side thereof, or contrived as those in ye midst of Choire at St. Pauls, to run undʳ yᵉ stals on each side.

As for lights, as they ought not to be too many, or too wide: so I think they ought not to be too few, or too narrow, because, it would make the air of a church too like that of a cave, or grotto, pernicious to the infirme, and to those who happen to come to church in a sweat especially, when it is thin, or empty. But one spacious window at the East end of the chancel, I think, would still be of great grace and ornamᵗ to a church.

It is worthily proposed by this famous Architect not to make churches burying places, but to purchase Coemetaries in the skirts of the town, about wᶜʰ I would not have bare walls built but large Cloysters, wᶜʰ would serve for a shelter in all ill wether for the people, and render the walls of wᶜʰ monuments may be built, like that of Mr. Cowley in Westminster-Abbey, or monumental tables of inscriptions fixed in them, wᶜʰ for that purpose ought to be very solid and thicke. As for planting them wᵗʰ trees to make a distinction between one part and another, it may be allowed, provided they be trees, that are evergreen, such as the cypresse, and have not great, and spreading roots; but as for lofty and noble Mausoleums for Statues they are in my opinion to be condemned as contrary to Christian humility, and ancient custome & certainly all good dying Christians would despise and forbid them and they would soon encumber the burying places, and therefore are not to be tolerated, but for such eminent [word unclear] benefactours to their country as public authority should command statues, and tombes to be erected for at publick charge. I think in each of those Coemeteries a charnel house or repository for bones,

and sculs ought to be built, because time, and great mortalities will make them needful.

In this paper there is no consideration had of chancels, wch I think it were convenient to raise two, or at most three steps above the Nave of the church, and thereby be free from all fixed seats, but have such as may easily be brought in at the time of the H. communion for the communicants to kneel at with their faces towards the altar. Neither is any mention made of fonts for baptiscing infants, wch I think ought to be made large and deep enough for immersion, and may be placed towards the west end of the church near the tower, as I have observed many ancient fonts to be. There is also no mention made of Vestrys properly, and primarily so called for the sacerdotal garments, and robeing, and unrobeing the priests, wch in the ancient churches were at the end of the south aile, or Ile over agr the altar, as the place for Repositing the peoples oblations of bread, and wine etc. was at the end of the north aile.

To conclude, I humbly conceive the gentlemen in Commission for building of churches will take care, that the new models of Architecture, do not exclude the old manner of building churches either as to forme, or situation East and West, as a late learned Authour in another language observes and complaines hath been often one of late by Architects of churches to show their skill, and get themselves a name particularly. It is to be hoped, that they will guard agr the Theatrical form, to wch many of our new churches, and chappels too nearly approach. Especially it will concern the clergymen in the Commission to use their endeavours, that new modelles and fashions, and customes do not prevail agr the old. I would not be understood as if I were agr the state, and magnificence of churches, because those I plead for are capable of as stately, and beautiful portiocos, battlements, and pinnacles without, as the new modelles can be, and within of as stately fonts, pulpits, vestrys, and Altar peices, wch are the principal structures within the church.

Rules for the Fifty New Churches Set Down by the Commissioners and Their Subcommittee

1. LPL, MS 2693, pp. 5–6, meeting of the subcommittee on 11 July 1712

The Committee further came to the Several Resolutions following, Viz.

That one General Modell be made and Agreed upon for all the fifty New intended Churches.

That the Scituation of all the said Churches be Insular where the Scites will admit thereof.

That the Ministers Houses be as near the said Churches as conveniently may be.

That there be at the East end of Each Church two small Roomes. One for the Vestments, another for the Vessells & other Consecrated things.

That there be at the West end of each Church, a convenient Large Room for Parish business.

That, the Fonts be so large as to be capable to have Baptism administered in them by dipping, when desir'd.

That, the Churches be all built with Stone on the Outside, and Lined with Brick on the Inside thereof.

That, the pews be all of Equal height, so low that every person in them may be seen, either Kneeling or Sitting, and so contrived that all persons may Stand and kneel towards the Communion Table.

That, Moveable Forms be so contrived as to run under the Seats of the Pewes, and draw out into the Isles upon occasion.

That, the Chancels be raised three Steps above the Nave or Body of the Churches.

That, there be handsome Porticoes at the West end of each Church where the Scite will admit of the same.

That, no Person shall be admitted a General Undertaker to build any of the said New intended Churches, but that every Artificer be separately agreed with, to perform the Work belonging to his particular Trade or business.

The Resolutions of the Committee on the 11 July Instant were read, and amendments made to Several of them; after which, they were agreed to by the Commissioners; and are as followeth: Viz.[1]

That, one general design or Forme be agreed upon for all the fifty New intended Churches, where the Scites will admit thereof; The Steeples or Towers excepted.

That, the Scituations of all the said Churches be Insular, where the Scites will admit thereof.

That, the Ministers Houses be as near the said Churches as conveniently may be.

That, there be at the East end of each Church two small Roomes, One for the Vestments, another for the Vessells or other Consecrated things.

That, there be at the West end of each Church a convenient large Room for Parish business.

That, the fonts in each Church be so large as to be capable to have Baptism be administred in them by dipping, when desired.

That the pewes be Single and of equal height, so low that every person in them may be seen either kneeling or Sitting, and so contrived that all persons may Stand or kneel towards the Communion Table.

That Moveable Forms or Seats be so contrived in the middle Isles, as to run under the Seats of the pewes, and draw out into the said Isles.

That the Chancels be raised three Steps above the Nave or body of the Churches.

That there be handsome Porticoes to each Church.

That no person shall be admitted a General Undertaker to build any of the said New intended Churches; but that every Artificer be separately agreed with to perform the Work belonging to his particular Trade or business.

ℵOTES

Chapter One

1. Allacci's book, which I will return to later in this chapter, has been published as *The Newer Temples of the Greeks,* trans. Anthony Cutler (University Park, Pa., 1969).

2. The archaeologist Jean-Pierre Adam went so far as to call them the most famous but least studied monuments in antiquity. See Jean-Pierre Adam and Nicole Blanc, *Les sept merveilles du monde* (Paris, 1989), 14. This book also provides a translation of Philo's partially preserved text (47–53).

3. Christopher Wren, comp., *Parentalia, or Memoirs of the Family of the Wrens* (London, 1750), 142. Eduard Sekler, *Wren and His Place in European Architecture* (London, 1956), 26 n. 2, notes that Dean Wren's association-copy of Wotton's book was in the library of Shirburn Castle, Oxfordshire.

4. John Summerson, *Architecture in Britain, 1530–1830,* 5th ed. (Harmondsworth, Eng., 1970), 301.

5. Vitruvius, *Les dix livres d'architecture de Vitruve,* trans. Claude Perrault, 2d ed. (Paris, 1684). This copy, formerly in the Graham Foundation's library in Chicago, is now in the Canadian Centre for Architecture, Montréal. It was presumably the copy still in Hawksmoor's library at the time of its sale in 1740. See David Watkin, ed., *Sale Catalogues of Libraries of Eminent Persons: Architects* (London, 1972), 104, lot 111. Queen's University at Kingston, Ontario, recently added to its collection Hawksmoor's copy of Michael Wright's *An Account of His Excellence Roger Earl of Castlemaine's Embassy from . . . James III . . . to His Holiness Innocent XI* (London, 1688) inscribed with great flourish on the flyleaf (see my frontispiece). Another book from Hawksmoor's library is a copy in the British Art Center at Yale University of David Loggan's *Cantabrigia illustrata, sive Omnium celeberrimae istius universitatis collegiorum, aularum, bibliothecae, academica scholarum publicarum . . .* (Cambridge, 1695?). On the title page the inscription reads: "Ex Libris N. Hawksmoor Anno 1695," which provides a useful terminus ante quem for the undated publication. It was lot 119 in the Hawksmoor sale.

6. An entry of 1676 records the large payment of £3 for this office copy. Kerry Downes, *Hawksmoor,* 2d ed. (London, 1979), 28 n. 46, claims this would probably be the Perrault translation (subsequent citations are to the second edition of *Hawksmoor* unless otherwise noted). Based on the wording of the account book entry ("for a Book, viz, Vitruves"), I agree with him. But Margaret Whinney, *Wren* (London, 1971), 52, maintains that Daniele Barbaro's Venice edition of 1556 is in question. Hawksmoor certainly owned a copy of the 1567 second edition of Barbaro (Watkin, *Sale Catalogues,* 102, lot 70).

7. Eileen Harris, *British Architectural Books and Writers, 1556–1785* (Cambridge, 1990), 463, quoting from a statement that Evelyn made in 1697 and later printed in the appendix called *Account of Architects and Architecture*, added to the 1719 edition of his translation of Fréart de Chambray's *Parallèle*. For more on Evelyn and Fréart see note 36 below. Harris also discusses Evelyn's relationship with the Latinist Christopher Wase (1625–90). See note 8 below.

8. Robert Hooke, *The Diary of Robert Hooke, 1672–1680,* ed. Henry Robinson and Walter Adams (London, 1935), 250. Hooke himself owned Perrault's first edition of Vitruvius as well as two Latin editions. See H. A. Feisenberger, ed., *Sale Catalogues of Eminent Persons: Scientists* (London, 1975), 67, lots 294 and 292–93, respectively.

9. Wren, *Parentalia,* tract 2, 356, alludes to it derisively as the "flower de luce [capital] of the French." In general Wren had every reason to admire Perrault and regard him as his French counterpart. One would like to think they knew one another, but there is no real evidence to support the notion. Wren's letter written to an anonymous correspondent from Paris in 1665 (*Parentalia,* 261–62) does not mention Perrault among his Parisian acquaintances.

10. Whinney, *Wren,* 53, mentions the possible debt of Wren's churches to the Fano engraving, and she also notes that the idea of galleried side aisles came from another French source: the Protestant Temple at Charenton.

11. Downes, *Hawksmoor,* 21, authoritatively identified the drawing as by Hawksmoor. Previously *The Wren Society,* vol. 19 (Oxford 1942), had identified it as by Sir Christopher Wren in the caption to its plate 78.

12. Geoffrey Webb, "The Letters and Drawings of Nicholas Hawksmoor relating to the Building of the Mausoleum at Castle Howard, 1726–1742," *Walpole Society* 19 (1930–31): 136.

13. Wren, *Parentalia,* 367–68.

14. See Lawrence Weaver, "The Interleaved Copy of Wren's *Parentalia* with Manuscript Insertions," *Royal Institute of British Architects Journal,* 3d ser., 18 (1911): 569–83, esp. 569; and on the Royal Society's manuscript see Weaver, "Memorials of Wren," *Architectural Review* 26 (1909): 175–83, esp. fig. 9.

15. Watkin, *Sale Catalogues,* 16, 23 for Wren (lot numbers 188 and 292 list printed editions of 1635 and Jean Hardouin's French translation of 1723); 103–4 for Hawksmoor (lot numbers 84 and 99 list an undated edition and a Frankfort 1599 edition).

16. Lydia Soo's useful new compendium *Wren's "Tracts" on Architecture and Other Writings* (Cambridge, 1998) covers the whole of Wren's written output and pays attention, as never before, to his musings on the history of architecture.

17. Claude Perrault, *Ordonnance for the Five Kinds of Columns after the Method of the Ancients,* trans. Indra Kagis McEwen (Santa Monica, Calif., 1993). Arthur T. Bolton in some editorial notes on *Parentalia* in *Wren Society,* 19:124, made a connection between Wren and Charles Perrault.

18. Wren referred to the Pliny letter (bk. 9, letter 39) according to which the writer instructed his architect, Mustius, to supply him with any columns he could find, no matter what the order.

19. John Summerson opened up the modern debate in 1948 with "The Mind of Wren," reprinted in his *Heavenly Mansions and Other Essays on Architecture,* 2d ed. (New York, 1963), 79–82. The following are some of the subsequent opinions: Sekler, *Wren,* 50–57; Whinney, *Wren,* 199–203; Kerry Downes, *Christopher Wren* (London, 1971), 47–49; J. A. Bennett, "Christopher Wren: The Natural Causes of Beauty," *Architectural History* 15 (1972): 5–22;

Wolfgang Herrmann, *The Theory of Claude Perrault* (London, 1973); Joseph Rykwert, *The First Moderns: The Architects of the Eighteenth Century* (Cambridge, Mass., 1980); Harris, *British Architectural Books;* Hanno-Walter Kruft, *A History of Architectural Theory: From Vitruvius to the Present,* trans. Ronald Taylor, Elsie Callander, and Antony Wood (New York, 1994), 234–35; but Soo, *Wren's "Tracts,"* 133–52, discusses the theoretical writings without neglecting Wren's historical interest and knowledge (120–33).

20. For the Wren and Hawksmoor collections of travel books see Watkin, *Sale Catalogues,* passim, and for Hooke see Feisenberger, *Sale Catalogues,* passim. Hugh May's signed copy of George Sandys's *A Relation of a Journey Begun Anno Domini 1610 in Four Books* (London, 1615) is in the collection of Queen's University at Kingston, Ontario, and has been discussed by Samantha Mussells, "Architects, Travellers, and the Revival of the Early Christian Basilica," in *Architects, Books, and Libraries: A Collection of Essays,* ed. Pierre de la Ruffinière du Prey (Kingston, Ont., 1995), 9–15. Wren also owned a copy of Sandys's account.

21. Downes, *Hawksmoor,* 29. The original Jean Marot engravings that served as Hawksmoor's source for his Baalbec reconstructions have been fully discussed and well illustrated in Robert Berger's *The Palace of the Sun: The Louvre of Louis XIV* (University Park, Pa., 1993), appendix D.

22. Webb, "Letters and Drawings," 135–36.

23. The contemporary statement about Saint George's portico comes from William Stukeley, *The Family Memoirs of Rev. William Stukeley, M.D. . . . ,* 3 vols., Surtees Society Publications, vols. 73, 76, 80 (Durham, Eng., 1882–87), 80:9, an extract from Stukeley's diary entry for 17 February 1750 ("Hawksmoor made the portico of Blomesbury church in imitation, and the size, of that at Balbeck"). Howard Colvin, "Fifty New Churches," *Architectural Review* 107 (1950): 195 n. 60, mentions this statement. For more about Stukeley see chapter 3, notes 41 and 59 below and figures 57 and 58.

24. Christopher Wren, "Discourse on Architecture. By S. C: W:," 7, inserted in Wren, *Parentalia.* Ibid., tract 4, 360, rephrases this statement slightly as follow: "Great monarchs are ambitious to leave great monuments behind them; and this occasions great inventions in mechanic arts." To my mind the slightly more polished prose of the printed version suggests that the "Discourse" predates it. I disagree on this point with Harris, *British Architectural Books,* 507–8 n. 27. She sees the "Discourse" coming after the tracts.

25. The facts regarding the mausoleum are given in Wren, *Parentalia,* 331–33, and are well laid out by J. Douglas Stewart in his essay "A Mililant, Stoic Monument: The Wren-Cibber-Gibbons Charles I Mausoleum Project: Its Authors, Sources, Meaning, and Influence," in *The Restoration Mind,* ed. W. Gerald Marshall (Newark, Del., 1997), 21–64. On pages 44–45 Stewart refers in passing to the resemblance between Wren's restitution of the Halicarnassus mausoleum and the Charles I Mausoleum project, but he does not mention the tomb of Porsenna in this connection.

26. Hooke, *Diary of Robert Hooke,* 317, 320–22. Presumably by this time Hooke owned his own copy of Pliny. In December 1678 he certainly purchased one at auction (388, 390). Cf. Robert W. T. Gunther, *Early Science in Oxford,* 15 vols. (Oxford, 1923–67), 10:98, 176, 178, for other references to Pliny in translation. Feisenberger, *Sale Catalogues,* 68, lot 23, lists a Pliny in Domenichi's Italian translation published at Venice in 1573. Soo, *Wren's "Tracts,"* 121–22, gives a full account of Porsenna's tomb as visualized by Wren and Robert Hooke.

27. Downes, *Hawksmoor,* 27, suggests that the Porsenna restitution may have inspired Wren's design for the catafalque for the state funeral of Queen Mary in 1695, and he refers his

readers to an illustration of it in *The Wren Society,* vol. 5 (Oxford, 1928), plate opposite p. 12. But the connection, if one does exist, must be tenuous. The catafalque has four obelisks rather than five pyramids, and they break through rather than support a circular disk from the top of which are draped flags rather than the wind bells so engagingly described by Pliny.

28. Webb, "Letters and Drawings," 117, letter dated 3 September 1726.

29. Downes, *Hawksmoor,* 266, lists Mrs. Hawksmoor's bill and on 223 gives the relevant details from the Hawksmoor sale, subsequently published by Watkin, *Sale Catalogues,* 87, lot 153.

30. *Read's Weekly Journal,* no. 603, 27 March 1736. It is reprinted by Downes, *Hawksmoor,* 6–7, which attributes it to Nathaniel Blackerby, Hawksmoor's son-in-law.

31. Wren, "Discourse," 3 (Tower of Babel); 5 (Joseph in Egypt); 10 (the walls of Babylon).

32. Comments on the "Discourse" and its historical sources tend to be sparser than those on the tracts. See Sekler, *Wren,* 51–52; Downes, *Hawksmoor,* 27; and Kruft, *History of Architectural Theory,* 233–35. Arthur T. Bolton, in an editorial note to *The Wren Society,* 19:122 and pl. 79, identifies the source of Wren's discussion of Absalom's tomb as Cornelis Le Bruin's *Voyage au Levant . . .* (Delft, 1700), also published as *A Voyage to the Levant . . .* (London, 1702). *Parentalia,* 359 n. a, refers to Le Bruin as Le Bruyn. The Wren family library contained a copy of the 1702 English translation, according to Watkin, *Sale Catalogues,* 15, lot 140. Soo, *Wren's "Tracts,"* 122–23, provides evidence that Wren compiled drawings of biblical buildings based on his readings of Flavius Josephus's *Antiquities of the Jews.* In contrast, my interpretation of Wren's writings suggests that he drew most of his inspiration directly from "Holy Writ," as he put it, rather than from the Roman Jewish historian Josephus.

33. Wren, "Discourse," 8. I have referred to the Loeb Classical Library edition of the writings of Josephus, translated by H. St. John Thackeray, Ralph Marcus, and others.

34. Wren, *Parentalia,* tract 4, 360. This passage repeats verbatim the one in the "Discourse," 7.

35. Despite different dates for each of the three volumes, they were all issued in 1605, according to John B. Bury in Dora Wiebenson, ed., *Architectural Theory and Practice from Alberti to Ledoux* (Chicago, 1982), item II–1, and Harris, *British Architectural Books,* 113 n. 19. Villalpando's work has recently been translated into Spanish under the title *El templo de Salomón,* trans. José Luis Oliver Domingo, 2 vols. (Madrid, 1991), and it has a useful companion volume of scholarly essays edited by Juan Antonio Ramirez, *Dios, arquitecto: J. B. Villalpando y el templo de Salomón* (Madrid, 1991).

36. Geoffrey Keynes, *John Evelyn: A Study in Bibliography,* 2d ed. (Oxford, 1968), 166, letter from Evelyn to Wren of 4 April 1665. Keynes notes that Evelyn also gave copies to the Queen Mother and the lord chancellor. Wren's copy, inscribed "For my most honor'd Friend Dr. Wren," was sold at Sotheby's in 1928. Wren presented a copy himself to the Savilian Library, and it is still at Oxford according to Bennett, "Christopher Wren," 22 n. 91. Wren knew Fréart's writings for a long time and quoted from one of them in his anonymous letter of 1665 sent from Paris (Wren, *Parentalia,* 262).

37. Roland Fréart de Chambray, *A Parallel of the Ancient Architecture with the Modern,* trans. John Evelyn (London, 1664), 74. For the interest in Fréart's Temple of Jerusalem material shown by Dean Henry Aldrich of Christ Church, Oxford, see Harris, *British Architectural Books,* 111–12.

38. On Hooke's ownership see Feisenberger, *Sale Catalogues,* 100, lot 109, and for Hawksmoor see Watkin, *Sale Catalogues,* 104, lot 108. For Wren's ownership see note 36 above.

39. The letter in the Koninklijke Bibliotheek in The Hague (MS KAXLVIII) goes on to say that similar introductions were written to the Portuguese ambassador in London, to Lord Arlington, and to Henry Oldenburg, the secretary of the Royal Society. The letter also asks Wren to try to get an audience for Rabbi Leon with the archbishop of Canterbury. I owe the translation of the Latin passage in the letter to my colleague Ross Kilpatrick and the careful transcription from the original to Odilia Bonebakker. It has been published in *Rijks Geschiedkundige Publikaten*, no. 32 (1917), by J. A. Worp, 274–75. I initially owe the reference to Helen Rosenau, *Vision of the Temple: The Image of the Temple of Jerusalem in Judaism and Christianity* (London, 1979), 135 and 141 n. 4. Rosenau gives the wrong date and misidentifies the sender as Christiaan Huygens (1629–95), the discoverer of wave mechanics, the son of Constantijn. Wren also knew Christiaan, because a copy of his book *Horologium oscillatorium* (Paris, 1673), inscribed "Pour Monsieur Wren," is in the Thomas Fisher Rare Book Library, University of Toronto. Concerning this book, see Jonathan Bikker, "Re-reading Wren's Mind in the Light of the Bookish Evidence," in *Architects, Books, and Libraries: A Collection of Essays,* ed. Pierre de la Ruffinière du Prey (Kingston, Ont., 1995), 16–23. The Rabbi Leon model is also briefly mentioned in Soo, *Wren's "Tracts,"* 123.

40. See in Ramirez, *Dios, arquitecto,* René Taylor's essay "Datos biographicos," 157–67, discussing the training of Villalpando under Herrera. On the Escorial in particular see Taylor, "Architecture and Magic," in *Essays in the History of Architecture Presented to Rudolf Wittkower,* ed. Douglas Fraser, Howard Hibbard, and Milton J. Lewine (London, 1967), 81–109.

41. Most of this information is contained in W. J. Chetwolde Crawley, "Rabbi Jacob Jehudah Leon," *Transactions of the Quatuor Coronati Lodge* 12 (1899): 150–58, and in various responses to that article by Crawley's brother Freemasons (158–63). According to Graham Midgely, the editor of John Bunyan's *Solomon's Temple Spiritualized: The House of the Forest of Lebanon: The Water of Life* (Oxford, 1989), xxx, the viewing of the model was advertised in the *City Mercury* newspaper in February 1675. It was said to have been already seen by "his Majesty and several persons of quality." I owe this reference to Sally Hickson. The ultimate fate of the model is unknown, but it still survived in 1778 in the possession of M. P. de Castro, according to Lewis Edwards, "Rabbi Jacob Jehuda Leon," *Transactions of the Quatuor Coronati Lodge* 73 (1961): 52–54. Ramirez, "Jacob Juda Leon y el modelo tridimensional del templo," in *Dios, arquitecto,* 100–103, covers much the same ground as does Alex Horne, *King Solomon's Temple in the Masonic Tradition* (Wellingborough, Eng., 1972), but neither gives proper references to the Masonic articles cited above. See also Rosenau, *Vision of the Temple,* 133–35.

42. Hooke, *Diary of Robert Hooke,* 179 (for the model). Page 209 records the cost of a copy of Villalpando, but neither Hooke's library nor Wren's nor Hawksmoor's apparently contained one. Hooke's word "module," of course, could have a specific architectural meaning with respect to the temple order's dimensions. But in checking over Hooke's various other uses of the word "module" in the diary, I believe that "model" is the correct interpretation.

43. See appendix 1; Frank E. Manuel, *Isaac Newton as Historian* (Cambridge, Mass., 1963); and also René Taylor's essay "Isaac Newton: Persistencia de la interpretacion mistica," in Ramirez, *Dios, arquitecto,* 139–42. A full discussion of Newton and the temple remains to be written.

44. Arthur Bedford, *The Scripture Chronology Demonstrated by Astronomical Calculations. . . . Together with the History of the World, from the Creation, to the Time When*

45. Ibid., i, vi. Bedford's earlier work in response to Newton was titled *Animadversions upon Sir Isaac Newton's Book Entitled the Chronology of Ancient Kingdoms Amended* (London, 1728).

46. Joseph Mead, *Key to Revelation, Searched and Demonstrated out of the Natural and Proper Character of the Visions,* trans. Richard More (London, 1643), compendium at the end of the book and pt. 2, 2–5. Cf. Mead, *Clavis apocalyptica* . . . (Cambridge, 1627), pt. 2, 121.

47. Joseph Mead, *The Reverence of God's House: A Sermon Preached at St. Marie's in Cambridge, before the University on St. Matthias's Day, Anno 1635* (London, 1638), 81, 96. I owe this reference to David H. Smart, "Primitive Christians: Baroque Architecture and Worship in Restoration London" (Th.D. diss., University of Toronto, 1997).

48. Foulke Roberts, *God's Holy House and Service according to the Primitive and Most Christian Form Thereof* (London, 1639), 7–8. The imprimatur is dated 31 July 1638. The reference to Mead's writings is to his book *Churches, That Is Appropriate Places for Christian Worship* . . . (London, 1638).

49. Roberts, *God's Holy House,* 33–34.

50. *De Templis, a Treatise of Temples: Wherein Is Discovered the Ancient Manner of Building, Consecrating and Adorning of Churches* (London, 1638). The imprimatur is dated 13 April 1638. The quotations come from pages 158, 58, and 201, respectively. See also the article by John Newman that brought Roberts and R. T. to light, "Laudian Literature and the Interpretation of Caroline Churches in London," in *Art and Patronage in the Caroline Courts: Essays in Honour of Sir Oliver Millar,* ed. David Howarth (Cambridge, 1993), 168–88.

51. John Lightfoot, *The Temple Especially as It Stood in the Days of Our Savior* (1650), in *The Works of the Reverend and Learned John Lightfoot D.D. . . . with Three Maps: One of the Temple Drawn by the Author Himself . . . ,* ed. George Bright, 2 vols. (London, 1684), 1:1065. The persons Lightfoot claimed were capable of having seen the two temples would have had to be almost as old as Methuselah! The section on the architecture of the temple runs from 1049–1170 (owing to a printer's error, the table of contents claims the last page is 2070). A variant title in the two-volume collected works is given as *A Prospect of the Temple Especially as It Stood in the Days of Our Savior.* Lightfoot lists the five divine attributes of the original temple missing from the later structures as follows: the ark; the Urim and Thummin; the fire from heaven; the cloud of glory upon the mercy seat; and the spirit of prophecy. Humphrey Prideaux, *The Old and New Testament Connected in the History of the Jews and Neighboring Nations . . . ,* 4th ed., 2 vols. (London, 1718), 1:145, follows Lightfoot's list implicitly and acknowledges him on many other points as well. I thank the Reverend Brian Prideaux for helpful information about his ancestor.

52. Lightfoot, *Temple Especially,* in *Works,* page opposite 1:1048. The earlier preface is page opposite 1:895 in the same edition of the collected writings.

53. Lightfoot, "Appendix to the Author's Life" by John Strype, in *Works,* 1:xi. Strype states: "This last edition [1684] of his works exhibits . . . the Temple itself accurately drawn by the doctor's own hand upon vellum and now printed from that original." The fate of the vellum plan is unknown. Could it be preserved together with the manuscript of the text said to be in Chetham's Library, Manchester? The Rotterdam 1686 edition reproduces the plan in a virtually identical form. It was later reengraved to accompany Johannes Jacob Scheuchzer's

Kupfer-Bibel, in welcher die Physica Sacra, oder geheiligte Naturwissenschaft deren in
heilige Schrift vorkommenden natürlichen Sachen, deutlich erklärt und bewährt . . . , 4 vols.
(Augsburg, 1731–35).

54. Lightfoot, *Temple Especially,* in *Works,* 1:1065. A useful and more easily accessible
edition of Lightfoot is the one edited by John Rogers Pitman and titled *The Whole Works of
the Rev. John Lightfoot, D.D., Master of Catherine Hall Cambridge,* 13 vols. (London,
1825–33). Prideaux, *Old and New Testament Connected,* 1:144, wrote perspicaciously:
"Solomon's Temple . . . was but a small pile of building . . . no more than 150 foot in length . . .
which is exceeded by many of our parish churches."

55. Lightfoot, "the author's life" by George Bright, in *Works,* 1:6–7.

56. *Biblia Sacra Polyglotta . . .* , ed. Bryan Walton, 6 vols. (London, 1653–57), 1:51–53; John
Lightfoot's *Animadversiones in tabulas chorographicas Terrae Sanctae* (the maps are op-
posite p. 53); and ibid., 1:1–38; Louis Cappel, Τρισάγιον, *sive Templi Hiersolymitani triplex
delineatio . . .* (the Hollar etched plate is opposite p. 38). On the temple studies of Cappel see
Wolfgang Herrmann, "Unknown Designs for the Temple of Jerusalem by Claude Perrault,"
in *Essays in the History of Architecture Presented to Rudolf Wittkower,* ed. Douglas Fraser,
Howard Hibbard, and Milton J. Lewine (London, 1967), 157.

57. A case in point is the copy of the *Biblia Sacra Polyglotta* that I was able to examine
in the American Bible Society Library in New York City, for which I have to thank the li-
brarian, Dr. Lianna Lupas. Although several of its plates are still bound in place, all that re-
mains of one of Hollar's foldouts of temple plans is a tiny torn stub. Furthermore, the Bader
Temple Collection at the Agnes Etherington Art Centre, Queen's University at Kingston,
Ontario, has a nearly full set of the Hollar plates removed from the *Biblia Sacra Polyglotta.*
Identical fold marks on two of the prints suggest that they were removed from the same copy.
The collection came from the London rare book dealer Ben Weinreb, but nothing more is
known about the prints' provenance, despite my discussions with the late Mr. Weinreb and
with Dr. Robert Jan van Pelt, who collaborated with him on assembling the collection.

58. Here a note of caution is necessary. The destination of Hollar's last two temple prints,
dated 1659 and 1660, is said to be the Field-Ogilby Bible by the etcher's first biographer,
George Vertue, *Description of the Work of the Ingenious Delineator and Engraver Wences-
laus Hollar . . . ,* 2d ed. (London, 1759), 103. This traditional attribution seems to have been
taken more or less on faith by Gustav Parthey, *Wenzel Hollar: Beschriebendes Verzeichniss
seiner Kupferstiche* (Berlin, 1853), 243, and more recently by Richard Pennington, *A De-
scriptive Catalogue of the Etched Work of Wenceslaus Hollar* (Cambridge, 1982), 199. Nei-
ther Parthey nor Pennington, however, states clearly which copies of the Field-Ogilby Bible
he consulted. My researches in the New York Public Library, and those of Alexandra Sharma
elsewhere, failed to turn up a copy of the 1660 or 1659 Field-Ogilby Bible containing all or
even most of the Hollar prints ascribed to them. The clearest indication of the inclusion of
the last two temple plates in the copy of the 1660 Bible in the British Library is given by
Katharine S. van Eerde, *John Ogilby and the Taste of His Times* (Folkestone, 1976), 44. For
the relation between the two editions of this Bible see T. H. Darlow and H. F. Moule, *His-
torical Catalogue of Printed Editions of the English Bible, 1525–1961,* ed. Arthur Sumner
Herbert, 2d ed. (London, 1968).

59. Watkin, *Sale Catalogues,* 82–83, see esp. lot 25, and also lots 18, 24, 33, 44, 58, 69, and
72.

60. William Beveridge, "The Excellence and Usefulness of the Common Prayer:
Preached at the Opening of the Parish Church of St. Peter's, Cornhill, the 27th of Novem-

ber 1681," in *The Theological Works of William Beveridge,* 12 vols. (Oxford, 1842–46), 6:367.

61. Paul Jeffery, *The City Churches of Sir Christopher Wren* (London, 1996), 327–28. Jeffery strongly hints at Hooke's design role but omits to mention such diary entries as Thursday, 1 April 1675 ("with [John] Oliver [the City surveyor], and [Sir Gilbert] Sheldon [future lord mayor of London], &c. about St Peters Cornhill"); 22 June 1672 ("With Sir Ch. Wren to St. Peters and St. Clements"); 13 October 1677 ("To Sir Ch. Wrens, agreed with [Joshua] Marshall [the mason] about St. Peters"); 16 August 1678 ("Stopt Olivers proceedings at St. Peters"); 20 August 1678 ("St. Peters minister [William Beveridge] interrogated at Allhallows"); 15 January 1679 ("the churchwardens of St. Peters [gave me] one £5 ☉ [Hooke's symbol for gold]"); 13 January 1680 ("With Sir Ch. Wren at St. Peters"). See Hooke, *Diary of Robert Hooke,* 156, 109, 320, 372 (both entries for August 1678), 393, 425. These and other entries on Saint Peter's have mercifully been tabulated from the poorly indexed printed diary by Margaret 'Espinasse in her biography, *Robert Hooke* (London, 1958), 179 n. 46.

62. See Gunther, *Early Science in Oxford,* 10:209 (entry for Sunday, 29 January 1693, "M[ary, his servant] at St. Peters. Dr. Beveridg"); 134 (entry for Sunday, 7 July 1689, "To St. Peters. Rd. [received] Sacramt of Perry").

63. Berveridge, *Theological Works,* 6:388–89.

64. Ibid., 389. George William Addleshaw and Frederick Etchells, *The Architectural Setting of Anglican Worship* (London, 1950), 41, discuss Beveridge's chancel screen in the context of medieval practices. This comparison is true in a sense, but it is strange that they overlook Beveridge's early Christian sources for the practice, since they knew he was the author of the Συνοδικόν and had illustrated in it an early Christian church plan with a chancel screen (83 n. 1). Their idea is followed by Sekler, *Wren,* 72, who interprets Beveridge's screen as "a continuation of a type sanctioned by medieval tradition." In a discussion of liturgy, Jeffery, *City Churches,* 161, stresses that the chancel screen was installed at Beveridge's "instigation."

65. William Beveridge, Συνοδικόν, *sive Pandectae canonum SS. Apostulorum, et conciliorum ab ecclesia Graeca receptorum; nec non canonicarum SS. Patrum epistolarum . . .* , 2 vols. (Oxford, 1672), 1:71–77. The fuller title of Goar's book is Ευχολογιον, *sive Rituale Graecorum, complectens ritus et ordines divinae liturgiae . . . illustratum.* The word *illustratum* refers to four plans placed opposite pages 13, 21, 26, and 27. The second of these is the one copied in the lower left corner of my figure 14.

66. Emanuel Schelstrate, *Sacrum Antiochenum concilium pro Arianorum conciliabulo passim habitum . . .* (Antwerp, 1681), plate opposite p. 186.

67. Beveridge, *Theological Works,* 6:388.

68. I am quoting from the sixth edition of Cave's popular *Primitive Christianity, or The Religion of the Ancient Christians in the First Ages of the Gospel* (London, 1702), 89.

69. Addleshaw and Etchells, *Architectural Setting,* 41, claim that Beveridge's chancel screen (and by extension Cave's) was "rather against Wren's wishes." I find no evidence for this assertion unless it is Robert Hooke's "interrogation" of Beveridge on 20 August 1678 (see note 61 above). I am puzzled by this diary entry not least because the "interrogation" took place at "Allhallows." Could this be All Hallows Barking, where George Hickes became the minister in 1680, or All Hallows-the-Great, where Cave was about to become the minister? The screen at Saint Peter's is still in its original location. For a good illustration of it see Colin Amery's *Wren's London* (London, 1988), 139. All Hallows-the-Great was demolished in 1895, and the fittings were dispersed to various places. Its chancel screen ended up at Saint Margaret's Lothbury Street. For a discussion see Paul Jeffery, "The Great Screen of All Hallows-

the-Great," *Transactions of the Ancient Monuments Society* 37 (1993): 157–64. Jeffery dates the screen to shortly after 1682 but does not connect it with Cave's rectorship at All Hallows or with his writings.

70. LPL, MS 3286, fols. 33r–36r. The manuscript was acquired at Christie's in 1985, and I am grateful to the librarian of the Lambeth Palace Library, E. G. W. Bill, for allowing me to consult it so soon after its purchase. Edward Cheney very kindly supplied me with the printed version of the autobiography, but it omits the letter. See George Wheler, *Autobiography of Sir George Wheler*, ed. E. G. Wheler (Birmingham, 1911). I will refer in these notes to the manuscript version. Wheler was knighted in 1682.

71. LPL, MS 3286, fol. 15v.

72. For a good general discussion of Spon and Wheler's books see Dora Wiebenson, *Sources of Greek Revival Architecture* (London, 1969).

73. Rykwert, *First Moderns*, 266.

74. George Wheler, *An Account of the Churches, or Places of Assembly of the Primitive Christians, from the Churches of Tyre, Jerusalem and Constantinople Described by Eusebius, and Ocular Observation of Several Very Ancient Edifices of Churches Yet Extant in Those Parts; with a Reasonable Application* (London, 1689), 11.

75. Ibid., 20–24.

76. Ibid., 29, and esp. 65, which cites Beveridge's tripartite church plan and takes issue with it.

77. Ibid., 21. Rykwert, *First Moderns*, 266–67, reproduces both engravings without commentary.

78. Wheler, *Account*, 64.

79. Ibid., 55. Wheler's words paraphrase closely those of the translation of Eusebius by Wye Saltonstall titled *Eusebius His Life of Constantine in Four Books: With Constantine's Oration to the Clergy* (London, 1649), 70.

80. Wheler, *Account*, 27–28. Wheler refers his readers to the writings on Hagia Sophia of Guillaume-Joseph Grelot (see note 85 below). Wheler, *A Journey into Greece by George Wheler Esq. in Company with Dr. Spon of Lyon* (London, 1682), 181–82, also passes over Hagia Sophia very lightly.

81. Wheler, *Account*, 37, 103.

82. Ibid., 68, 70 (regarding ancient practices) and 120 (regarding modern malpractices). With respect to galleries, Wheler was aware of French Protestant precedent, perhaps through contact with Spon, because on page 118 he cites the book by Paul Colomiés, *Parallèle de la pratique de l'église ancienne et de celle des Protestants de France* (n.p., 1682). I have been unable to locate a copy of this book.

83. John Evelyn, *The Diary of John Evelyn*, ed. Esmond S. de Beer, 6 vols. (Oxford, 1955), 4:528 (entry for 24 October 1689). Evelyn's copy of Wheler's *Account* is in the library of Queen's University at Kingston, Ontario. For a detailed discussion of Wheler's tabernacle, with special reference to an unpublished letter of his concerning it, see *Survey of London*, vol. 27, *Spitalfields and Mile End New Town*, ed. F. H. W. Sheppard (London, 1957), 100–103. After the revocation of the Edict of Nantes in 1685, the population of Spitalfields experienced an influx of Huguenot silk weavers.

84. Wheler, *Account*, 46–51, and plate opposite p. 12 acknowledge Sandys, *Relation of a Journey*. See also note 20 above. A copy of Sandys's little book was in the Wren family library at the time of its sale according to Watkin, *Sale Catalogues*, 12, lot 109. Lot 114 indicates that

the Wrens also owned a copy of Wheler's *Journey into Greece*. For a discussion see Mussells, "Architects, Travellers," 10.

85. Guillaume-Joseph Grelot, *A Late Voyage to Constantinople: Containing . . . an Account of the Ancient and Present State of the Greek Church . . .* (London, 1683), 107, 110, 130–31.

86. Watkin, *Sale Catalogues,* 19 (lot 207), 27 (lot 367, a Paris 1689 quarto edition). Downes, *Wren,* 47, draws attention to the date of the publication of Grelot's book as a means of dating Wren's second tract to the 1680s. For the Wren quotation see *Parentalia,* 357. Soo, *Wren's "Tracts,"* 125, adds that Wren's interest in Hagia Sophia was widely known among his contemporaries. Susan Lang, "Vanbrugh's Theory and Hawksmoor's Buildings," *Journal of the Society of Architectural Historians* 24 (1965): 144, first mentioned Grelot in conjunction with Hawksmoor's plan of "The Basilica after the Primitive Christians." She goes on to claim that Grelot "must have been Hawksmoor's source" for a number of that plan's provisions. My chapter 2 modifies that claim considerably.

87. Grelot, *Voyage to Constantinople,* 84, took exception to Justinian's boast. "I cannot believe," Grelot wrote, "that ever it [Hagia Sophia] came near to the famous Temple of Jerusalem."

88. This precious volume was advertised in *Hugh Pagan Limited Architecture and the Fine Arts Catalogue Number 3* (London, June 1988), 18–21, with information and an attribution of the drawings to Wren supplied by Kerry Downes. I discussed this attribution with Professor Downes on 19 and 20 July 1988 and am grateful to him for the insights he shared. Thanks to the generosity of Chancellor Agnes Benidickson, Phyllis Lambert, J. P. Spang III, the Social Sciences and Humanities Research Council of Canada, and other donors, this book was purchased later that year for the library of Queen's University at Kingston, Ontario.

89. The plan on the right of figure 19 measures 186 mm by 103 mm wide and the one on the left 188 mm by 190 mm wide. Dimensions are taken according to the sense of the book and not of the plans as such.

90. Watkin, *Sale Catalogues,* 15, lot 145, lists the *Journal du voyage du chevalier Chardin en Perse et aux Indes Orientales* (London, 1686). This edition contained only the section of Chardin's journey from Paris to Isfahan. The complete travels in three volumes with seventy-eight engravings by Grelot did not come out until 1711. The principal information on Chardin, Wren, and Evelyn comes from Evelyn's *Diary of John Evelyn,* 4:212–13 (entry for 30 August 1680), 358 (entry for 27 December 1683), and 369 (entry for 23 February 1684). Hooke also knew Chardin, though less well. See *Diary of Robert Hooke,* 449 (entry for 17 July 1680), which reads simply "At . . . Mons. Chardins." Chardin was knighted in 1681 and became a member of the Royal Society. But as Soo, *Wren's "Tracts,"* 124–25, points out, three years earlier Hooke in company with Wren had discussed Hagia Sophia with Thomas Smith, a fellow member of the Royal Society.

91. This drawing, the first of the three inserted into the copy of Leroy, measures 192 mm square. The drawing is too firmly pasted down to permit photographing the sketch on the verso without damaging the sheet.

92. Julien-David Leroy experimented with the *parallèle* for the first time in his *Histoire de la disposition et des formes différentes que les chrétiens ont données à leurs temples, depuis le règne de Constantin le Grand, jusqu'à nous* (Paris, 1764) and perfected the technique in 1770 by arranging the ground plans of a whole series of religious structures in three neat descending columns all shown to the same scale for ease of comparison. See his *Ruines des plus*

beaux monuments de la Grèce, 2d ed., 2 vols. (Paris, 1770), vol. 2, plate opposite p. ix. Werner Szambien's biography of Leroy's pupil, Durand, gives an interesting summary of the early developments in the *parallèle* technique, including those of Juste-Aurèle Meissonnier. See Szambien's *Jean-Nicolas-Louis Durand, 1760–1834: De l'imitation à la norme* (Paris, 1984), 27–30. For more on Leroy, see Richard A. Etlin, *Symbolic Space: French Enlightenment Architecture and Its Legacy* (Chicago, 1994), 101–4. For more on Meissonnier, see 29–31 of Dorothea Nyberg's introduction to the reprint edition of Meissonnier's *Oeuvre de Juste-Aurèle Meissonnier* (New York, 1969). This is a topic that deserves more study.

CHAPTER TWO

1. John Evelyn, *The Diary of John Evelyn,* ed. Esmond S. de Beer, 6 vols. (Oxford, 1955), 4:436 (entry for Good Friday, 17 April 1685); 531 (entry for 12 December 1686: "I went to St. James's New Church, where Dr. Tenison preach'd"); 5:61–62 (entry for 19 July 1691). De Beer, 4:308 n. 2, claims that Tenison's sermons were rarely published and implies that Evelyn either had a phenomenal memory or saw Tenison's sermon in manuscript. The fascination with tabernacles did not cease with Tenison and Wheler. An anonymous manuscript, datable to the late 1720s, is titled "A Proposal For the Building of Tabernacles, by the Remainder of the Fund given by Parliament for Building Fifty New Churches . . . which are now near being Finished" (BL, Bills. 357B. 4. 91. [MS]). This document is briefly quoted from in Howard Colvin's introduction to E. G. W. Bill's *The Queen Anne Churches: A Catalogue of the Papers in Lambeth Palace Library of the Commission for Building Fifty New Churches in London and Westminster, 1711–1759* (London, 1979), ix. Sir Howard very kindly sent me his copy of the manuscript when the British Library was unable to locate the original for me.

2. Evelyn, *Diary of John Evelyn,* 5:63–65.

3. William Cave, *Primitive Christianity, or The Religion of the Ancient Christians in the First Ages of the Gospel,* 6th ed. (London, 1702), 91–92. The first edition came out in 1692. For Evelyn's lengthy praise of Saint James's on 7 December 1684 see Evelyn, *Diary of John Evelyn,* 4:397.

4. *Journal of the House of Commons* 16 (1708–11): 495, meeting of 14 February 1711.

5. *Journal of the House of Commons* 16 (1708–11): 580–82, meeting of 6 April 1711.

6. *Journal of the House of Commons* 16 (1708–11): 581, meeting of 6 April 1711. The Deptford parishioners put the case even more bluntly than Stanhope had done: "We beg leave to add . . . that the want of convenient Reception in our Parish Church has we fear kept Many of our Inhabitants in Ignorance and Irreligion and driven others to the separate Congregations" (LPL, MS 2717, fols. 64–65, memorial datable to 16 October 1711).

7. Bill, *Queen Anne Churches,* xxiii–xxiv, conveniently provides the names of the first, or 1711, commissioners and the three sets of their successors appointed by Parliament with royal assent. For the text of the acts of Parliament themselves I have referred to a printed collection of those acts pertaining to the churches: *The Acts of Parliament relating to the Building Fifty New Churches in and about the Cities of London and Westminster . . .* (London, 1721). The first act is 9 Anne, cap. 22.

8. Francis Atterbury, *The Epistolary Correspondence Visitation Charges, Speeches and Miscellanies . . . ,* 4 vols. (London, 1783–87), 2:227–28, address to the clergy of the archdeaconry of Totnes, delivered in 1703. It should be noted that relations between Atterbury and Archbishop Tenison, as he had then become, were cool. See Thomas Tenison, *Memoirs of the Life and Times of the Most Reverend Father in God, Dr. Thomas Tenison, Late Arch-*

bishop of Canturbury (London, n.d.). This book, which went through several editions in quick succession after appearing about 1716, has no reference whatever to the 1711 act of Parliament or the commission for building fifty new churches. In fact Tenison's participation in the commission's work was minimal, as is pointed out by Michael H. Port's useful introduction to his edition of *The Commissions for Building Fifty New Churches: The Minute Books, 1711–27: A Calendar* (London, 1986), xiv. But he downplays unduly, I believe, Atterbury's involvement, which took place behind the scenes (see p. xv).

9. Gareth Vaughan Bennett, *The Tory Crisis in Church and State, 1688–1730: The Career of Francis Atterbury, Bishop of Rochester* (Oxford, 1975), 64. Before his untimely death, the author kindly drew my attention to his chapter "University, Society, and Church, 1688–1714," in *The History of the University of Oxford,* vol. 5 (Oxford, 1986).

10. Bennett, *Tory Crisis,* 129.

11. George Smalridge, *Sixty Sermons Preached on Several Occasions . . . ,* 5th ed., 2 vols. (Oxford, 1852), 1:271, 2:71. The first edition was published at Oxford in 1724. Atterbury was a subscriber. See also note 37 below.

12. Atterbury, *Epistolary Correspondence,* 2:228 ("the cornerstone and pillar of our church fabric"), and 2:269 (a visitation speech of 1716). For Atterbury's books see Hugh Amory, ed., *Sale Catalogues of Libraries of Eminent Persons: Poets and Men of Letters,* vol. 7 (London, 1973), 50 (lot 354, a 1649 Amsterdam edition of Vitruvius), 43 (lot 283, Palladio), 12 (lot 223, *Biblia Sacra Polyglotta*), 16 (lot 52, Beveridge), 17 (lot 133, Cave), 26 (lot 139, Eusebius), 36 (lot 217, Lightfoot), 37 (lot 233, Mead's collected works), 40 (lot 260, Prideaux), 48 (lots 600–603, various works by William Whiston).

13. Atterbury, *Epistolary Correspondence,* 2:313–14 (an editorial note outlining the events in Convocation and in Parliament that preceded the legislation), 4:297n (an editorial note mentioning Atterbury and Bromley's friendship at Christ Church), 4:304 (gives the text of Atterbury's memorandum). *Journal of the House of Commons* 16:528–29 chronicles the meetings between the parliamentarians and the divines.

14. E. Carpenter, *The Protestant Bishop: Being the Life of Henry Compton, 1632–1713, Bishop of London* (London, 1956), 203.

15. See Bennett, *Tory Crisis,* 134, on the October Club.

16. Speaker Bromley's grandfather and father were friends and neighbors of Thomas Archer's grandfather, Sir Simon, and his father Colonel Thomas. I owe this information to Janet Temos, whose Princeton doctoral dissertation, "'Augusta's Glittering Spires': Thomas Archer and the 1711 London Church Commission," is currently in progress.

17. Howard M. Colvin, "Fifty New Churches," *Architectural Review* 107 (1950): 195 n. 63, first drew attention to his letter on the verso of a drawing in the Victoria and Albert Museum (D. 108-1891). The full text is published in Kerry Downes, *Vanbrugh* (London, 1977), appendix F. But Downes, unlike Colvin, does not connect this letter with the commission, despite its reference to the parliamentarian commissioners George Clarke and John Aisladie and its statement that "the new Commission will be broke open next Wensday." This obviously must relate to the first meeting of the second group of church commissioners, which took place on 28 October 1712. In light of all this I speculate that the Vanbrugh sketch on the recto of the letter (Downes, fig. 20) is for a churchyard mausoleum rather than a garden building as Downes suggests.

18. LPL, MS 2690, has the minutes of the subcommittee (10 October to 21 December 1711) bound in at the end with its own reverse numbering system. I have respected the original pagination, which reads backward. MS 2693 consists of the minutes of the subcommittee

from 11 June 1712 through 23 January 1720. The subcommittee's mandate was reaffirmed on 28 October 1712 (p. 58). Although the minute books have been expertly summarized in Port, *Commissions,* I have chosen to refer readers to the original manuscripts because these are readily available on microfilm.

19. Atterbury, *Epistolary Correspondence,* 3:343, publishes a letter from Smalridge to Atterbury dated 17 January 1718, referring to a "gent." who traveled between Oxford and London, as Hawksmoor frequently did.

20. Kerry Downes, *Hawksmoor* (London, 1969), 157, associates the shift of power to the Whigs with the decline in the number of churches. Colvin's introduction to Bill, *Queen Anne Churches,* xii, agrees with Downes and states: "The Tories had largely failed in their scheme to kindle the fires of worship by means of the coal tax." See also xvi. Port, *Commissions,* xvi, mentions Stanhope as a moderate.

21. LPL, MS 2690, pp. 1b, 2, meeting of the commissioners on 3 October 1711.

22. LPL, MS 2690, p. 38, meeting of the subcommittee on 21 December 1711.

23. *Journal of the House of Commons* 17 (1711–14): 34, 234, gives the report of the first commissioners and the decision to extend their mandate. The new bill enacted to create the second commission is 10 Anne, cap. 11. LPL, MS 2690, p. 58, records the first meeting of the second commission on 28 October 1712.

24. Christopher Wren, comp., *Parentalia, or Memoirs of the Family of the Wrens . . .* (London, 1750), 318–21. The editors preface their transcription of the letter as follows: "The Surveyor . . . took occasion to impart his thoughts . . . in a letter to a friend in that commission." Lydia Soo, *Wren's "Tracts" on Architecture and Other Writings* (Cambridge, 1998), 107–18, discusses the letter and publishes it in full.

25. LPL, MS 2690, p. 13, meeting of the commissioners on 14 November 1711.

26. *Acts of Parliament,* 50; and see *Journal of the House of Commons* 17 (1711–14): 181, recording that a separate vote on the burial clause took place on 10 April 1712.

27. Wren, *Parentalia,* 295–302.

28. Vanbrugh's proposals do not survive in the commission's papers but are preserved in two versions, an original and a copy: BLO, MS Rawl. B. 376, fols. 351–52, and BLO, MS Eng. Hist. b.2, fol. 47, respectively. For a full transcript, see Downes, *Vanbrugh,* appendix E, 257–58, which also includes an illustration of Vanbrugh's sketch of Surat attached to the original letter (plate 55).

29. Howard Colvin, "Mr. Vanbrugg's Proposals," *Architectural Review* 107 (1950): 209–10, identifies the original letter as among Robinson's papers bequeathed to the BLO by Richard Rawlinson (1690–1755). Colvin claims the original is in Hawksmoor's handwriting. Downes, *Vanbrugh,* 83, says the hand is "without doubt Vanbrugh's." Interestingly enough, Amory, *Sale Catalogues,* 4, discusses a volume once in Atterbury's possession that belonged to Rawlinson and surmises that other material with an Atterbury provenance may be in the Rawlinson bequest to the Bodleian.

30. See John Henry Overton, *The Nonjurors: Their Lives, Principles and Writings* (London, 1902), and David Fairer, "Anglo-Saxon Studies," in *The History of the University of Oxford,* vol. 5 (Oxford, 1986), 815–16. See also note 31 below on Hickes's Anglo-Saxon studies.

31. Thanks to the generosity of David Cast, who discovered Hickes's four-page document and provided me with a copy of his typed transcription of it, I had a much easier time making out all its difficult-to-read addenda and corrigenda. The version given in my appendix 3 is initially based on Cast's typescript and my comparisons of it against the original on two

occasions, most recently in 1993, when I had the benefit of the careful reading John Newman kindly undertook at my request in 1989. His expert eye helped clarify a number of unclear passages. Stephen Parks, the curator of the Osborn collection at Yale, told me that James M. and Marie-Louise Osborn purchased the manuscript in 1953 from a bookseller named Winney Myers. A bookseller's catalog of the time had identified the document as by Hickes based on the handwriting and such revealing passages about Anglo-Saxon studies as the following parenthetical remark: "Who knows how many thousands of their Saxon Ancestors converted from Heathen sin were baptised in y manner." Except for the canceled-out title quoted within square brackets in appendix 3, the text ignores erasures and corrections because they add nothing to our understanding. Some of the interpolations are in a lighter ink, but they seem to me to be in the same handwriting.

32. The copy of Vanbrugh's recommendations is BLO, MS Eng. Hist. b. 2. fol. 47. Another folio in the same group of manuscripts (fol. 110) pertains to Hickes. This, and the fact that Hickes's "Observations" quote almost exactly the title of the copy of the Vanbrugh recommendations in the Bodleian, suggests to me that the copy was once among Hickes's papers.

33. LPL, MS 2690, p. 16, meeting of the commissioners on 21 November 1711.

34. It is worth noting Hickes's connections with Smalridge and Atterbury. The latter collected Hickes's published writings and is known to have been warmly disposed toward him. See BLY, Osborn Files Potter 32.36, a letter from John Potter, Regius Professor of Divinity, to George Hickes dated 8 July 1712. In it Potter voices Atterbury's offer to be of service to Hickes in the publication of a third companion volume of *Spicilegium SS. Patrum . . .* , 2 vols. (Oxford, 1698–99), that he had been editing from the writings of the recently deceased theologian John Ernest Grabe (1666–1711). Hickes was Grabe's literary executor and was succeeded in that capacity by Smalridge, who had ministered to Grabe on his deathbed. According to Amory, *Sale Catalogues*, 24–25, lots 257–62, and 28, lot 144, the Atterbury library contained seven books by Hickes in addition to the *Spicilegium* (24, lot 234).

35. LPL, MS 2690, p. 26, meeting of the subcommittee on 4 December 1711, mentions designs for a church by Hawksmoor "within the great Square in Lincolns Inn Fields."

36. LPL, MS 2690, pp. 47, 49.

37. Smalridge, *Sixty Sermons*, 1:271, undated sermon.

38. LPL, MS 2690, p. 63, meeting of the commissioners on 10 December 1712, mentions that the two surveyors undertook the "charges of making Wooden Modells." This meeting marks Smalridge's return to full activity on the commission after an absence from his subcommittee that lasted from 26 August until 24 November 1712. The fullest discussion of the models is in Colvin's introduction to Bill, *Queen Anne Churches*, xvii–xix, which reproduces ten plans of the models made by Thomas Leverton Donaldson in 1843. Colvin's earlier article, "Fifty New Churches," 194, reproduces Charles Robert Cockerell's nineteenth-century plans and elevations of two of the models, including the one for Hawksmoor's Saint Anne's Limehouse.

39. LPL, MS 2690, p. 49.

40. Ibid., p. 1, meeting of the subcommittee on 16 October 1711; 11, meeting of the subcommittee on 16 November 1711; 12, meeting of the subcommittee on 20 November 1711; and MS 2693, p. 13, meeting of the subcommittee on 29 July 1712). MS 2712, fol. 191v, is a petition dated 12 November 1725 that makes it clear that a snag over clear title to Sclater's land put a stop to its sale. Folio 179 is a letter of 5 July 1715 from James Gibbs saying that he has viewed Sclater's Bethnal Green property.

41. A neater version of this plan in ink and gray and blue wash, without the interesting marginalia, is LPL, MS 2750, item 17. This drawing is titled "Bethnall Green / M^r Hawksmoor's plan."

42. Ibid., p. 13, meeting of the commissioners on 14 November 1711.

43. Kerry Downes, *Hawksmoor,* 2d ed. (Cambridge, Mass., 1979), 162–63 and fig. 52a, first published the drawing. See also Downes, *Hawksmoor* (1969), 100–101 (which dates the drawing to soon after November 1711) and fig. 87 (which reproduces only part of the drawing). The drawing has also been included in the Arts Council of Great Britain exhibition catalog *Hawksmoor* (London, 1962), item 12, and the more recent Whitechapel Art Gallery exhibition catalog *Hawksmoor* (London, 1977), 20–21. Both were largely written by Downes. Howard Colvin's introduction to Bill, *Queen Anne Churches,* xii, mentions the drawing and Peter King's possible connection with it. Lord Chief Justice King, later Baron King, whose house at Ockham, Surrey, Hawksmoor later altered, was a member of the third or 1715 commission but, in fact, attended hardly any commissioners' meetings.

44. LPL, MS 2690, p. 16.

45. I wonder whether it is pure coincidence that Hawksmoor's statement recalls the definition in Thomas Hobbes's *Leviathan* (London, 1651), chap. 13, of life in a time of warfare as "solitary, poor, nasty, brutish, and short." Hobbes also noted that such a time was antithetical to "commodious building," something Hawksmoor might have taken to heart.

46. The "chel," or *septum,* in the temple is discussed by John Lightfoot in his *The Temple Especially as It Stood in the Days of Our Savior* (London, 1650) and again in his *Horae Hebraicae et Talmudicae . . . ,* first published in 1658. Both texts can be found in *The Works of the Reverend and Learned John Lightfoot D.D. . . . with Three Maps: One of the Temple Drawn by the Author Himself . . . ,* ed. George Bright, 2 vols. (London, 1684), 1:1089 and 2:29–30, respectively. The second of these citations refers the reader to an alternative passage in Josephus's *Jewish Antiquities* (bk. 15, chap. 4), in which the word περίβολον appears in the Greek original with reference to this same enclosure wall. I have referred to the Loeb Classical Library edition for this text and to a Greek-Latin version of *The Jewish War,* edited by Franz Oberthür, 3 vols. (Leipzig, 1782–85), 3:853. Charles Burroughs drew my attention to the *septum,* or voting enclosure, erected by Julius Caesar as a feature of ancient Roman topography. It appears on the Pirro Ligorio and Mario Cartaro maps of Rome of 1561 and 1579, respectively.

47. See Mary Gwladys Jones, *The Charity School Movement: A Study of Eighteenth Century Puritanism in Action* (Cambridge, 1938), 56. The Reverend David H. Smart brought to my attention Craig Rose's "Evangelical Philanthropy and Anglican Revival: The Charity Schools of Augustan London, 1698–1740," *London Journal* 16 (1991): 35–65.

48. Francis Atterbury, *Sermons and Discourses on Several Subjects and Occasions,* 2 vols. (London, 1723), 2:299 (sermon of 6 December 1709); Smalridge, *Sixty Sermons* 2:428. See Downes, *Hawksmoor* (1969), 66, for the Kensington Charity School.

49. Port, *Commissions,* xv.

50. White Kennett, *The Charity Schools for Poor Children Recommended . . .* (London, 1706), 10.

51. Cave, *Primitive Christianity,* 89.

52. Guillaume-Joseph Grelot, *A Late Voyage to Constantinople: Containing . . . an Account of the Ancient and Present State of the Greek Church . . .* (London, 1683), 107.

53. Joseph Bingham, *Origines Ecclesiasticae, or The Antiquities of the Christian*

Church, 10 vols. (London, 1708–22), 3:171. In these notes I have referred to this first edition unless otherwise specified.

54. Atterbury, *Epistolary Correspondence,* 3:277–78. See also Amory, *Sale Catalogues,* 10, lot 41. The original sale catalog notes that volumes 2 and 3 were missing.

55. The letter of 9 November 1713 from Bingham mentioning his friendship with Smalridge is contained in the life of Bingham written by his grandson, the Reverend Richard Bingham, published in Bingham, *Origines,* 4th ed., 9 vols. (London, 1843–45), 1:xxxiii.

56. Bingham, *Origines,* 3:124–27.

57. Ibid., 3:148, 151. For this information James Ussher (1581–1656), archbishop of Armagh, was footnoted. See Ussher's reference to a misoriented church founded by Saint Patrick in Ireland in James Ussher, *The Whole Works of the Most Rev. James Ussher . . . ,* 17 vols. (Dublin, 1847–64), 15:175, letter of 1622.

58. Bingham, *Origines,* 10:2.

59. Ibid., 3:135 (quoting from Tertullian); 154 (parphrasing Tertullian).

60. Peter Ackroyd, *Hawksmoor* (London, 1985), 10. LPL, MS 2714, fols. 103–6, reports the thefts of materials from the construction site at Saint George's-in-the-East.

61. Bingham, *Origines,* 3:225–26 (refuting Durant); 215–16 (citing Cave, *Primitive Christianity,* 198–99); 158–62, which insists that early Christians had separate baptisteries, in contrast to Beveridge's opinion that common practice required that the font be in the porch.

62. Ibid., 3:227–30 (citing Crabbe's edition of the Constantinopolitan Councils).

63. Ibid., 3:209–11 (repositories for "vestments and vessels"); 180 (chancel); 184 (raised apse).

64. Bennett, *Tory Crisis,* 16.

65. A preliminary drawing for this engraving in the All Souls College collection (AS, vol. 2, item 76) is reproduced in *The Wren Society,* vol. 9 (Oxford, 1932), pl. 25. The engraving itself is the fourteenth in a series devoted to Wren's buildings. See the next note for more information.

66. This drawing, formerly in the Bute collection (see Summerson in note 68 below), is datable to 1721 based on an inscription on the verso. It is reproduced in Paul Jeffery, *The City Churches of Sir Christopher Wren* (London, 1996), fig. 139. It was engraved by Henry Hulsbergh as the fifteenth of his plates devoted to Wren buildings. See *The Wren Society,* vol. 18 (Oxford, 1941), pl. 21, for a reproduction. These engravings, at least three of them after drawings by Hawksmoor, constitute a publication titled *A Catalogue of the Churches of the City of London; Royal Palaces; Hospitals; and Public Edifices; Built by Sir Christopher Wren* (London, 1749?). See Gerald Beasley's detailed entry in *The Mark J. Millard Architectural Collection: British Books Seventeenth through Nineteenth Centuries* (Washington, D.C., 1998), 2:369–72.

67. See note 35 above. Also see Paul Jeffery, "The Church That Never Was: Wren's St. Mary's and Other Projects for Lincoln's Inn Fields," *Architectural History* 31 (1988): 137–47, and Jeffery, *City Churches,* 124–26, 348.

68. Jeffery, *City Churches,* 229–32, discusses Saint Clement's Danes. For a discussion of the Bute sale, see John Summerson, "Drawings of London Churches in the Bute Collection: A Catalogue," *Architectural History* 13 (1970): 30–42. For the drawings relating to Saint Clement's in the Kimball collection, see John Harris, *A Catalogue of British Drawings for Architecture, Decoration, Sculpture and Landscape Gardening 1500–1900 in American Collections* (Upper Saddle River, N.J., 1971), 281. A drawing similar to the Kimball plan (fig.

33, top half) is in the All Souls College collection at Oxford (AS, vol. 2, item 57). See *The Wren Society,* vol. 9, pl. 12, for a reproduction of this plan.

69. Owing to the great hospitality of the late Tweet Kimball, I was able to study her Wren drawings in 1988 at Cherokee Ranch, Sedalia, Colorado. She generously consented to let my students and me exhibit them in 1989 at the Agnes Etherington Art Centre, Queen's University.

70. Downes, *Hawksmoor* (1969), 138. Downes, *Hawksmoor,* 278, does not associate this drawing in All Souls College, or the other three like it there, with a church at all but connects them with structures more or less loosely inspired by the Halicarnassus mausoleum. See my figures 64 and 65 for illustrations of two of the other related drawings.

71. AS, vol. 4, item 61, is a faint pencil version of item 62 reproduced here (fig. 35), but without the quadriga on top. For further discussion, see chapter 3.

72. LPL, MS 2693, p. 3, meeting of the subcommittee on 4 July 1712; MS 2690, p. 40, meeting of the commissioners on 9 July 1712. For full details on the progress of Saint Alphege's construction, see Port, *Commissions,* passim; Downes, *Hawksmoor,* 167–70; and Downes, *Hawksmoor* (1969), 110–11.

73. Bingham, *Origines,* 3:97–107.

74. For previous interpretations of Hawksmoor's term "basilica" see Susan Lang, "Vanbrugh's Theory and Hawksmoor's Buildings," *Journal of the Society of Architectural Historians* 24 (1965): 144; Downes, *Hawksmoor* (1969), 107; and Timothy Rub, "'A Most Solemn and Awfull Appearance': Nicholas Hawksmoor's East London Churches," *Marsyas* 21 (1981–82): 20–21.

75. Downes, *Hawksmoor,* 138–41, discusses the All Souls design in relation to Saint Alphege's and Hawksmoor's "explanation" of the design written on 17 February 1715. See also Howard Colvin, *Unbuilt Oxford* (New Haven, 1983), 40–47.

76. Downes, *Hawksmoor,* 169, aptly calls them "Roman altars." Colvin in his introduction to Bill, *Queen Anne Churches,* xv, records the bill of £14 apiece submitted by the masons Tufnell and Strong for the "Altars with 6 Cherubs heads, and two festoons of Drapery in each."

77. Eusebius Pamphilius, *Eusebius His Life of Constantine in Four Books: With Constantine's Oration to the Clergy,* trans. Wye Saltonstall (London, 1649), 48. Eusebius wrote this with reference to the Holy Sepulcher in Jerusalem, built by Constantine.

78. Bingham, *Origines,* 3:146.

79. See Simon Houfe, *Sir Albert Richardson: The Professor* (Luton, 1980), 182, for an interesting anecdote about the restoration of Saint Alphege's.

80. Atterbury, *Epistolary Correspondence,* 2:337–38, document dated March 1711.

81. Ibid., 1:3–5.

CHAPTER THREE

1. Thomas Bisse, *The Merit and Usefulness of Building Churches: A Sermon Preached at the Opening of the Church of St. Marie in the Town and County of Southampton, on Christmas Day, 1711* (LONDON, 1712), 6, and see also 17, 22 on the importance of beautifying and proliferating churches. I owe the reference to Bisse to David H. Smart, "Primitive Christians: Baroque Architecture and Worship in Restoration London" (Th.D. diss., University of Toronto, 1997).

2. Bisse, *Merit and Usefulness of Churches,* 5, 23, and see also 3–4 concerning Solomon and 20 concerning the chancel of Saint Mary's Southampton.

3. Ibid., 8, 12.

4. This idea of the churches as a unit forms the imaginative starting point for Iain Sinclair's *Lud Heat: A Book of the Dead Hamlets* (London, 1975). Sinclair writes on page 7: "From what is known of Hawksmoor it is possible to imagine that he did work a code into the buildings . . . templates of meaning, bands of continuing ritual." And to make his point he draws a map showing the lines of sight between the churches with their obelisk spires and their supposed Egyptian cult of the dead symbolism.

5. *The Acts of Parliament relating to the Building Fifty New Churches in and about the Cities of London and Westminster . . .* (London, 1721), 7.

6. LPL, MS 2693, pp. 15–19, meetings of the subcommittee on 12, 15, and 22 August 1712.

7. LPL, MS 2690, p. 51, meeting of the commissioners on 6 August 1712; MS 2691, p. 14, meeting of the commissioners on 1 May 1718.

8. This now familiar phrase about schism is contained in LPL, MS 2714, fol. 93, the petition of the inhabitants of Wapping dated 10 June 1714. LPL, MS 2690, p. 169, contains the minutes of the commissioners' meeting of a week later.

9. LPL, MS 2690, p. 182, meeting of the commissioners on 29 July 1714. Kerry Downes, *Hawksmoor,* 2d ed. (London, 1979), 276, catalogs the drawings relevant to Saint George's, including the fourteen in the King's Maps division of the British Library, of which he reproduces three. Two separate site plans for the church in the LPL were included in the Whitechapel Art Gallery exhibition catalog, *Hawksmoor,* 22.

10. The slow progress and loss of materials are recorded in LPL, MS 2724, fols. 60v–61r, a report of March 1718. Ibid., fol. 76, a later report of 7 April 1720, complains of the mob's vandalism. See also chapter 2, note 60. The date of the consecration is given in John Britton and Augustus Pugin, *Illustrations of the Public Buildings of London,* 2 vols. (London, 1825–28), 2:94.

11. LPL, MS 2690, p. 301, meeting of the commissioners on 24 August 1716. Reference is made to the roofing estimate of Grove the carpenter.

12. James Stirling, Robert Maxwell, et al., *James Stirling: Architectural Design Profile* (London, 1982), 12.

13. The sky appearing through the oculus of the east pediment in plate 4 is accounted for by the fact that between 1960 and 1964 the gutted church was replaced by a much lower church built within the limestone walls to the designs of Arthur Bailey. See Mervyn Blatch, *A Guide to London's Churches* (London, 1978), 399–402.

14. LPL, MS 2724, fols. 60v–61r, is James's progress report of 6 March 1718 concerning Saint George's, among other churches. The work book for Saint George's (LPL, MS 2698, p. 55) refers to the "Top of the Finishing" of the west tower in 1722–23.

15. David Watkin, *Sale Catalogues of Eminent Persons: Architects* (London, 1972), 86, lot 148. On page 46 he speculates that lot 166, comprising thirty drawings for Saint Anne's Limehouse, is also in the British Library, King's Maps collection. For a full discussion of the drawings and the various sale lots see Downes, *Hawksmoor,* 286–87.

16. LPL, MS 2722, fol. 39.

17. Westminster Abbey Muniments, MS 24878. Quoted in full in Downes, *Hawksmoor,* 255–58. The date "circa 1735" is written in pencil on the verso. The letter is in the hand of a scribe with autograph Hawksmoor interpolations.

18. William Cave, *Primitive Christianity, or The Religion of the Ancient Christians in the First Ages of the Gospel*, 6th ed. (London, 1702), 92.

19. See note 17 above.

20. Stirling, *James Stirling*, 12, noted Hawksmoor's ability to combine "Roman, French, and Gothic, etc. sometimes in the same building." Timothy Rub, "'A Most Solemn and Awfull Appearance': Nicholas Hawksmoor's East London Churches," *Marsyas* 21 (1981–82): 24, suggests Ely cathedral as one source for Saint George's tower; David Cast, "Seeing Vanbrugh and Hawksmoor," *Journal of the Society of Architectural Historians* 43 (1984): 319, agrees with Rub and adds Fotheringay Castle as another source. John Summerson, *Georgian London*, 2d ed. (London, 1962), 87, suggests Boston Stump as another source. And Summerson, *Architecture in Britain, 1530–1830*, 5th ed. (Harmondsworth, Eng., 1970), 303, sees the pepper pots of Saint George's as a reference to King's College Chapel, Cambridge. Finally, Susan Lang, "Vanbrugh's Theory and Hawksmoor's Buildings," *Journal of the Society of Architectural Historians* 24 (1965): 148, adduces from the inscription "M͡ Vanbrugh / in Duke Street," on the drawing reproduced as my figure 41 that Hawksmoor's medievalism came directly from Vanbrugh.

21. Downes, *Hawksmoor*, 175, transcribes the inscription as follows: "If what Mr Groves [the carpenter] has provided for Waping Stepney Cannot Serve at Limehouse—then we must be content to put it upon Wapping Church."

22. Cast, "Seeing Vanbrugh," 319.

23. LPL, MS 2690, p. 104, meeting of the commissioners on 16 July 1713; p. 157, meeting of the commissioners on 29 April 1714. The matter of the statue cast by Giovanni Battista Foggini in Italy is discussed in detail by Terry Friedman, *James Gibbs* (New Haven, 1984), 42–43.

24. BL, King's Maps, K. Top. XXVIII–11–d. The north side elevation shows quoining at both the east and west ends.

25. The drawing is discussed for the first time by Downes in the 1977 Whitechapel Art Gallery exhibition catalog, *Hawksmoor*, 22.

26. Ibid., and Downes, *Hawksmoor*, 174. The drawing in question is BL, King's Maps, K. Top. XXVIII–11–g. Note that the verso has the inscription "2 D[ay] Lot 29," which I am at a loss to explain since it agrees with neither the Wren sale catalog nor that of the Hawksmoor sale.

27. BL, King's Maps, K. Top. XXVIII–11–c.

28. I differ from the interpretation of Giles Worsley's article "Designs on Antiquity: Hawksmoor's London Churches," *Country Life* 184, no. 42 (1990): 172–74. Worsley suggests that the source for the Saint Anne's steeple (and that of Saint George's-in-the-East) is a series of Jacques du Cerceau prints from the mid-sixteenth century. The similarities are interesting but probably attributable to the finite range of possibilities within the classical tradition. No evidence supports Hawksmoor's having owned or known these obscure prints.

29. Cast, "Seeing Vanbrugh," 319, prefers to see the name Christ Church as a reference to the "High Church of the Tories."

30. Watkin, *Sale Catalogues*, 87. Part of the heavily crossed out inscription appears alongside the right margin of an earlier drawing in the portfolio (see my figure 54, lower right). The inscription on the drawing reads: "166/ 30 Drawings of Limehouse and Spittlefields Church/ by Mr. Hawksmord."

31. Downes, *Hawksmoor*, 179–83, and Downes, *Hawksmoor* (London, 1969), 141–46,

156–60. See also *Survey of London,* vol. 27, *Spitalfields and Mile End New Town* (London, 1957), 148–77.

32. LPL, MS 2691, p. 193, meeting of the commissioners on 24 January 1723.

33. Kerry Downes, R. A. Beddard, et al., "A.D. Profiles 22: Hawksmoor's Christ Church Spitalfields," *Architectural Design* 49 (1979): 1–32. Downes's discussion of the evolution of Hawksmoor's design is on page 5, and the illustrations supplement those in his earlier books (see note 31 above). The same monograph includes R. A. Beddard's interesting contribution concerning Christ Church's "Ecclesiastical and Liturgical Background," 3–4. He rightly sees Christ Church as an expression of "the scholarly preoccupations of Augustan High Churchery."

34. Watkin, *Sale Catalogues,* 104, lot 102.

35. Rub, "East London Churches," 22.

36. Summerson, *Architecture in Britain,* 136. Jones knew the lore about the humbleness of the Tuscan order from reading the writings of the sixteenth-century Italian theorist Sebastiano Serlio. Jones's annotated copy of Serlio is at Queen's College, Oxford. The set of measured drawings of the Temple of Bacchus at Baalbec compared with drawings of Saint Paul's Covent Garden was first attributed to Hawksmoor in Howard Colvin's *Catalogue of Architectural Drawings of the Eighteenth and Nineteenth Centuries in the Library of Worcester College, Oxford* (Oxford, 1964), 45, catalog numbers 321 a,b,c. Downes, *Hawksmoor,* 285, believes the drawings are in the hand of an assistant, and I defer to his opinion on this matter of attribution. But the handwriting on the packet that contained them seems to me to be Hawksmoor's, as does the typical inscription on the verso of 321c reading "Balbeck/Templum Heliopolitan." On Clarke see also note 17 of chapter 2.

37. BL, King's Maps, K. Top. XXIII–11–u.

38. Downes, *Hawksmoor,* fig. 2b.

39. Hawksmoor's definition of "crockets" is quoted from an inscription on a drawing of his for All Souls dated 21 February 1734. It is still preserved in the college (AS, vol. 3, item 84).

40. George Smalridge, *Sixty Sermons Preached on Several Occasions . . . ,* 5th ed., 2 vols. (Oxford, 1852), 2:71, undated sermon.

41. Stukeley's drawings are in the BLO, Gough Maps 41c, items 130–32, and MS Top. Gen. b. 52, fols. 38, 41, 44, 46v, 47, 51–52, 56–57, 63, 69, 71, 73–76, 78v, 79–89. Some have been reproduced in Joseph Rykwert, *The First Moderns: The Architects of the Eighteenth Century* (Cambridge, Mass., 1980), 157–59. Rykwert notes the resemblance to Christ Church. Details of Stukeley's involvement with the temple restitution in the 1720s and his rivalry with Newton are provided in his diary: William Stukeley, *The Family Memoirs of Rev. William Stukeley, M.D. . . .* 3 vols., Surtees Society Publications, vols. 73, 76, 80 (Durham, Eng., 1882–87), esp. 73:62 (entry for 10 December 1720), and 76:262 (letter of 17 March 1728). For Stukeley's admiration of Hawksmoor's Saint George's Bloomsbury, see note 59 below.

42. Christopher Wren, comp., *Parentalia, or Memoirs of the Family of the Wrens* (London, 1750), 315.

43. See Summerson, *Georgian London,* 88, "a piece of sheer architectural eloquence hard to match"; Rub, "East London Churches," 22, "as willful and eclectic as anything Hawksmoor designed"; Downes, *Hawksmoor,* 193, "their complex concavity . . . brings to mind Borromini." Alison Shepherd's axonometric drawing was specially commissioned in 1945 for inclusion in the first edition of Summerson's book cited above. She erroneously shows panes of window glass in the aedicular frames, which have been blocked to keep down street noise but were originally open as at James Gibbs's commissioners' church of Saint Mary-le-Strand.

44. Wren, *Parentalia*, 314.

45. George Godwin and John Britton, *The Churches of London . . .* , 2 vols. (London, 1839), vol. 2, p. 2 of the section devoted to the church. Earlier, Britton and Pugin, *Public Buildings of London*, 1:91, had specified that the remains of pottery, the bones and tusks of sacrificial animals, and so on, had been excavated at twenty-two feet belowground.

46. Cast, "Seeing Vanbrugh," 318–19, gives the history of Saint Mary's Woolnoth's medieval origins and assumes, rightly I believe, that "it was an English church of old foundation and, as such, it embodied . . . the perfect form of the twin towers of old English churches." See also Kerry Downes, *English Baroque Architecture* (London, 1966), 104, concerning the medieval cathedral aspect of Saint Mary's.

47. *Acts of Parliament*, 55–56. The act points out that Saint Mary's Woolnoth should have been the fifty-first of the City churches rebuilt by Wren after the Great Fire had he not stopped at fifty.

48. Downes, *Hawksmoor*, 277, catalogs the drawings related to Saint Mary's Woolnoth. The inscription quoted is on BL, King's Maps, K. Top. XXIII–28-3–m. Downes (ibid., 190) stresses John James's contributing role to the design. But LPL, MS 2690, p. 334, meeting of the commissioners on 9 May 1717, makes it clear that the initial model for the church was entirely Hawksmoor's. They ask that he and James submit another plan "as they two shall think fit." The next meeting, that of 16 May, states that the commissioners' reservations had to do with reducing the number of internal columns. The model, like all the others, is lost.

49. Ibid., 192.

50. Downes, *Hawksmoor*, 192, makes the connection between Saint Mary's Woolnoth and the plate in Perrault's translation. Godwin and Britton, *Churches of London*, vol. 2, p. 3 of the section on Saint Mary's, notes that the date of completion was given as 1727 by an inscription on the organ gallery, not 1724 as is usually recorded.

51. LPL, MS 2690, 215, meeting of the commissioners on 17 May 1715. Ibid., p. 144a, meeting of 3 March 1714, refers to Gibbs's ground plan for a church on the Bloomsbury site.

52. See note 44 in chapter 2.

53. Downes, *Hawksmoor*, 184–85, 276, discusses this proposal and what I take to be its mate (BL. K. Top. XXIII–16-2–b), which shows a rectangular plan and an elevation with a belfry on each side of a low dome.

54. Just such a combination of a Serliana under a pediment makes a notable appearance near the audience chamber in the marine palace at Split, built for the last pagan Roman emperor, Diocletian. It recurs in a decidedly Christian context above the papal throne in Donato Bramante's Sala Regia of about 1512 in the Vatican. That Hawksmoor might have been familiar with these regal connotations of the *fastigium* is supported by the architectural writings on the motif by his near contemporary Roger North (ca. 1653–1734). See Howard Colvin and John Newman eds., *Of Building: Roger North's Writings on Architecture* (Oxford, 1981), 60.

55. Christ Church's portico is Tuscan; that of Saint Alphege's is enriched Doric; that of Saint Anne's is plain Doric; that of Saint Mary's Woolnoth is rusticated Tuscan; that of Saint George's-in-the-East is astylar except for the Ionic frontispiece; and that of Saint George's Bloomsbury is Corinthian. Only the Composite is conspicuous by its absence, except for the interiors of Christ Church and Saint Anne's.

56. LPL, MS 2690, p. 284, meeting of the commissioners on 6 June 1716. And see p. 297 concerning the petition to begin laying Saint Mary's foundations, submitted to a meeting of the commissioners on 10 August 1716.

57. For a full discussion of the alterations to Saint George's, see Downes, *Hawksmoor,* appendix D.

58. For some of the literature regarding the many interpretations of the inspiration behind Sant'Ivo see Pierre de la Ruffinière du Prey, "Revisiting the Solomonic Symbolism of Borromini's Church of Sant'Ivo alla Sapienza," *Volume Zero* 1 (1985–86): 58–71, and more recently Joseph Connors, "S. Ivo alla Sapienza: The First Three Minutes," *Journal of the Society of Architectural Historians* 55 (1996): 38–57.

59. Stukeley, *Family Memoirs,* 80:9.

60. An illustration of Malton's print of Saint George's together with much else about it and the other commissioners' churches is contained in that entertaining mine of information *The London Encyclopaedia,* ed. Ben Weinreb and Christopher Hibbert (London, 1983).

61. AS, vol. 4, item 61.

62. Wren, *Parentalia,* 367 ("I conclude this work must be the exactest form of the Doric").

63. For a discussion of the restitutions based on these villas see Pierre de la Ruffinière du Prey, *The Villas of Pliny from Antiquity to Posterity* (Chicago, 1994).

64. Michael H. Port, *The Commissions for Building Fifty New Churches: The Minute Books, 1711–27: A Calendar* (London, 1986), xxvi–xxix, chronicles some of the commission's financial woes, despite which Hawksmoor's steeples were finished.

65. LPL, MS 2691, p. 357, meeting of the commissioners on 26 November 1725.

66. Anonymous article, "Professor Cockerell's Second Lecture on Architecture," *Builder* 14 (1856): 29. I owe the Hogarth observation to John Pinto and to the *London Encyclopaedia,* 707. The encyclopedia also states that the statue of George I on the steeple of Saint George's was paid for by a Mr. Huck, the brewer to the royal household! Again, the themes of sobriety and inebriation mingle. Surprisingly, perhaps, the church's amazing steeple had an impact on actual church design elsewhere-the only contemporary instance I know of influence being exerted by a Hawksmoor church. A design by William Halfpenny (alias Michael Hoare; d. 1755) for Holy Trinity, Boar Lane, Leeds, of about 1723 calls for a steeple whose pyramidal topmost state is clearly indebted to that of Saint George's. For a discussion, see Terry Friedman, *Church Architecture in Leeds, 1700–1799* (LEEDS, 1997): 74–78 and fig. 16.

67. The anonymous and undated pasquinade is quoted by John Soane, *Lectures in Architecture,* ed. Arthur T. Bolton (London, 1929), 98.

68. A copy of the cartoon, signed by one Marlowe, is in my collection of ephemera.

\mathcal{B} I B L I O G R A P H Y

Ackroyd, Peter. *Hawksmoor.* London, 1985.

*The Acts of Parliament relating to the Building Fifty New Churches in and about the Cities of London and Westminster.... * London, 1721.

Adam, Jean-Pierre, and Nicole Blanc. *Les sept merveilles du monde.* Paris, 1989.

Addleshaw, George William, and Frederick Etchells. *The Architectural Setting of Anglican Worship.* London, 1950.

Allacci, Leone. *De templis Graecorum recentioribus, ad Ioannen Morinum; de narthece ecclesiae veteris, ad Gasparem de Simeonibus; necnon de Graecorum hodie quorundam opiniationibus ad Paullum Zacchiam.* Cologne, 1645.

———. *The Newer Temples of the Greeks.* Trans. Anthony Cutler. University Park, Pa., 1969.

Amory, Hugh, ed. *Sale Catalogues of Libraries of Eminent Persons: Poets and Men of Letters.* Vol. 7. London, 1973.

Arts Council of Great Britain. *Hawksmoor.* London, 1962.

Atterbury, Francis. *The Epistolary Correspondence Visitation Charges, Speeches and Miscellanies....* 4 vols. London, 1783–87.

———. *Sermons and Discourses on Several Subjects and Occasions.* 2 vols. London, 1723.

Bedford, Arthur. *The Scripture Chronology Demonstrated by Astronomical Calculations.... Together with the History of the World, from the Creation, to the Time When Dr. Prideaux Began His Connection.* London, 1730.

Bennett, Gareth Vaughan. *The Tory Crisis in Church and State, 1688–1730: The Career of Francis Atterbury, Bishop of Rochester.* Oxford 1975.

Bennett, J. A. "Christopher Wren: The Natural Causes of Beauty." *Architectural History* 15 (1972): 5–22.

Beveridge, William. "The Excellence and Usefulness of the Common Prayer: Preached at the Opening of the Parish Church of St. Peter's, Cornhill, the 27th of November 1681." In *The Theological Works of William Beveridge.* 12 vols. Oxford, 1842–46.

———. Συνοδικόν, *sive Pandectae canonum SS. Apostulorum, et conciliorum ab ecclesia*

Graeca receptorum; nec non canonicarum SS. Patrum epistolarum. . . . 2 vols. Oxford, 1672.

———. *Biblia Sacra Polyglotta.* . . . Ed. Bryan Walton. 6 vols. London, 1653–57.

Bikker, Jonathan. "Re-reading Wren's Mind in the Light of the Bookish Evidence." In *Architects, Books, and Libraries: A Collection of Essays,* ed. Pierre de la Ruffinière du Prey, 16–23. Kingston, Ont., 1995.

Bill, E. G. W., ed. *The Queen Anne Churches: A Catalogue of the Papers in Lambeth Palace Library of the Commission for Building Fifty New Churches in London and Westminster, 1711–1759.* London 1979.

Bingham, Joseph. *Origines Ecclesiasticae, or The Antiquities of the Christian Church.* 10 vols. London, 1708–22.

Bisse, Thomas. *The Merit and Usefulness of Building Churches: A Sermon Preached at the Opening of the Church of St. Marie in the Town and County of Southampton, on Christmas Day, 1711.* London, 1712.

Britton, John, and Augustus Pugin. *Illustrations of the Public Buildings of London.* 2 vols. London, 1825–28.

Cast, David. "Seeing Vanbrugh and Hawksmoor." *Journal of the Society of Architectural Historians* 43 (1984): 310–27.

Cave, William. *Primitive Christianity, or The Religion of the Ancient Christians in the First Ages of the Gospel.* 6th ed. London 1702.

Colvin, Howard. *Catalogue of Architectural Drawings of the Eighteenth and Nineteenth Centuries in the Library of Worcester College, Oxford.* Oxford, 1964.

———. "Fifty New Churches." *Architectural Review* 107 (1950): 189–96.

———. "Mr. Vanbrugg's Proposals." *Architectural Review* 107 (1950): 209–10.

Crawley, W. J. Chetwolde. "Rabbi Jacob Jehudah Leon." *Transactions of the Quatuor Coronati Lodge* 12 (1899): 150–58.

Downes, Kerry. *Christopher Wren.* London, 1971.

———. *English Baroque Architecture.* London, 1966.

———. *Hawksmoor.* London, 1969.

———. *Hawksmoor.* 2d ed. London, 1979.

———. *Vanbrugh.* London, 1977.

Downes, Kerry, R. A. Beddard, et al. "A.D. Profiles 22:1 Hawksmoor's Christ Church Spitalfields." *Architectural Design* 49 (1979): 1–32.

Du Prey, Pierre de la Ruffinière. "Hawksmoor's 'Basilica after the Primitive Christians': Architecture and Theology." *Journal of the Society of Architectural Historians* 48 (1989): 38–52.

———. *The Villas of Pliny from Antiquity to Posterity.* Chicago, 1994.

Eusebius Pamphilius. *Eusebius His Life of Constantine in Four Books: With Constantine's Oration to the Clergy.* Trans. Wye Saltonstall. London, 1649.

Evelyn, John. *The Diary of John Evelyn.* Ed. Esmond S. de Beer. 6 vols. Oxford,

1955.

Feisenberger, H. A., ed. *Sale Catalogues of Eminent Persons: Scientists.* London, 1975.

Fréart de Chambray, Roland. *A Parallel of the Ancient Architecture with the Modern.* Trans. John Evelyn. London, 1664.

Fuller, Thomas. *A Pisgah-Sight of Palestine and the Confines Thereof, with the History of the Old and New Testament Acted Thereon.* London, 1650.

Goar, Jacques. *Ευχολογιον, sive Rituale Graecorum, complectens ritus et ordines divinae liturgiae . . . illustratum.* Paris, 1647.

Godwin, George, and John Britton. *The Churches of London. . . .* 2 vols. London, 1839.

Grelot, Guillaume-Joseph. *A Late Voyage to Constantinople: Containing . . . an Account of the Ancient and Present State of the Greek Church. . . .* London, 1683.

——. *Relation nouvelle d'un voyage de Constantinople enrichie de plans levés par l'auteur sur les lieux. . . .* Paris, 1680.

Gunther, Robert W. T. *Early Science in Oxford.* 15 vols. Oxford, 1923–67.

Harris, Eileen. *British Architectural Books and Writers, 1556–1785.* Cambridge, 1990.

Hooke, Robert. *The Diary of Robert Hooke, 1672–1680.* Ed. Henry Robinson and Walter Adams. London, 1935.

Jeffery, Paul. *The City Churches of Sir Christopher Wren.* London, 1996.

Journal of the House of Commons, 16 (1708–11), 17 (1711–14).

Kennett, White. *The Charity Schools for Poor Children Recommended. . . .* London, 1706.

Keynes, Geoffrey. *John Evelyn: A Study in Bibliography.* 2d ed. Oxford, 1968.

King, Peter. *An Enquiry into the Constitution, Discipline, Unity and Worship of the Primitive Church. . . .* London, 1691.

Kruft, Hanno-Walter. *A History of Architectural Theory: From Vitruvius to the Present.* Trans. Ronald Taylor, Elsie Callander, and Antony Wood. New York, 1994.

Lang, Susan. "Vanbrugh's Theory and Hawksmoor's Buildings." *Journal of the Society of Architectural Historians* 24 (1965): 127–51.

L'Empereur, Constantijn. *Talmudis Babylonici Codex Middoth, sive De mensuris templi.* Leiden, 1630.

Leroy, Julien-David. *Histoire de la disposition et des formes différentes que les chrétiens ont données à leurs temples, depuis le règne de Constantin le Grand, jusqu'à nous.* Paris, 1764.

Lightfoot, John. *The Temple Especially as It Stood in the Days of Our Savior.* London, 1650.

——. *The Temple Service as It Stood in the Days of Our Savior.* London, 1649.

——. *The Works of the Reverend and Learned John Lightfoot D.D. . . . with Three*

Maps: One of the Temple Drawn by the Author Himself. . . . Ed. George Bright. 2 vols. London, 1684.

The London Encyclopaedia. Ed. Ben Weinreb and Christopher Hibbert. London, 1983.

Maundrell, Henry. *A Journey from Aleppo to Jerusalem at Easter, A.D. 1697.* 3d ed. Oxford, 1714.

Mead, Joseph. *Clavis apocalyptica. . . .* Cambridge, 1627.

———. *The Key to Revelation, Searched and Demonstrated out of the Natural and Proper Character of the Visions.* Trans. Richard More. London, 1643.

———. *The Reverence of God's House: A Sermon Preached at St. Marie's in Cambridge, before the University on St. Matthias's Day, Anno 1635.* London, 1638.

Mussells, Samantha. "Architects, Travellers, and the Revival of the Early Christian Basilica." In *Architects, Books, and Libraries: A Collection of Essays,* ed. Pierre de la Ruffinière du Prey, 9–15. Kingston, Ont., 1995.

Newman, John. "Laudian Literature and the Interpretation of Caroline Churches in London." In *Art and Patronage in the Caroline Courts: Essays in Honour of Sir Oliver Millar,* ed. David Howarth, 168–88. Cambridge, 1993.

Newton, Isaac. *The Chronology of Ancient Kingdoms Amended. . . .* London, 1728.

Perrault, Charles. *Parallèle des anciens et des modernes. . . .* Paris, 1688.

Perrault, Claude. *Ordonnance for the Five Kinds of Columns after the Method of the Ancients.* Trans. Indra Kagis McEwen. Santa Monica, Calif., 1993.

Port, Michael H. *The Commissions for Building Fifty New Churches: The Minute Books, 1711–27: A Calendar.* London, 1986.

Prideaux, Humphrey. *The Old and New Testament Connected in the History of the Jews and Neighboring Nations, from the Declension of the Kingdoms of Israel and Judah to the Time of Christ.* 4th ed. 2 vols. London, 1718.

Ramirez, Juan Antonio, ed. *Dios, arquitecto: J. B. Villalpando y el templo de Salomón.* Madrid, 1991.

Roberts, Foulke. *God's Holy House and Service according to the Primitive and Most Christian Form Thereof.* London, 1639.

Rosenau, Helen. *Vision of the Temple: The Image of the Temple of Jerusalem in Judaism and Christianity.* London, 1979.

Rub, Timothy. "'A Most Solemn and Awfull Appearance': Nicholas Hawksmoor's East London Churches." *Marsyas* 21 (1981–82): 17–27.

Rykwert, Joseph. *The First Moderns: The Architects of the Eighteenth Century.* Cambridge, Mass., 1980.

Schelstrate, Emanuel. *Sacrum Antiochenum concilium pro Arianorum conciliabulo passim habitum. . . .* Antwerp, 1681.

Sekler, Eduard. *Wren and His Place in European Architecture.* London, 1956.

Sinclair, Iain. *Lud Heat: A Book of the Dead Hamlets.* London, 1975.

Smalridge, George. *Sixty Sermons Preached on Several Occasions....* 5th ed., 2 vols. Oxford, 1852.

Smart, David H. "Primitive Christians: Baroque Architecture and Worship in Restoration London." Th.D. diss., University of Toronto, 1997.

Soane, John. *Lectures in Architecture.* Ed. Arthur T. Bolton. London, 1929.

Soo, Lydia. *Wren's "Tracts" on Architecture and Other Writings.* Cambridge, 1998.

Stewart, J. Douglas. "A Mililant, Stoic Monument: The Wren-Cibber-Gibbons Charles I Mausoleum Project: Its Authors, Sources, Meaning, and Influence." In *The Restoration Mind,* ed. W. Gerald Marshall, 21–64. Newark, Del., 1997.

Stirling, James, Robert Maxwell, et al. *James Stirling: Architectural Design Profile.* London, 1982.

Stukeley, William. *The Family Memoirs of Rev. William Stukeley, M.D....* 3 vols. Surtees Society Publications, vols. 73, 76, 80. Durham, Eng., 1882–87.

Summerson, John. *Architecture in Britain, 1530–1830.* 5th ed. Harmondsworth, Eng., 1970.

———. *Georgian London.* 2d ed. London, 1962.

———. "The Mind of Wren." In *Heavenly Mansions and Other Essays on Architecture,* 2d ed., 79–82. New York, 1963.

Survey of London. Vol. 27. *Spitalfields and Mile End New Town.* Ed. F. H. W. Sheppard. London, 1957.

T., R. *De Templis, a Treatise of Temples: Wherein Is Discovered the Ancient Manner of Building, Consecrating and Adorning of Churches.* London, 1638.

Villalpando, Juan Bautista, and Jeronimo de Prado. *In Ezechielem explanationes et apparatus urbis ac templi Hierosolymitani commentariis et imaginibus illustratus.* 3 vols. Rome, 1605.

———. *El templo de Salomón.* Trans. José Luis Oliver Domingo. 2 vols. Madrid, 1991.

Vitruvius. *Les dix livres d'architecture de Vitruve.* Trans. Claude Perrault. 2d ed. Paris, 1684.

Watkin, David, ed. *Sale Catalogues of Libraries of Eminent Persons: Architects.* London, 1972.

Weaver, Lawrence. "The Interleaved Copy of Wren's *Parentalia* with Manuscript Insertions." *Royal Institute of British Architects Journal,* 3d ser., 18 (1911): 569–83.

———. "Memorials of Wren." *Architectural Review* 26 (1909): 175–83.

Webb, Geoffrey. "The Letters and Drawings of Nicholas Hawksmoor relating to the Building of the Mausoleum at Castle Howard, 1726–1742." *Walpole Society* 19 (1930–31): 111–64.

Wheler, George. *An Account of the Churches, or Places of Assembly, of the Primitive*

Christians, from the Churches of Tyre, Jerusalem and Constantinople Described by Eusebius, and Ocular Observation of Several Very Ancient Edifices of Churches Yet Extant in Those Parts; with a Reasonable Application. London, 1689.

———. *Autobiography of Sir George Wheler.* Ed. E. G. Wheler. Birmingham, 1911.

———. *A Journey into Greece by George Wheler Esq. in Company with Dr. Spon of Lyon.* London, 1682.

Whinney, Margaret. *Wren.* London, 1971.

Whitechapel Art Gallery. *Hawksmoor.* London, 1977.

Worsley, Giles. "Designs on Antiquity: Hawksmoor's London Churches." *Country Life* 194, no. 42 (1990): 172–74.

Wren, Christopher, comp. *Parentalia, or Memoirs of the Family of the Wrens.* London, 1750.

The Wren Society. Ed. Arthur T. Bolton and H. D. Hendry. 20 vols. Oxford, 1924–43.

＆NDEX